THE ART AND MAKING OF
TRANSFORMERS®
WAR FOR CYBERTRON
TRILOGY

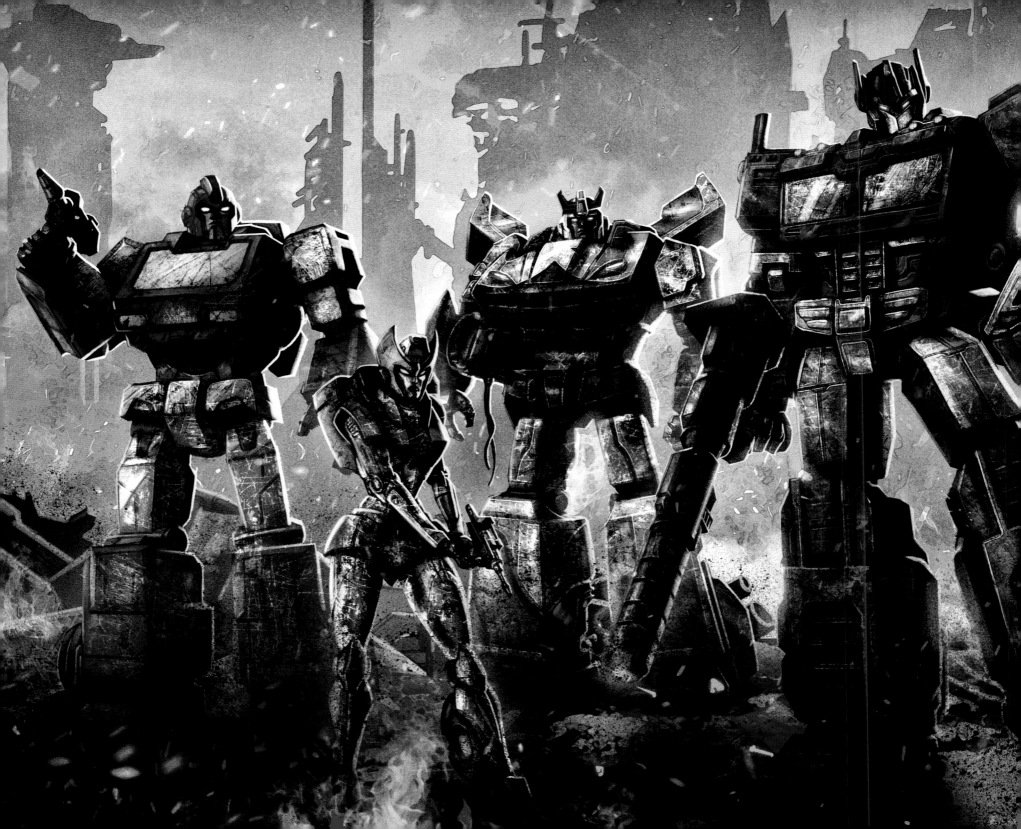

THE ART AND MAKING OF

TRANSFORMERS

WAR FOR CYBERTRON
TRILOGY

WRITTEN BY **MIKE AVILA**

FOREWORD BY **F.J. DESANTO**

VIZ MEDIA

CONTENTS

PAGES 2–3: Key art for *War for Cybertron: Siege.*

OPPOSITE: A stylized image of Optimus Prime designed to look like an in-world propaganda poster.

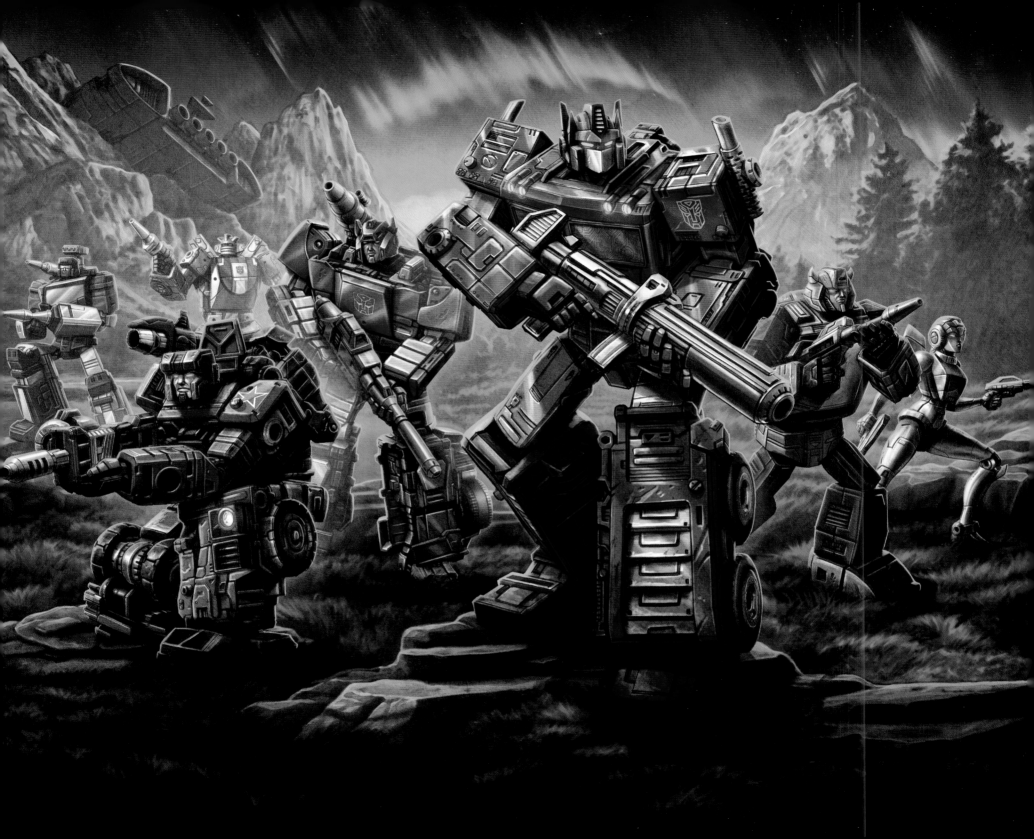

FOREWORD

What you are holding in your hands is the culmination of years of incredible work from hundreds of people who are not just supremely talented, but also unified by a passion to bring a new vision of *Transformers* to the world. But before you dive in, allow me to share some of the backstory:

In 2018, Hasbro called me. They wanted to show me something. When you get that kind of call, you don't ask questions; you drop everything and get on a plane. As I arrived in Rhode Island, my expectations were high, but nothing—absolutely nothing—could have prepared me for what I was about to see.

Seated in a conference room, I bounced with anticipation as the *Transformers* team gathered to show me their next big event. The lights dimmed, and on a huge screen I saw the words I knew would change *Transformers* (and my life) forever: *War for Cybertron Trilogy*. This series was an opportunity to craft a brand-new story that would allow us to dive deeper into the heart of the classic conflict between Megatron and Optimus Prime and answer many questions about their history together.

War for Cybertron Trilogy would be an animated series composed of three chapters: *Siege*, *Earthrise*, and *Kingdom*. The first chapter would be a gritty war epic, the second would take the Transformers into the far reaches of space, and the third chapter—well, the third chapter was the real jaw-dropper. It would deliver something that fans had been anxiously waiting for: the return of the beloved *Beast Wars* characters! The Maximals and Predacons would be back for the first time in twenty-five years, but this time they would be meeting the classic Generation 1 characters from the 1980s! I couldn't believe what I was hearing—Autobots, Decepticons, Maximals, and Predacons all sharing the screen together? This was something truly historic.

OPPOSITE: Marketing art featuring the Autobots after landing on Earth at the end of *War for Cybertron: Earthrise*.

ABOVE: Showrunner F.J. DeSanto in the Polygon Pictures offices in Tokyo.

LEFT: Supervising producer Matt Murray, F.J. DeSanto, and Sound Designer/ Re-Recording Mixer Jamie Hardt in a Los Angeles studio during sessions for *War for Cybertron: Kingdom* in 2021.

I left the Hasbro office both buzzing with excitement that I had been asked to guide this show and trembling with fear at the responsibility this amazing project presented. This wasn't just a toy line or an event; it was a celebration of all things *Transformers*. Luckily, the folks at Rooster Teeth and Netflix also knew we had something special on our hands and gave us all the support we needed to assemble a top-tier team to produce this trilogy.

As *War for Cybertron Trilogy* came together, something became clear very quickly: everyone involved in this show had a genuine love of *Transformers* and understood the privilege and responsibility of working on something that means so much to millions of people all over the world. I am eternally grateful to everyone at Hasbro, Netflix, Rooster Teeth, Polygon Pictures, Technicolor, Horseless Cowboy, our producers, and all the other companies and artists who helped bring the series to life.

From day one, *Transformers: War for Cybertron Trilogy* was our love letter to both the robots of Cybertron and their fans on Earth. I think I can speak on behalf of everyone involved in saying that we are proud of our contribution to one of the biggest franchises in the galaxy and appreciate you all coming on the journey with us.

—F.J. DeSanto

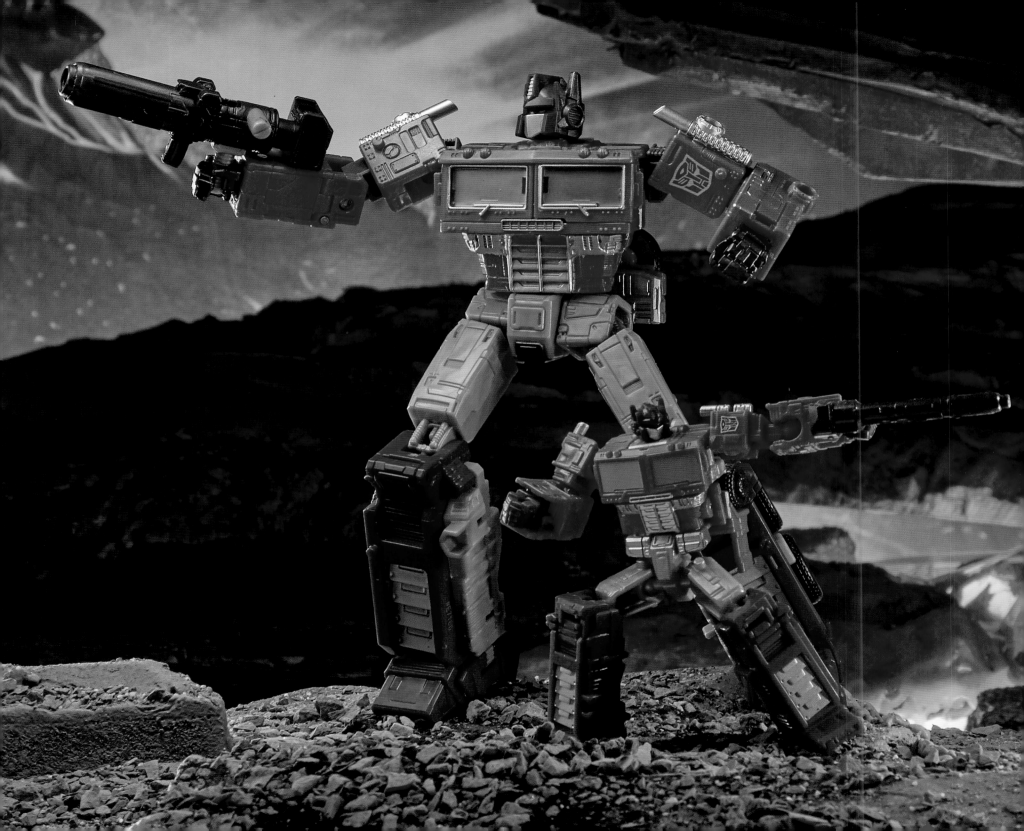

CHAPTER 1

ORIGINS

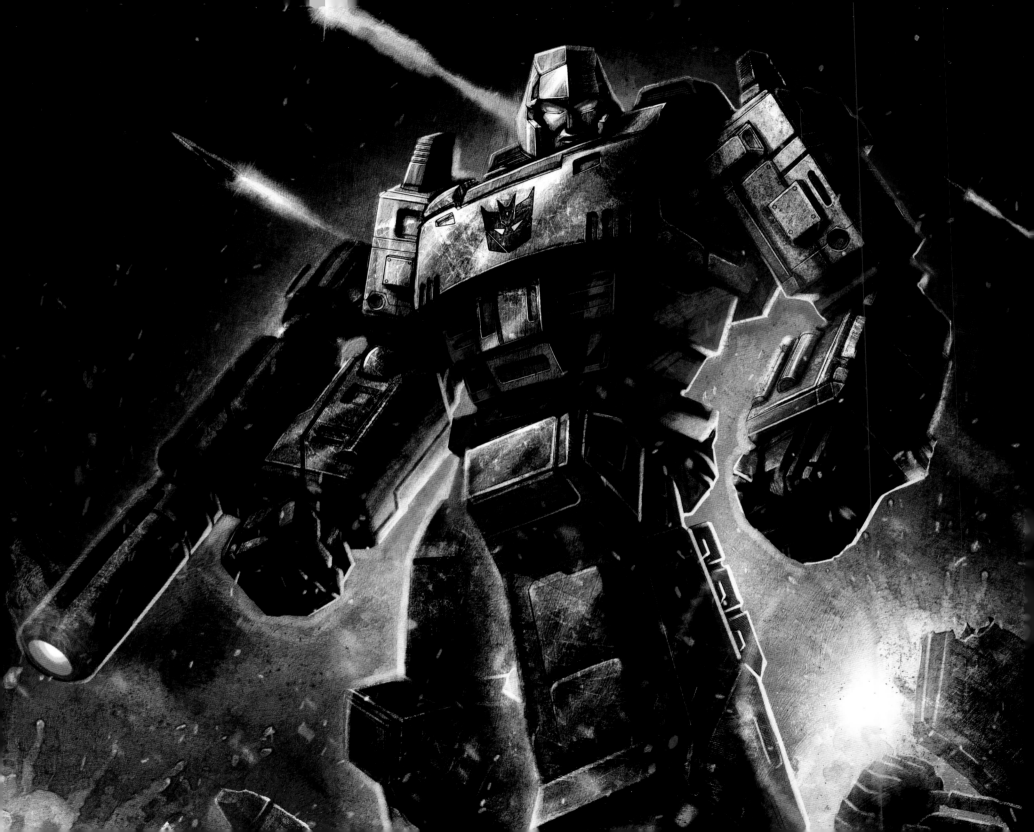

When one is tasked with telling a new story within the rich and robust mythology of *Transformers*, sometimes the only way to move forward is to go back—all the way to the beginning.

Transformers: War for Cybertron Trilogy tells the story of the final days of the war that felled the technological planet that is home to the Autobots and Deceptions. This chapter in the iconic series had never been told in animated form. The idea to explore this story sprung from the minds at Hasbro, the company that, along with Takara Tomy in Japan, oversees the *Transformers* brand.

"*War for Cybertron* sort of started out as a toy line," recalls John Warden, director of product design at Hasbro and the design lead on the *Transformers* toy line. That is nothing new, as most of the multimedia iterations of the robots in disguise have been birthed from concepts that originated with the toys that have been incredibly popular for decades.

In 2018, *Transformers: Prime Wars Trilogy*, a transmedia property that included toys, comics, and an online animated series, had just wrapped up. The *Transformers* brand found itself at a bit of a crossroads, so Warden and his team—which included *Transformers* brand writer Matt Clarke and senior creative manager of global franchise strategy and management Tom Marvelli—were trying to determine a new direction.

"We weren't sure what was happening with the future of the *Transformers* line, so we wanted to use this moment in time to reassess what we wanted to do," Warden says. "Very early on, we were working with Takara Tomy on new concepts for toy lines, and we thought about the beginning—retelling the origin story in a way. We were thinking about what those characters were like... and what sorts of things might have happened on Cybertron as they were trying to leave."

Kelly Johnson, senior brand manager for *Transformers*, puts it another way. "It's important to stay

PAGE 8: Optimus Prime in bot mode. These 3.5-inch and 7-inch scale action figures are part of the toy line designed for *War for Cybertron Trilogy*.

OPPOSITE: Concept artwork of Megatron. Once allies and friends, Megatron and Optimus have become mortal enemies fighting for control of their home planet.

ABOVE: The last functioning Spacebridge explodes on Cybertron as the *Ark* passes through during the climax of *Siege*.

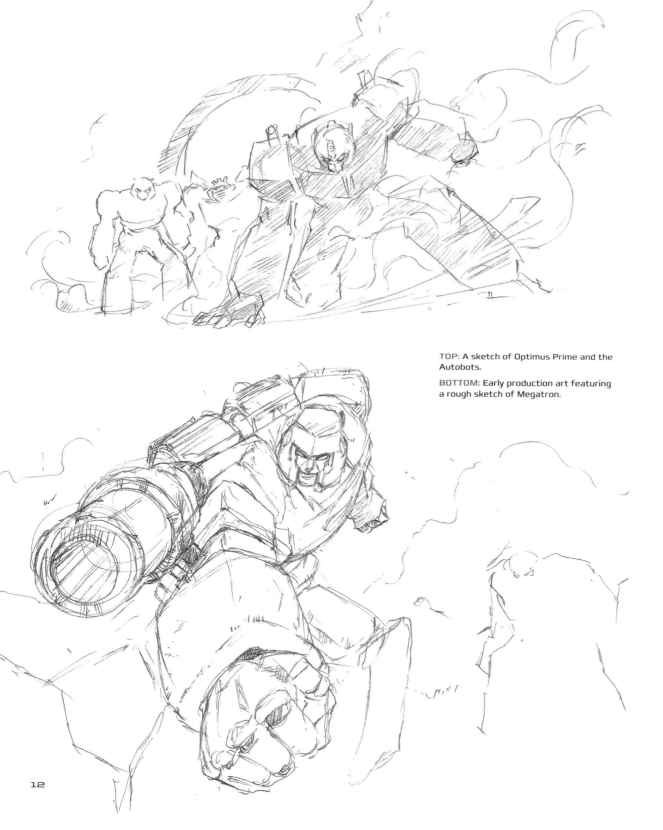

TOP: A sketch of Optimus Prime and the Autobots.

BOTTOM: Early production art featuring a rough sketch of Megatron.

relevant and offer new entry points to the franchise. Our unique and diverse Cybertronian characters, like us, face all of the same, if not more, human conditions that we face as an evolving species," Johnson says. "It's not always light. Everyone is the bad guy in some version of a memory; it depends on who is presenting the information."

"If we were to retell this universe through a contemporary lens, what might it look like? And what are the tenets of the *Transformers* universe that we want to build on, keep intact?" Warden continues. "We were keeping in mind that between all the various properties and the original G1 series, and especially the comic book series, there's all sorts of really wonderful storytelling potential to tap into."

G1 refers to Transformers: Generation One, the original toy line that eventually led to the initial animation series and Marvel Comics series, which introduced audiences to the Autobots and Decepticons. This first series was originally known simply as *The Transformers* and ran from 1984 through 1990. G1 is what many fans identify as the defining era for *Transformers*. Along with the 1986 animated feature film, it has a significant influence on *War for Cybertron Trilogy*.

After meeting with the designers at Takara Tomy and seeing the ideas they had for revamping the *Transformers* toys, Warden went back to the workshop and started to kitbash (modifying existing toy models to create a new model) his vision for a new line of toys.

"I had a bin full of robot toys that I took to the model shop, and I started using the band saw to cut them apart and a glue gun to put them together," he recalls. Warden assembled a diorama that showcased a battle between the Autobots and Decepticons. The idea was to use storytelling to promote the toys to collectors, showing them how to bring their toy shelves to life.

"I glued weapons all over their bodies. I had little bursts and little laser effects and things like that," he remembers. "I had this big piece of foam core, and I used a buzzsaw to cut it in half. Then I glued all my

"IT'S NOT ALWAYS LIGHT. EVERYONE IS THE BAD GUY IN SOME VERSION OF A MEMORY."
– KELLY JOHNSON

abomination creations all over it so that it looked like a frozen moment in time."

The designer recalls feeling the pressure of trying to deliver a winning pitch. "When I brought [the diorama] out in front of the senior team, our CEO, Brian Goldner, was just staring at the model," Warden recalls. "And he turned around and said to the team in the room, 'This has to be a TV show. We need to figure out a way to make this into the last day on Cybertron.' When Brian said that, people took notice and knew we had to make this happen."

From there, the team worked on fleshing out the story line that would support this new animated series, one that retells the final days of Cybertron. This part of *Transformers* history had been touched upon before, notably in the IDW comics and in the *War for Cybertron* video game, but the Hasbro team believed there was much more story to be told.

Matt Clarke recalls a meeting with Warden and the rest of the team to brainstorm ideas and a hook, a purpose for the new toy line that would become *Siege*. "We came up with 'build the ultimate battlefield,' and it all grew out from there," Clark says. "The line wasn't tied to any content, so we needed to create a story to go with it—what is its reason for being?"

Marvelli recalls conversations with the *Transformers* team about the direction they wanted to take. "We wanted to make sure that the consumer was engaged in this bigger narrative. And I used the *Field of Dreams* idea. I said, 'If you build it, they will come,'"

he says, referencing a famous line from the sports film. "My point of view was, let's build out the story through these three chapters—*Siege*, *Earthrise*, and ultimately *Kingdom*—knowing that we have the anniversary of *Beast Wars* approaching. And so part of that was figuring out, what's the story?"

"What we were trying to do is connect the dots and bring heart to it," Warden says. "What does it feel like to be the last guy on Cybertron when you're running out of energy and you're desperate? You're fighting a battle that you're losing, and the Decepticons are taking over. The last thing that you can do is sacrifice your own planet in order to save it. And how do you make that decision happen?"

F.J. DeSanto was visiting Hasbro's Rhode Island headquarters when he got his first glimpse of *War for Cybertron Trilogy*. He was already deeply immersed in *Transformers* culture because of his involvement in the *Prime Wars Trilogy*, having joined that crew as a writer and producer before being elevated to showrunner for season 3.

"Hasbro showed me some concept art for what they were thinking about for the next *Transformers* project, and they said it was called *War for Cybertron*," DeSanto says. "They started telling me how they wanted to do all these things with the franchise, and they wanted to bring the *Beast Wars* characters back for their twenty-fifth anniversary. My jaw just dropped."

DeSanto minced no words with Hasbro by immediately declaring his interest in a project that was still

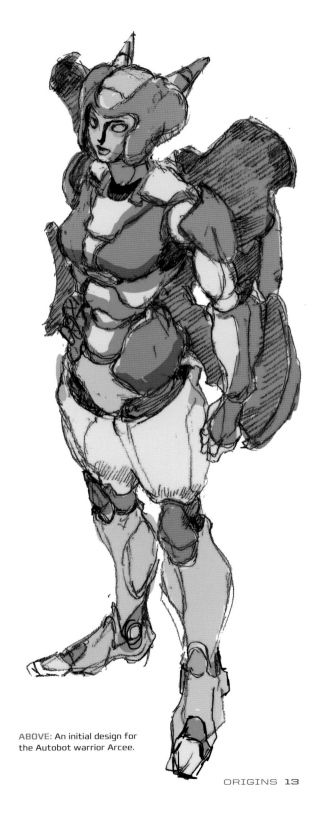

ABOVE: An initial design for the Autobot warrior Arcee.

very much in early development. "I told them, 'Oh my God. I would kill to do that series.'"

During talks with Hasbro, someone mentioned to DeSanto that they would, as he says, "love to see something on Netflix." As it turned out, he had just learned that the streaming service was launching an anime division. DeSanto, a longtime anime fan with extensive knowledge of the genre, called a contact in Netflix's anime group and asked, "What about *Transformers*?"

A meeting was quickly arranged with Netflix to pitch them on the project. "All I had was Hasbro's brand deck and some concept art. I hadn't written anything down," DeSanto recalls. "I gave a general thumbnail pitch letting them know that it's called *War For Cybertron* and it has three chapters," DeSanto recalls. "And Netflix immediately said, 'Okay, yes. We're in.' That was it. The concept and designs Hasbro had sold them on it. I didn't even have the story for the entire series figured out yet!"

Hasbro's brand deck was the backbone of the project in the beginning. To create the deck, Warden, Clarke, Marvelli, and others hunkered down in an office at the company's Rhode Island headquarters to develop the story that would tell the story of the final days of Cybertron.

"We needed to define the story, the tone, and rules of the world," remembers Clarke. "We gravitated toward this pivotal moment in the universe when the AllSpark is in play and the future really hinges on these events and looking at those moments in a new way."

The story would focus on the eternal war between the Autobots and Decepticons, the bedrock of the *Transformers* mythos. But *War for Cybertron Trilogy* would add a different element to the familiar conflict.

RIGHT: Concept art showing a vision of Cybertron as a gleaming metropolis before the war laid waste to the planet. The massive Arena was a centerpiece of Cybertronian culture, but it would later become ground zero for Megatron's propaganda campaigns.

NON-DESTROYED CYBERTRON
VER A

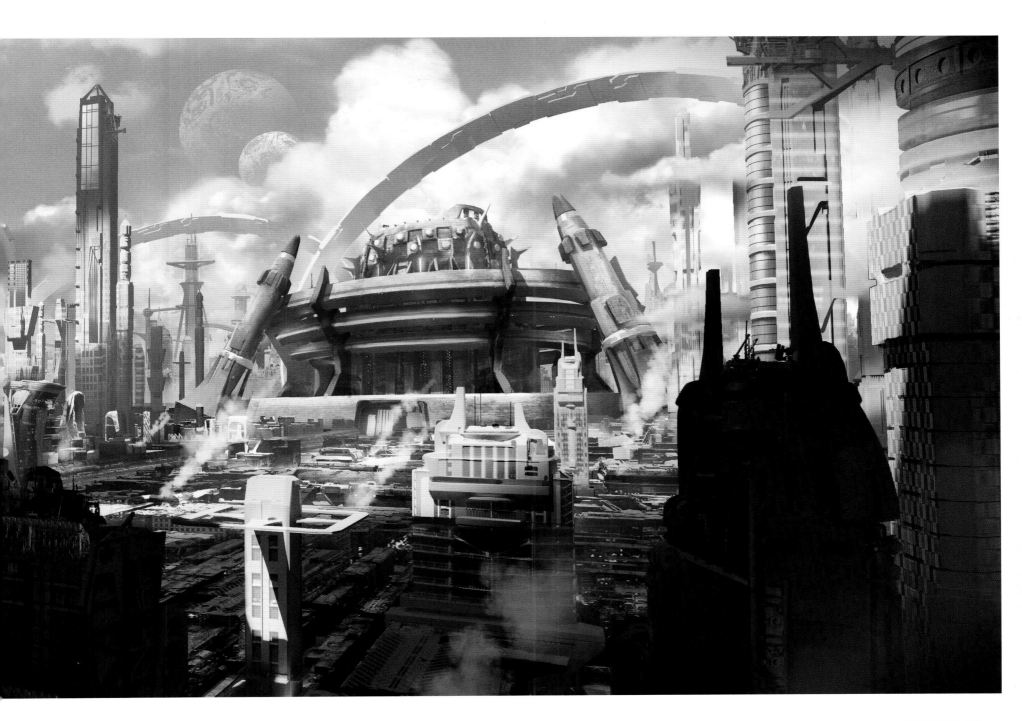

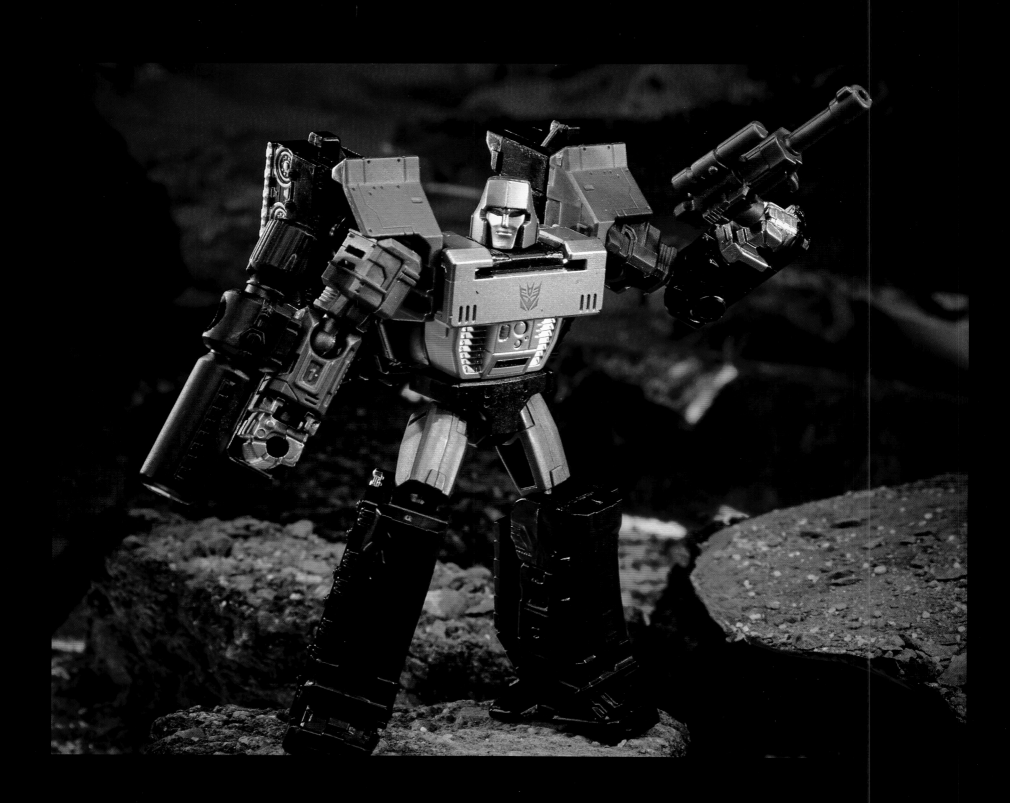

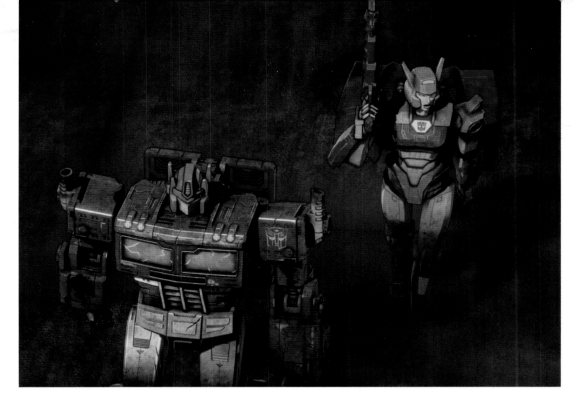

"SHE WAS THE ANSWER TO THE QUESTION, 'WHO COULD BE BADASS ENOUGH TO STAND UP TO BOTH OPTIMUS PRIME AND MEGATRON?'"

— F.J. DESANTO

OPPOSITE: An action figure of Megatron, Cybertron's most fearsome warrior, in bot mode.

ABOVE: Optimus Prime with Elita-1, the leader of the Autobots' strike force.

"We wanted to make it personal and look at the story through the eyes of the bots fighting the war," says Clarke. "These characters didn't start out as soldiers—what was it like having to choose a side and fight to save Cybertron? To leave your life behind?"

One of the first things DeSanto did when he officially joined the project as executive producer was to hire George Krstic, a veteran animation and video game writer who had worked on 2019's *Transformers: Combiner Wars* series, to write a show bible that would flesh out the overall story. "There was a realization early on that this project is so big," he says, "and that if we don't work out the story in advance and get everybody on board with it right away, we'd be in trouble."

"George was a big *Transformers* fan, and he was really effective when we laid out the show bible to capture the right tone for the show," DeSanto says. "That document gave all of the stakeholders in the show—especially Hasbro, Machinima, and Netflix—a comfort level that let them know, 'Okay, we know where the story is going,' and it helped get everyone on the same page. Subsequently, that show bible was given to the writers we hired, and that helped them."

Ted Biaselli, the Netflix executive overseeing the series, says tone was a key reason the show succeeded. *War for Cybertron Trilogy* features all the familiar *Transformers* characters that fans have enjoyed for decades, but this time in a more mature situation. "I think the series really did cater to the things that people love—those moments that they loved while watching *Transformers* in their childhood," Biaselli says. "Only now they saw those same exact moments in perhaps a little bit more of a sophisticated light."

Polygon Pictures, considered one of the top 3D computer graphic (3DCG) animation studios in Japan, was hired to handle the animation. It was an easy decision as Netflix was familiar with the company's work on the streaming service's first original anime, *Knights of Sidonia*, as well as the *Godzilla* anime trilogy. Polygon also had history with *Transformers*, having worked on 2010's *Transformers Prime* and 2015's *Transformers: Robots in Disguise*.

"Our company mission statement is 'To do what no other has done, in unparalleled quality, for all the world to see and enjoy,'" says Jack Liang, executive producer at Polygon. "When *War for Cybertron Trilogy* came up, the grittiness [of the story] was just so different [from the previous projects] we had worked on. We [felt] it was a perfect challenge for us to just go in a whole different direction than [that of] the previous two series. And we had all these G1 Transformers that we all grew up liking and loving, so for us, it was a great opportunity to continue working with the franchise."

ABOVE: Concept art showing the Alpha Trion protocols traveling across the city after the death of Ultra Magnus.

The producers were given a lot of latitude by Hasbro in terms of which characters and what parts of the *Transformers* canon could be incorporated into the story. They knew they were going to incorporate concepts such as the Dead Universe, a pocket dimension that was first introduced in the *Transformers* comics from IDW but had never been explored in animation. Iconic characters such as Galvatron, Unicron, and Nemesis Prime would also be involved, as well as new elements such as the Mercenary faction that seeks to profit from the destructive war on Cybertron.

The team also brought Elita-1 into the mix. Putting her in a prominent role allowed them to explore her relationship with Optimus Prime in greater depth than had been done in previous iterations. "We liked Elita-1 because she hadn't been used all that much, and she looked really cool," DeSanto says. "Plus, she was the answer to the question, 'Who could be badass enough to stand up to both Optimus Prime and Megatron?'"

The production team also knew they would be building up to what would arguably be the biggest element of the entire series: the reintroduction of the *Beast Wars* characters.

"*War for Cybertron Trilogy* starts off as a 'prequel' to G1, technically," says DeSanto. "But we knew that incorporating the *Beast Wars* characters into the mix inherently changed what was originally established. This actually gave us the freedom to expand the story and take some bigger risks."

The *Beast Wars* characters' return in the third chapter of the series was timed to match the twenty-fifth anniversary of the debut of those beloved characters. For a certain generation of *Transformers* fans, those characters are as important as G1 icons like Optimus Prime and Megatron. Count *War for Cybertron's* supervising producer Matt Murray in that group.

Getting a chance to work on a series with the *Beast Wars* characters was a dream project for Murray, who was first introduced to the franchise through the 1996 animated series, *Beast Wars: Transformers*, the first in the franchise to feature computer animation. "I didn't really watch the G1 show until I was basically out of college. *Beast Wars* was my only frame of reference for *Transformers* for a very long time," he says. Murray notes that his first exposure to anything from the original series came from the references made in *Beast Wars: Transformers*.

His excitement was tempered by a healthy dose of apprehension and questions—many, many questions. "I remember asking F.J. about things like, 'How will this work? Does our story contradict what came before in *Beast Wars*? Is this sort of like an alternate history?'" he says. "There were a lot of things that still needed to be worked out—what exactly [the timeline] was, and the mechanics of all that. But just the idea that the *Beast Wars* characters and G1 *Transformers* were going to meet and interact for the first time in animation—I thought, *Wow. That is so cool.*"

With the story template in place, the creative team behind *War for Cybertron Trilogy* set about exploring a chapter in the vast mythos of this globally popular franchise in a way no previous *Transformers* adaptation had attempted. "We decided to build our own sandbox and craft an original story that was inspired by several key pillars from the franchise's past: G1—including the Japanese animated series, the 1986 movie, the Marvel Comics series, and, of course, *Beast Wars*," DeSanto says. "We strove to respect the core mythology while simultaneously creating something longtime fans could enjoy, while making it a starting point for any new fans."

Tying it all together in a way that maintained the integrity of the franchise continuity and stayed true to the spirit of these iconic characters would be a daunting task. It would begin in the only place it could:

On Cybertron.

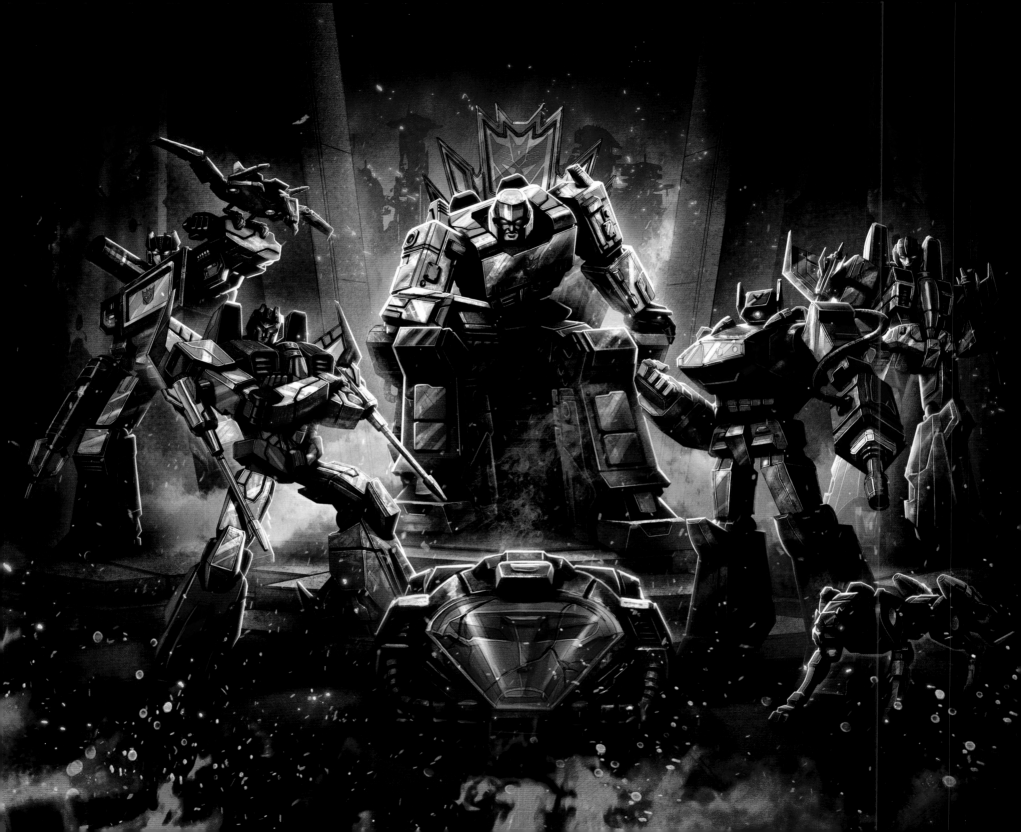

CHAPTER 2

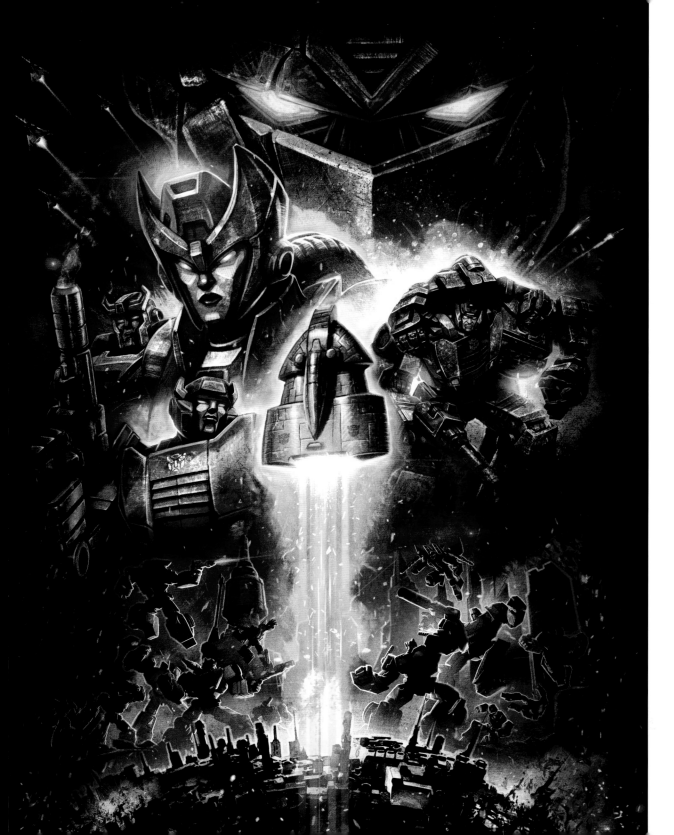

ach chapter of *War for Cybertron Trilogy* has a distinct theme that permeates its six-episode cycle. The first installment, *Siege*, takes its cues from war films like *Saving Private Ryan*. Set millions of years before the original animated series, these six episodes depict the civil war between the Autobots and Decepticons and the destruction it has brought to their home planet.

"Before the war, before they were Autobots and Decepticons, they were friends," explains showrunner F.J. DeSanto. "They were all Transformers bots until an ideological split occurred and led to this war. Our show begins in the waning days of that conflict."

It becomes apparent in the first episode of *Siege* that the Decepticons have the clear upper hand in the war, but Optimus Prime and his small band of rebels refuse to surrender. The beginning of that episode finds Autobots Bumblebee and Wheeljack scouring for Energon as the Decepticon Seekers track them. If this seems familiar to longtime fans of the franchise, it's because the scene is a purposeful homage to the opening sequence from the pilot of the original 1984 *Transformers* series. As the duo searches for Energon, they find an unlikely source: a damaged Spacebridge that is potentially salvageable. It's a discovery that gives the Autobots something they haven't had in quite some time: hope.

A desperate Optimus decides that finding the AllSpark, the key to all creation on Cybertron, is the Autobots' only remaining hope for survival. But several of his key lieutenants, especially Elita-1, object to

PAGE 20: A marketing illustration featuring Megatron and the Decepticons.

LEFT: Promotional artwork for *Siege*.

OPPOSITE TOP: Pre-production art of the opening sequence of the series where Bumblebee and Wheeljack discover an operational Spacebridge on Cybertron.

OPPOSITE BOTTOM ROW: The duo narrowly avoid detection by Decepticon scouts.

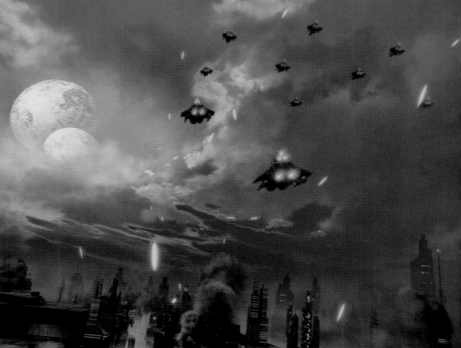

the idea of removing their planet's source of life.

The Decepticon leader Megatron is after the All-Spark for a more horrific reason: he wants Shockwave to use it to "reformat" the Autobots into Decepticons, intending to bring peace to Cybertron by wiping the entire Autobot faction from existence. But Megatron's plan doesn't sit well with others in the Decepticon camp. Jetfire, the leader of the Seekers, views it as an act of genocide. Even the duplicitous Starscream objects because he believes absorbing the Autobots would dilute "the honorable warrior heritage" of the Decepticon race.

Hounded by Megatron's forces and fighting dissension within their own ranks, the Autobots are coming undone. To longtime *Transformers* fans, the version of Optimus Prime seen in *Siege* may seem unfamiliar. Even though he bears the Matrix of Leadership, the burden of wartime leadership weighs heavily on him.

Unlike Megatron, Optimus wasn't gifted with a warrior's mentality. Before the war, he wasn't even a trained fighter; he was a clerk and an idealist who, by virtue of circumstance, had to become the commander of a revolution. His stubbornness, however, makes

him turn a deaf ear to his closest advisors, including his wise and battle-tested mentor, Ultra Magnus. As the war rages on, some Autobots begin to doubt that Optimus is the leader they need to survive.

"It's really hard to picture Optimus as not being that amazing boy scout we know, the 'everyone's dad' sort of character," explains supervising producer Matt Murray. "So we wanted to show him in this light where he actually doesn't have all the right answers and has to learn how to become that infallible hero. There were definitely a lot of questions that we had to answer along the way."

The clash between Optimus and Megatron, who once were as close as brothers and who both viewed Alpha Trion as a mentor, is a foundational element of the *Transformers* mythology. These mortal enemies were once friends. The series spends ample time detailing how both characters went down vastly different paths despite sharing a desire to bring peace to their world. Outclassing Optimus as both a military commander and hand-to-hand fighter, Megatron proves his fighting superiority when the two clash one-on-one in the first episode. But gradually they

both learn how to become the leaders they will be in the future—for better and for worse—and the events of *Siege* help push them along the paths to their disparate futures.

The Megatron we meet in *Siege* is ruthless and cunning, and as gifted at propaganda as he is at ground warfare. As he details his plans to defeat the Autobots and put an end to the fighting, Megatron distorts the meaning of the old battle cry "'Til all are one!" to fit his new world order.

At this point, the Decepticon leader still retains some semblance of personal honor. He began the civil war with the best of intentions: as a former Energon mine worker, he wanted to bring down an oppressive regime and create a new society on Cybertron built on equality. But the pressures of war and the strain to

OPPOSITE: Key moments from *Siege*, including Optimus and Elita-1's rescue of Wheeljack and Bumblebee at the Spacebridge. These images are from a "color-study," which is a type of pre-production painting used by animators to help capture the color and lighting of different scenes.

ABOVE: A frame from the finished series featuring Megatron and Jetfire.

establish the type of peace he envisions for Cybertron push Megatron to the edge, and beyond.

"Here was this guy with a chip on his shoulder, and his revolution's gone too far, and he's struggling with how far to go with it," says DeSanto. "This story is about Megatron's descent into madness."

Against the backdrop of the final battles in the Cybertronian civil war, *Siege* also explores the multi-faceted relationship between Optimus Prime and Elita-1. In addition to being the leader of the Autobots' Special Ops team, Elita is also Optimus's longtime lover and confidant. But a wedge is driven between them when she disagrees with Optimus's decision to take the AllSpark off planet, believing it will be a death sentence to Cybertron. Though they both want to save Cybertron, Optimus thinks the only way to is to use the Autobots' headquarters, the *Ark*, to leave the planet. "I think the reason she doesn't get on the *Ark* is because for her, it wasn't about continuing the fight with the Decepticons," says series writer Gavin Hignight. "She was staying behind to help and save those who had been left on this dying world. That is what helps define her."

Many of the principal characters face crises of conscience during *Siege*. Ultra Magnus, Optimus's military strategist and the heart and soul of the Autobots, sees the war as a lost cause. He tries to get Optimus to stop fighting and focus on the survival of the Autobots but is unable to sway him. Magnus then tries to surrender himself to Megatron to end the war, but he ultimately fails and is killed by Megatron. That brutal action triggers the Alpha Trion Protocols, a failsafe secretly embedded in Magnus by Alpha Trion, onetime mentor to Magnus, Optimus Prime, and Megatron. The protocols contain all of Trion's accumulated knowledge, which may prove crucial to the Autobots' cause.

Ultra Magnus's death was the first scene writer

LEFT: Early conceptual design for the sequence in which Bumblebee meets Alpha Trion and learns the purpose of the Protocols.

Brandon Easton scripted when he joined the series. "That was the beginning of episode 4," Easton says. "I tried to write a scene that was really reflective of the hero Ultra Magnus was, but that also showed how uncompromising Megatron was in terms of what he wanted. It was a really cool sequence too, because he murdered Magnus in cold blood. To me it was an important moment because it kind of crossed the threshold to make you realize that this is not the old cartoon."

Magnus's noble sacrifice and Megatron's "reformatting" scheme horrify Jetfire and convince him to switch allegiances. He defects to the Autobots, eventually earning their trust with his gallant fighting at the Sea of Rust against the Sparkless, reanimated corpses of Transformers.

Bumblebee has his own dilemma to work through. He initially turns down Optimus's offer to join the Autobot resistance, but the scavenger bot cannot remain neutral after he inherits the Trion Protocols from Ultra Magnus. Now armed with all of Alpha Trion's knowledge, Bumblebee returns to the *Ark* and helps the Autobots locate the AllSpark.

But all does not go as planned. By the end of *Siege*, Optimus has followed through with his plans to abandon Cybertron with the hope that he can return to save it. Unfortunately, as the *Ark* travels through the repaired Spacebridge and leaves the planet, the AllSpark is lost in space. Elita-1, Jetfire, Impactor, and other Autobots remain behind to continue the fight against Megatron's forces.

"The entire first season is about choices," says DeSanto. "It's Optimus's choice to throw the AllSpark into the Spacebridge. It's Megatron's choice to kill Ultra Magnus in cold blood, which sort of [pushes] the entire [situation] over the edge. It's about the choices these two former friends make as they battle."

Set against the backdrop of war, this was an opportunity to tell a *Transformers* story unlike any other that had come before: an expansive, epic tale defined by intensely personal conflicts.

"I've always wanted to write a darker, more mature *Transformers* story line," notes Easton. "I always wanted to write a Megatron who was a freedom fighter who went the wrong way. I wanted to write the Autobots and Decepticons as full-fledged science fiction characters, which is why [*War for Cybertron Trilogy*] is one of the greatest moments of my career."

"You empathize with these characters, you get attached to them, you can see the world through their eyes. I think that's why *Transformers* works so well," says Murray about the emotional arcs some characters experience during *War for Cybertron Trilogy*. "There are very few franchises that can pull off these dramatic tonal shifts without completely alienating their audience, but *Transformers* can."

At the end of *Siege*, the story—and the fierce war—between the Autobots and Decepticons is far from over. What comes next is full of new threats, unexpected allies, and those who fall in the cracks between.

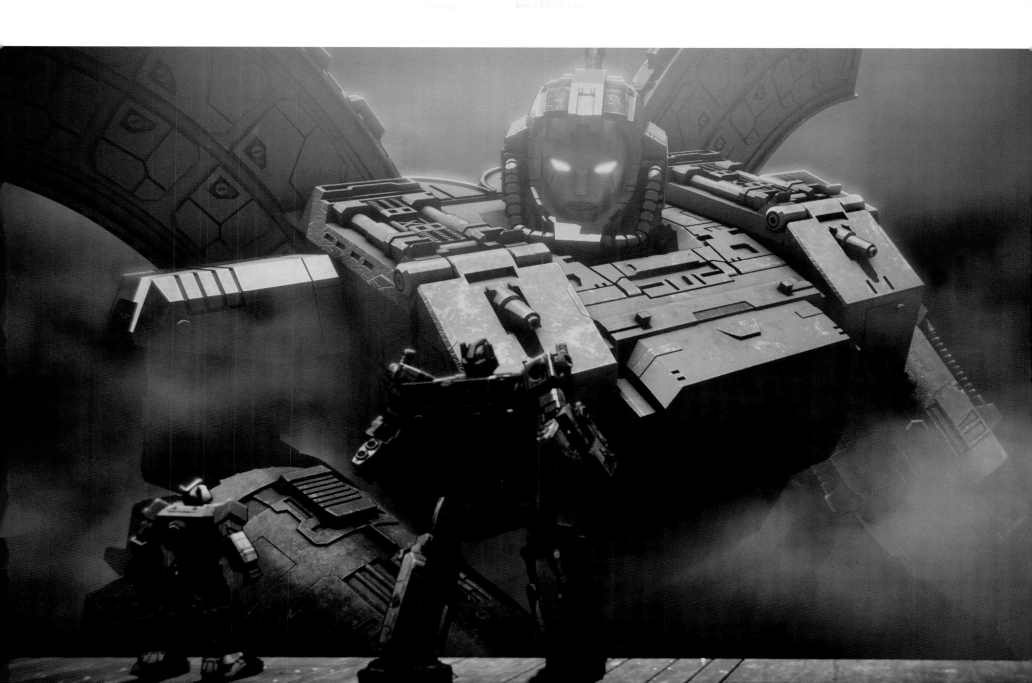

OPPOSITE LEFT: Megatron uses the colossal Arena to turn public sentiment against the Autobots in this sequence.

OPPOSITE RIGHT: Cog and Arcee join Bumblebee as he plans to steal Energon from Soundblaster.

ABOVE: Omega Supreme chooses to assist Optimus Prime, Bumblebee, and the Autobots.

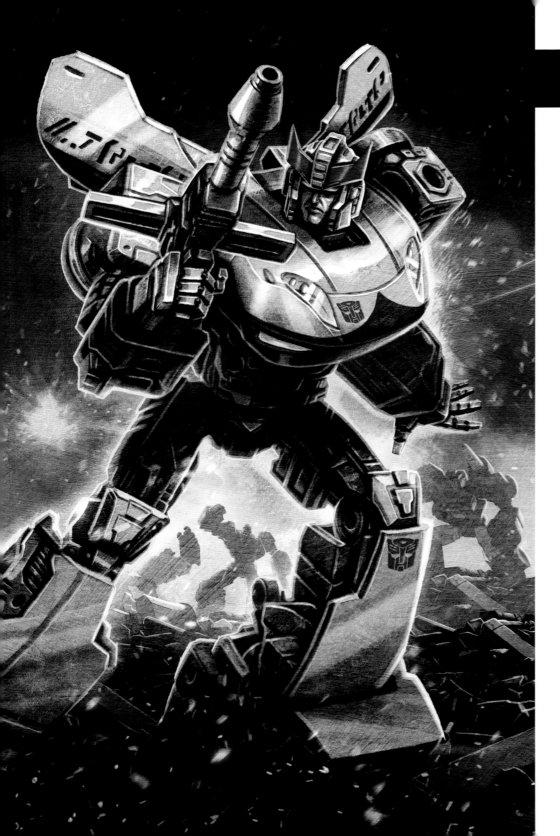

CHARACTERS

Given the vast landscape of the *War for Cybertron* story line, there are dozens of *Transformers* who make appearances. Nearly three dozen alone show up in *Siege*. While the series is a prequel with some expectations subverted, the producers were conscious about staying true to the core elements that defined storied characters such as Optimus Prime, Bumblebee, Jetfire, Megatron, and Starscream.

"Whether it was in development or in the voice-recording booth, at no point did the weight of our responsibility to these characters ever leave our shoulders," says Murray. "And sometimes I had to be the voice of reason to ask, 'Are we paying the proper respect to this particular character? Are we doing this right?' Because we needed to be sure that what we did was best for these characters and for the franchise."

This attention to detail and history extended to the character designs. Because the series was meant to loosely connect to the original animated series, Polygon's animation team wanted to establish aesthetic continuity with the look of the G1 Transformers. "One of the main themes of *War for Cybertron* is going back to the roots of the Transformers in G1," notes Takashi Kamei, the series' supervising director.

While the original 1984 series was done in traditional hand-drawn 2D animation, *War for Cybertron Trilogy* is animated with modern 3D computer-generated techniques. Kamei says, "We wanted to focus on the toy figures from back then and tried as much as possible to recreate those figures in the 3D models." However, some adjustments were required to better translate the figures for animation purposes. "For example, in Megatron's original design, there are some indentations on his face," notes

FAR LEFT: Prowl is one of the most hard-nosed warriors in the Autobot ranks and relies on precision and discipline.

LEFT: Bumblebee is initially reluctant to join the Autobots' fight.

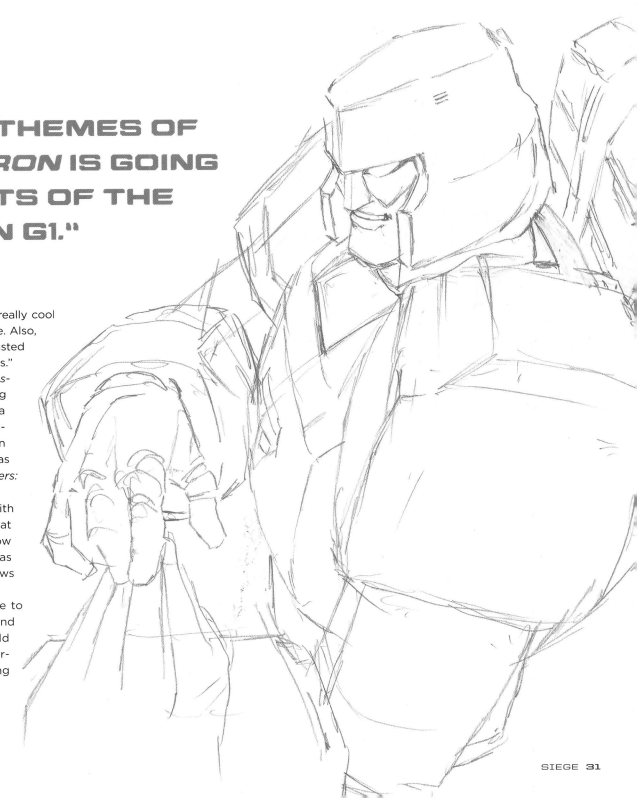

"ONE OF THE MAIN THEMES OF
WAR FOR CYBERTRON IS GOING
BACK TO THE ROOTS OF THE
TRANSFORMERS IN G1."
— TAKASHI KAMEI

Kamei. "But for animation purposes, to be able to give him really cool facial expressions, we adjusted where the lines fall on his face. Also, for the character's joints, like the knees and elbows, we adjusted them to make them more 'animation friendly' for battle scenes."

The robot conversions are a central element of any *Transformers* show, and they proved to be one of the most challenging aspects of production. Luckily, Polygon has a secret weapon: a mode shift animation specialist named Syuichi Kohno, who figures out all the vehicle transfigurations. Kohno has worked on the designs for the previous *Transformers* shows Polygon has helped make, including *Transformers: Prime* and *Transformers: Robots in Disguise*.

The process begins in a decidedly low-tech fashion, with Kohno trying out the toys. "We took the toys from Hasbro that were available and just transformed the figures to learn how they moved," says Kohno. "From there, we tried as much as possible to figure out a mode shift for the series that follows the conversions of the toy."

After that initial research, a few adjustments are made to account for the differences between a toy's configuration and a computer-generated character. "For those parts, I would remove excess parts that don't look as cool during the conversions," he says. "The goal was to make them look as interesting as possible while following the main process of the toy."

RIGHT: Animators use simple sketches like this one of Megatron to help plan out animation sequences.

PAGES 32–33: Marketing images for Ironhide, Shockwave, Starscream, and Chromia.

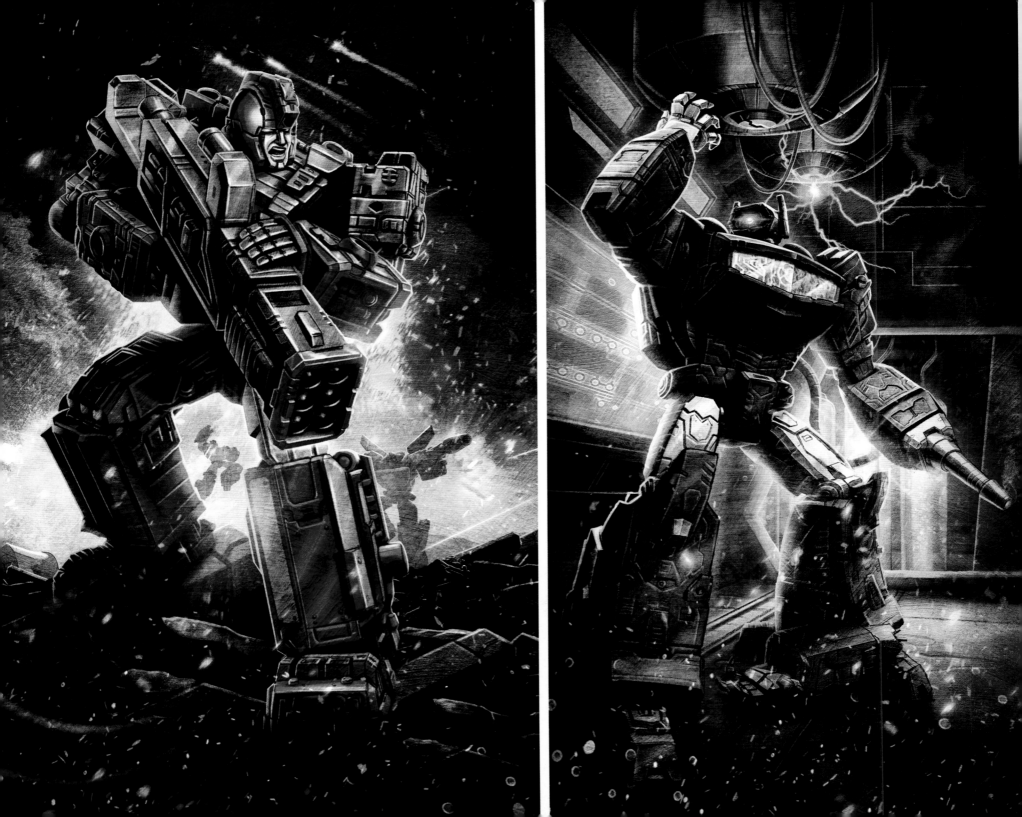

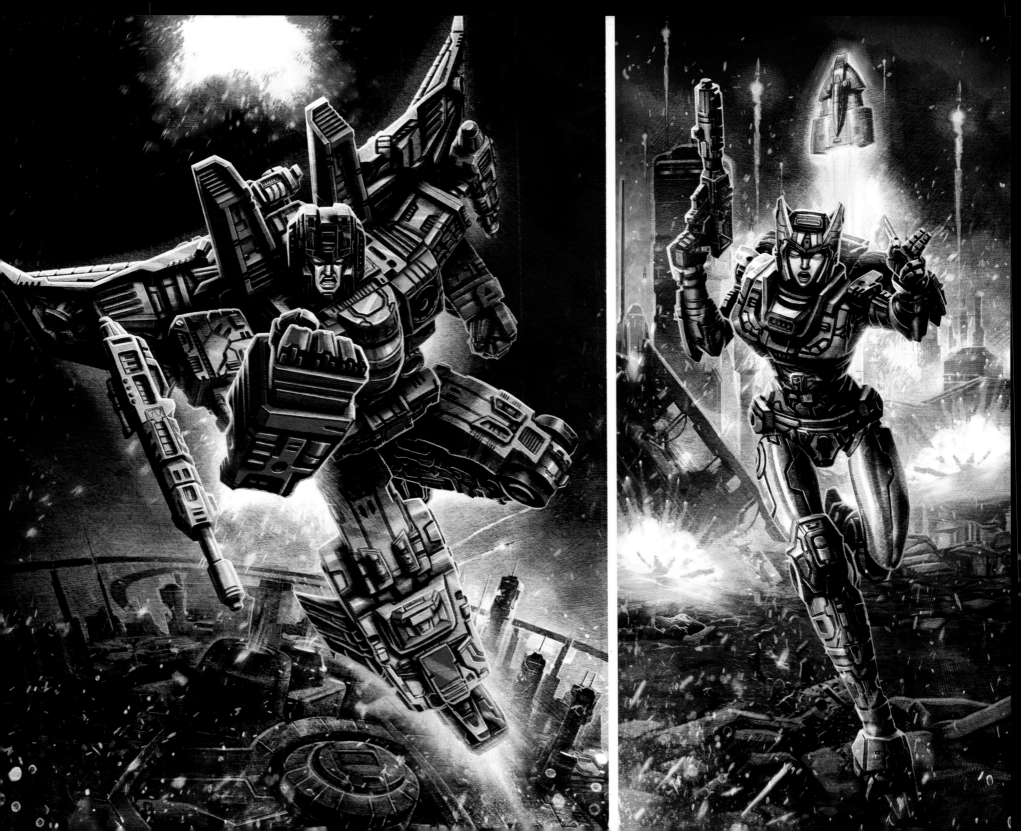

OPTIMUS PRIME

When we meet Optimus Prime in *Siege*, he is a far cry from the self-assured hero longtime *Transformers* fans are used to seeing. He seems overwhelmed as the leader of the Autobot resistance, thrust into a position of leadership that pits him against his former brother-in-arms Megatron—and frankly, he's outclassed.

"This is a prequel, and Optimus is still young here," notes executive producer F.J. DeSanto. "We wanted to start him in a place where he wasn't the fully realized person he would eventually become. He's hotheaded, and he makes mistakes."

Losing his trusted friend and advisor Ultra Magnus forces Optimus to overcome his self-doubt. Optimus realizes that if Megatron retrieves the AllSpark, he will use it to realize his genocidal intentions. To save the Autobots, Optimus makes the impossible choice to take the immensely powerful artifact off Cybertron. Doing so risks destroying the planet, but he firmly believes getting the AllSpark out of Megatron's reach is the only way to save their world.

In many ways, Optimus and Megatron are similar: both stubbornly believe their approach to the conflict is just and true. What separates them is that when Optimus is forced to confront the terrible mistakes and bad judgment calls he has made, he grows as a leader and sets himself on the path to become the hero he is destined to be.

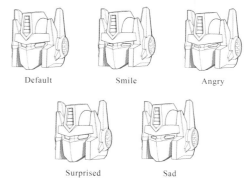

Default Smile Angry

Surprised Sad

LEFT: Image of Optimus Prime in action.

ABOVE: A study of Optimus Prime's facial expressions.

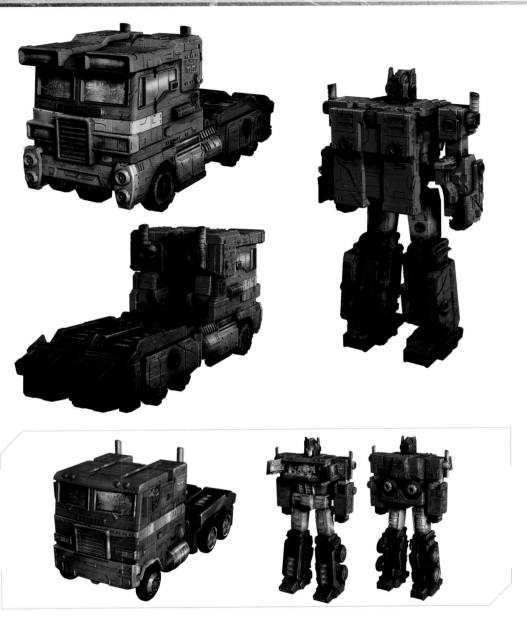

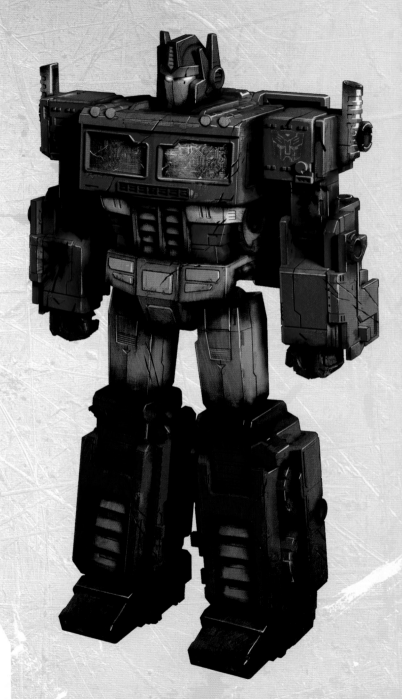

TOP LEFT: Optimus Prime in his vehicle mode.

TOP RIGHT: Back view of Optimus Prime.

ABOVE: The animators created an alternate design for Optimus Prime that was closer to his original G1 design for *Kingdom*, but this was cut at the last minute.

RIGHT: Optimus and the other Transformers character's designs feature distressing that resembles black oil and soot, which are more in keeping with the Cybertronian landscape, rather than dirt.

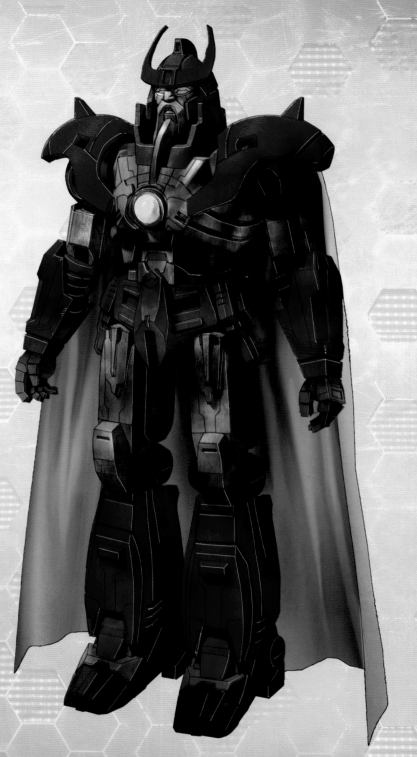

ALPHA TRION

As one of the oldest and wisest Transformers characters, Alpha Trion was the mentor to both Optimus Prime and Megatron. He led the enslaved Cybertronians in their rebellion against the alien Quintessons. Megatron eventually murders him, though his consciousness still pervades the Matrix of Leadership after he loses his physical form, providing guidance for future leaders like Optimus Prime. He is "resurrected" in holographic form after the death of Ultra Magnus triggers the Trion Protocols and provides the clues that help the Auto-bots find the AllSpark.

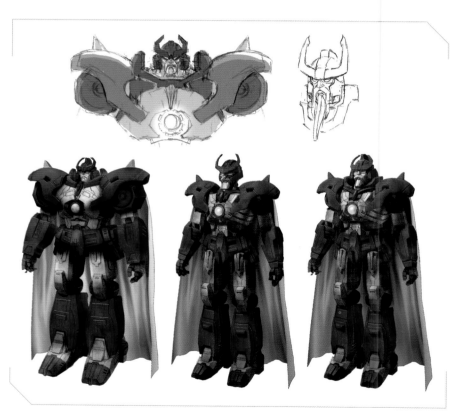

ABOVE: The designers experimented with Alpha Trion's silhouette and facial features before landing on his final design, seen left.

ULTRA MAGNUS

The revered military strategist for the Autobots, Ultra Magnus is renowned for his strength, battle prowess, and—most importantly—his sense of honor. He was a student of Alpha Trion who studied to become one of the leaders of the next generation of Transformers bots. He is a loyal soldier but also a realist who urges his friend Optimus to accept the reality of the situation.

"Magnus is a military guy, and he knows the battle is lost," says DeSanto. "He doesn't have that unending optimism that Optimus has, which is why he tries to get him to see there is no way to win against Megatron."

When he fails to convince his former friend Megatron to consider a peace treaty, Magnus sacrifices himself to aid the cause. It is that selflessness that makes him a legend and one of the most admired Transformers robots.

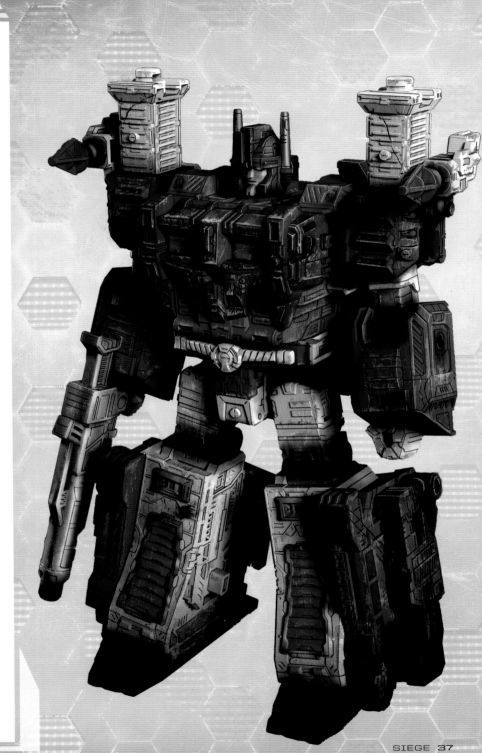

ABOVE: Ultra Magnus sustained significant damage when he was tortured by the Decepticons.

RIGHT: Ultra Magnus' design befits his military background. The dents, scars and other damage points across his body shows the physical impact the war has had on him.

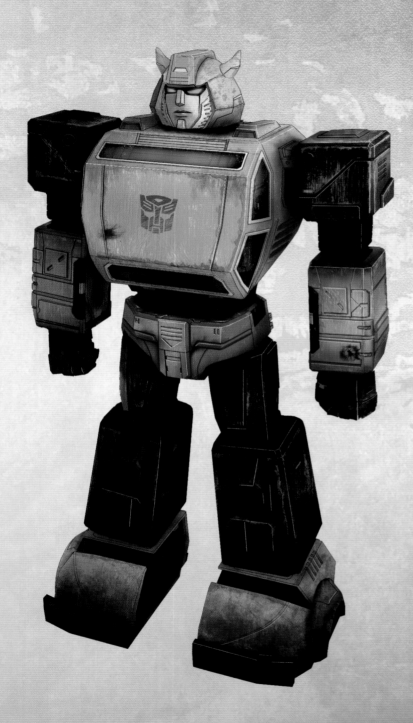

BUMBLEBEE

The Energon scavenger turned Autobot scout initially wanted no part in the war. But when Ultra Magnus's death triggers the Alpha Trion Protocols, Bumblebee inherits them. He encounters the spirit of Alpha Trion shortly after and decides he can no longer stay on the sidelines, so he joins the Autobots.

Bumblebee is an undersized Transformers bot and, in the context of this series, not able to convert into a vehicle. His ingenuity, courage, and evasiveness make him a key member of the Autobots.

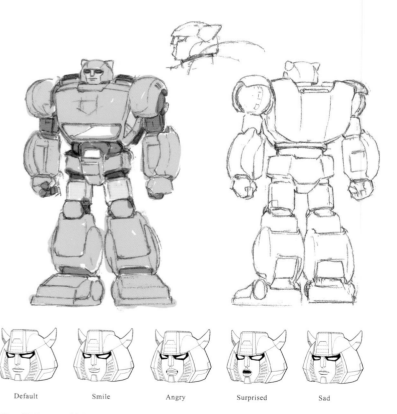

| Default | Smile | Angry | Surprised | Sad |

LEFT and TOP: Bumblebee's body texture is inspired by a yellow compact car.

CENTER: Early sketches of Bumblebee.

ABOVE: The black detailing around Bumblebee's eyes was inspired by *kumadori*, a style of Kabuki makeup.

ELITA-1

During the early stages of planning *War for Cybertron Trilogy*, it was quickly decided that Elita-1 would be not just part of the series, but also a central figure in the Autobot faction

"I wanted a strong female character for the show," says DeSanto. "We went through a list of past female Transformers characters and liked Elita-1 the best."

Elita-1 is a character who, despite having been around since G1, has not been utilized in storytelling as often as other characters. "There's so much more dimension to her, so much more potential," says John Warden, Hasbro's director of product design. "We wanted to explore that and reframe her as an important character in her own right."

As the leader of the Autobots Special Ops strike team, Elita-1 is someone Optimus turns to for tactical advice. But the two are also romantically involved. That relationship is an essential component of *Siege*, as Optimus's plan to remove the AllSpark from Cybertron puts them at odds. But Elita-1 is a dutiful soldier, so she follows orders. Their star-crossed romance comes to an end when she makes a last-second decision to stay behind on Cybertron in the *Siege* finale. "Someone has to stay and protect what's left of Cybertron," she tells Optimus in episode 6. "You've got your mission. Now I've got mine."

When Elita-1 sees the Spacebridge explode as the *Ark* travels through it, she believes that Optimus and the other Autobots perished in the explosion. Thinking that the great love of her life is dead, she continues the battle to save Cybertron.

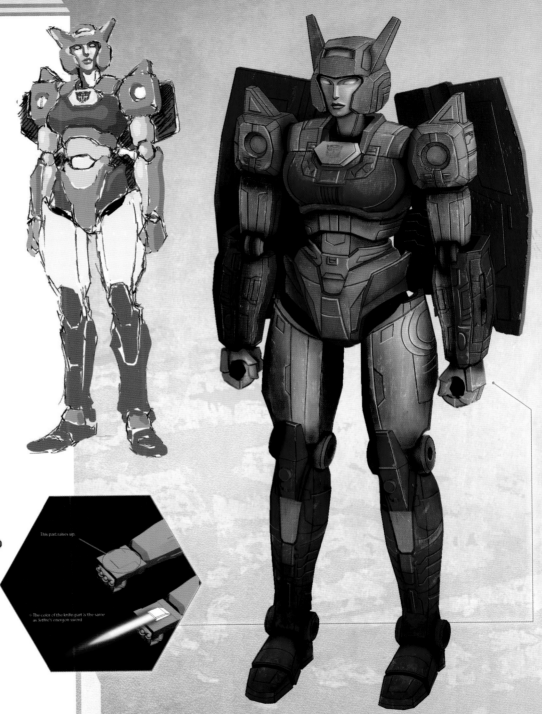

TOP: Early sketch of Elita-1.

LEFT and FAR RIGHT: Elita-1's design features battle damage, but because she's a sniper, she does not have any large scars.

ABOVE: A rendered image of Elita-1's sniper rifle.

RIGHT: A panel on the back of Elita-1's hand lifts up to reveal an Energon knife.

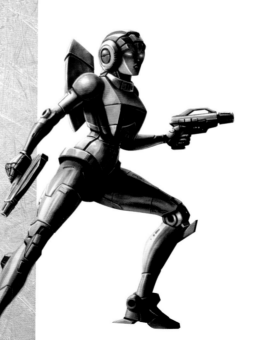

ARCEE

Arcee is a fearsome warrior and an expert in hand-to-hand combat. She would gladly sacrifice herself for any of her fellow compatriots. Arcee's great concern for her friends is her greatest strength and weakness, as she will gladly put her life on the line to protect her allies. As she says in *Earthrise*, "Ferocity without compassion is brutality."

A fan-favorite character, Arcee was introduced in 1986's *The Transformers: The Movie*. Writer Gavin Hignight notes that he would have liked for Arcee to receive even more screen time. "She's a strong character," he says. "Super heroic and an important one in the *Transformers* mythos."

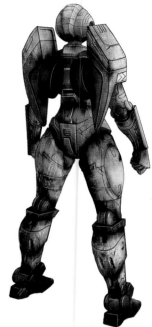

LEFT and ABOVE: Arcee is part of the team that leaves Cybertron with Optimus Prime.

ABOVE RIGHT: Sketches showing the side and back view of Arcee's design

CHROMIA

One of the toughest Autobots, Chromia is the leader whom Elita-1 relies on to run the Special Ops unit's field operations. Chromia is a loyal soldier, which explains why she stays behind with Elita-1 and the others at the end of *Siege*. She's a lethal sharpshooter, able to blast Seekers out of the sky with unerring accuracy.

"With most characters, I think we always want to see more, but with Chromia...less is more," says writer Gavin Hignight. "I think it worked really well with her personality and the type of character she is."

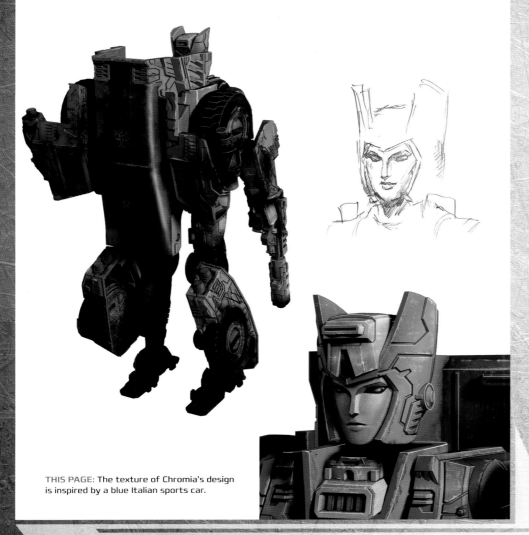

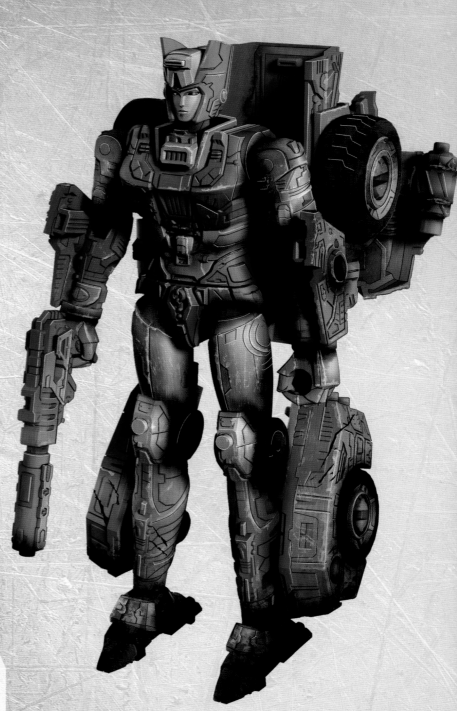

THIS PAGE: The texture of Chromia's design is inspired by a blue Italian sports car.

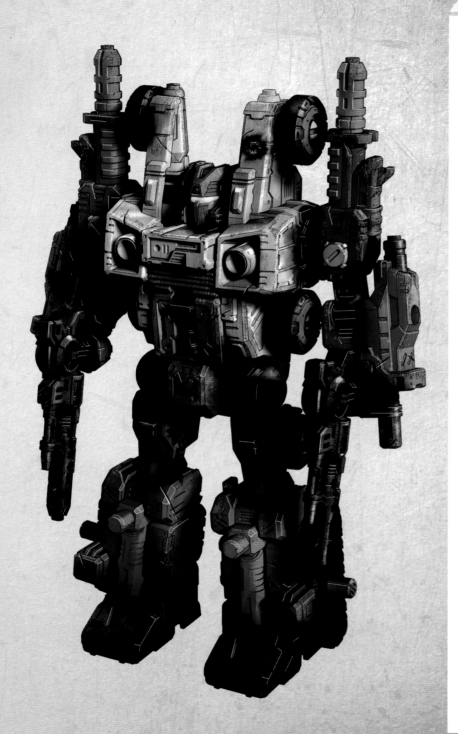

COG

An intensely loyal Autobot who is as good at fixing machines as he is at fighting, Cog is a walking weapons depot; he can split apart into six weapons that can be used by his fellow Autobots.

Cog dies in *Earthrise* while attempting to stop the Quintesson Deseeus aboard the *Fool's Fortune* ship. After Deseeus stabs him, Cog is helpless on the bridge as the Decepticons fire on the vessel. The brave Autobot is incinerated in the explosion.

FAR LEFT and ABOVE: The front and back of Cog's design as well as a battle-scarred iteration.

LEFT: Cog, Arcee, and Bumblebee's mission to steal Energon from Soundblaster almost ends in disaster, but the trio manages to escape. Here we see Arcee using weapons from Cog.

HOUND

Hound is a veteran of the battlefield who handles heavy weaponry for the Autobots and converts into a military-grade all-terrain vehicle. He can also project holograms to disguise himself. Despite his role with the Autobots, he's a gentle soul who keeps his feelings about the war largely to himself.

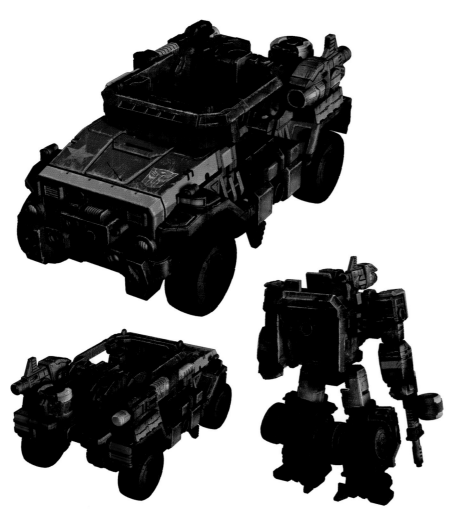

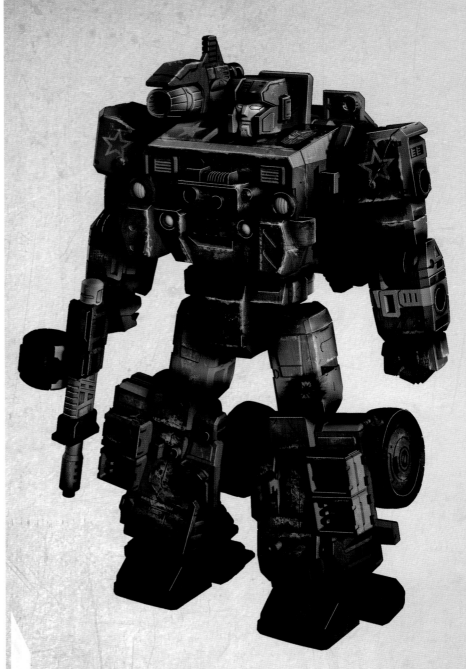

ABOVE: A view of the back of Hound's bot mode and Hound's vehicle mode.

RIGHT: Hound is intensely loyal and stood by Optimus' side fighting the Sparkless in the Sea of Rust and against Megatron at the Spacebridge portal.

IRONHIDE

As tough as his name suggests, Ironhide is a battle-tested fighter. He has nearly impregnable armor and has seen significant amounts of combat, which is why Optimus Prime has immense faith in him.

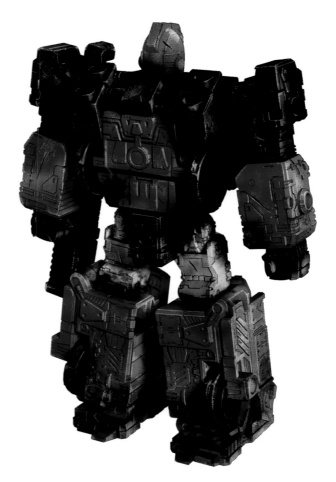

THIS PAGE: Ironhide's design was informed by a variety of armored personnel carriers. The blue, green, and yellow color variants are Cybertronian civilian models used to fill out city scenes.

MIRAGE

Mirage is a deft tracker and expert marksman, and his ability to render himself invisible and create illusions makes him a key intelligence asset for the Autobots. During *Siege*, he is even able to keep the *Ark* hidden from the Seekers. His rivalry with the reformed Decepticon Impactor makes him question the civil war and his role in it. Mirage was born into high society; Impactor comes from the Energon slave mines—their disparate backgrounds obscure how alike they are.

THIS PAGE: Mirage nearly extinguished his spark keeping the *Ark* from being seen by Decepticon Seekers.

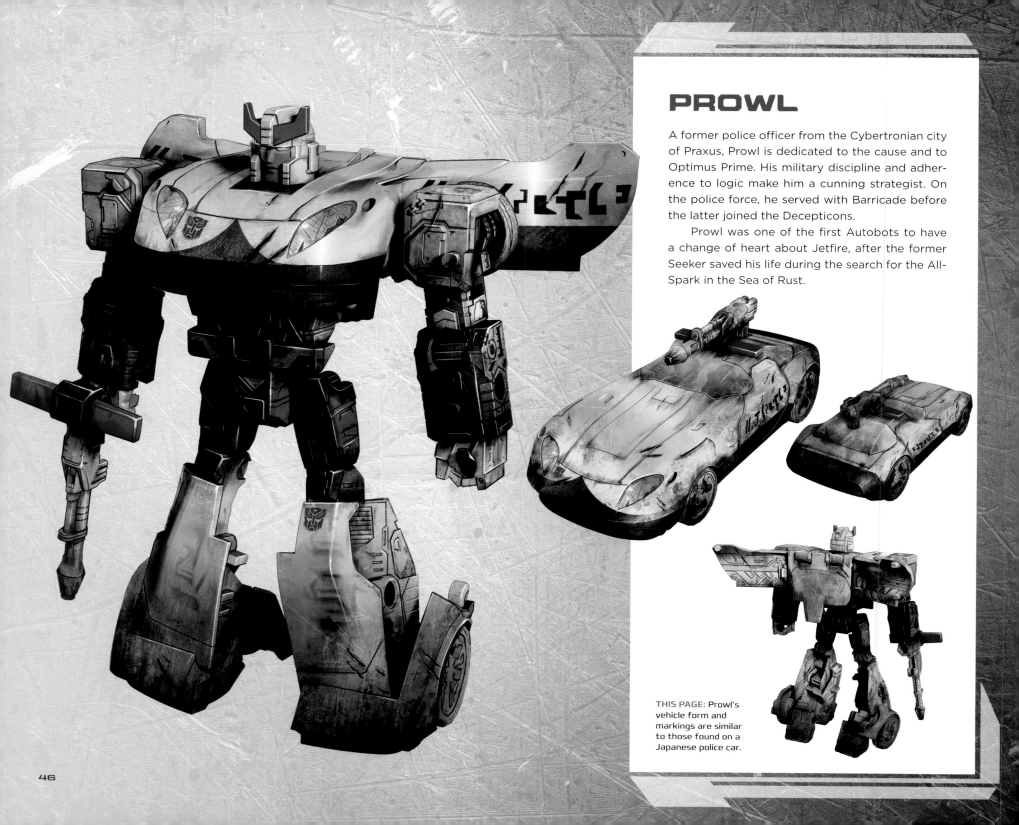

PROWL

A former police officer from the Cybertronian city of Praxus, Prowl is dedicated to the cause and to Optimus Prime. His military discipline and adherence to logic make him a cunning strategist. On the police force, he served with Barricade before the latter joined the Decepticons.

Prowl was one of the first Autobots to have a change of heart about Jetfire, after the former Seeker saved his life during the search for the All-Spark in the Sea of Rust.

THIS PAGE: Prowl's vehicle form and markings are similar to those found on a Japanese police car.

RED ALERT

Red Alert is a medic for the Autobots known for being a bit high-strung and occasionally prone to overdiagnosis. "Red Alert ended up being kind of a breakout character, and when we first got hold of him, we didn't necessarily know who he was," notes Hignight. "Then by kind of playing him the way we did, it left me wanting more with Red Alert."

BELOW: Red Alert can sometimes rub his teammates the wrong way with his alarmist attitude, but his medical skills are highly valued by the Autobots.

RATCHET

Once renowned for his weapons-building skills, Ratchet has turned his abilities toward rebuilding injured Autobots and Decepticons at his underground field hospital. He tells Elita-1, "I realized my former solutions were making things worse."

When Optimus informs Ratchet of Megatron's plan to find and weaponize the AllSpark, the rescue-and-repair specialist reluctantly decides to rebuild the Spacebridge. He does so to help all Cybertronians, not just the Autobots.

Rachet may not be an elite fighter, but his repair abilities make him indispensable to the Autobots. "I think one of the most rewarding and interesting character choices we made was Ratchet," says series writer Gavin Hignight. "The field hospital that he runs when we're introduced to him is probably the most noble effort made by any of the characters we meet in the series."

ABOVE: Ratchet is not a fan of Optimus Prime, but he chooses to help the Autobots because he believes it will save lives.

SIDESWIPE

When out on the front line, Sideswipe has no qualms about using his Photo-Pulser Proton Launcher. He's a bold fighter who can sometimes be reckless on the battlefield. When victory is within reach, Sideswipe is the type to do whatever it takes to win.

BELOW: Sideswipe's design is inspired by Italian sports cars.

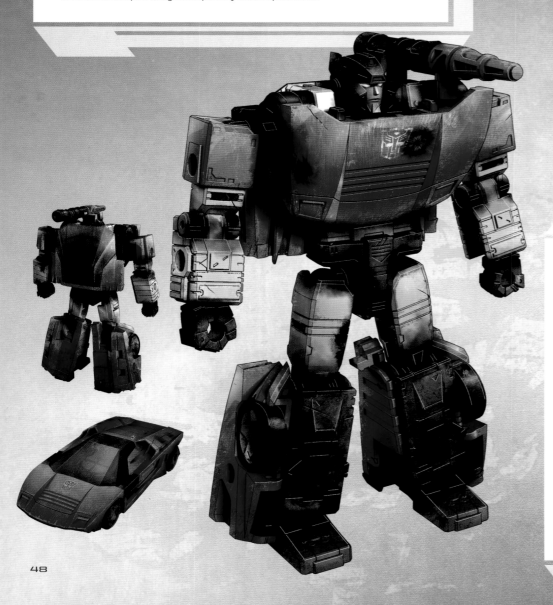

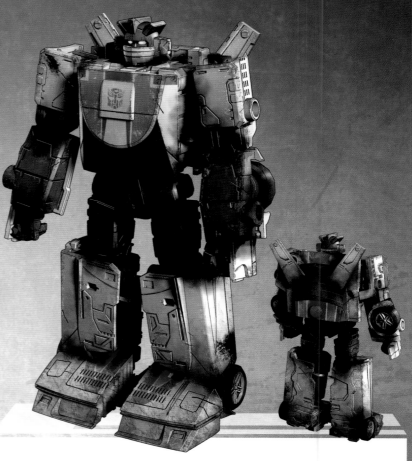

WHEELJACK

Autobot engineer Wheeljack loves to invent new weapons and gear and is undeterred by the occasional lab accident. His design is unique among the Transformers as his facial protrusions light up when he speaks.

Wheeljack's intellectual curiosity is one of his strengths, as is his enthusiasm. His and Bumblebee's discovery of the Space-bridge provides the spark for Optimus's last-gasp plan to keep the AllSpark out of Megatron's hands. He proves to be prescient when he tells a reluctant Bumblebee that he won't be able to stay out of the war much longer. "The Decepticons won't stop, kid," Wheeljack tells him in the first episode of *Siege*. "At some point, you'll have to choose a side."

ABOVE: The abrasions, dents, and peeled paint on Wheeljack's body are as likely to come from a lab experiment gone wrong as they are from the battlefield.

OMEGA SUPREME

The colossal Omega Supreme is one of the Guardians of Cybertron. Omega Supreme disagrees with the other Guardians' refusal to get involved in the Cybertronian civil war and instead believes it is in the planet's best interests for him to aid the Autobots.

His truly massive size, coupled with his immense power and numerous weapons, makes him the key element that helps tip the scales in the Autobots' favor, allowing them to escape Megatron and take the *Ark* through the Spacebridge.

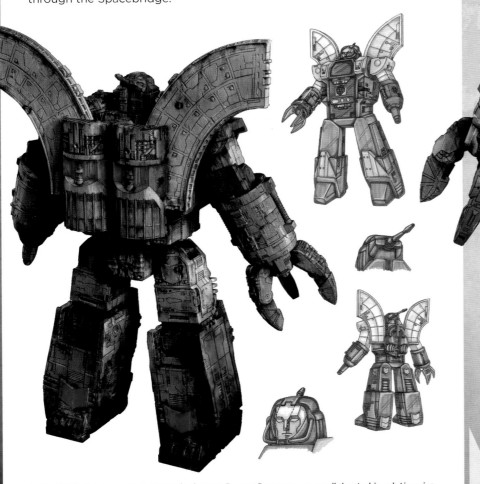

THIS PAGE: The damage marks and grime on Omega Supreme are small due to his relative size compared to other Transformers robots.

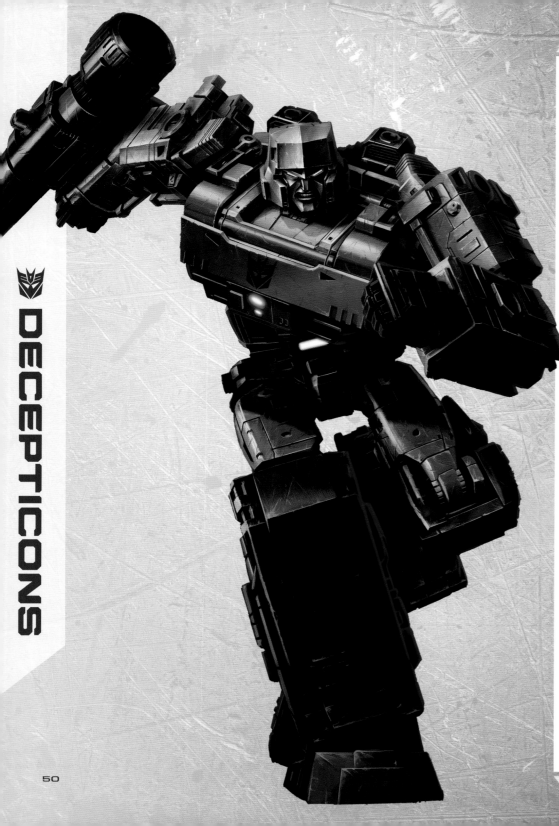

MEGATRON

The undisputed "alpha" of the Decepticons, Megatron was forged from the circumstances in which he was raised. He has endured much, from his early years spent in the Energon mines to his time in the gladiator pits where he earned his reputation as Cybertron's most fearsome fighter. Those experiences prepared him well for the civil war he sparked to overthrow Cybertron's corrupt ruling class. His initial goal was well-intentioned: to build a new society where all Cybertronians are equal. But the difficulty of change and the grind of war warped his goals, and the revolution he led turned into a campaign for absolute power.

Megatron leads the Decepticons through sheer force of will and intimidation. He is a warrior without peer and does not hesitate to dive into any battle. He is immensely powerful, and has a fusion cannon on his right arm.

War for Cybertron Trilogy aimed to provide context and depth to a character who has often been portrayed as evil beyond reproach. According to F.J. DeSanto, the series approached Megatron's story as if it were a tragedy. "The idea was that Alpha Trion had these students who were under his tutelage that were going to lead the world into the next generation: Megatron, Optimus Prime, Ultra Magnus, and Elita-1. But Megatron is the one that goes rogue."

It is Megatron who murders his former mentor, a decision that sets him and his former friend Optimus on disparate life paths. "He became radicalized," DeSanto noted. "And so Prime is thrust into this leadership role that he may not have been destined for. There is a part of Prime that once believed Megatron was the best choice to lead Cybertron into a new age, but he went too far, became too extreme."

"We really took the opportunity to flesh out how he is the hero of his own story," adds Tim Sheridan, a writer on the show for *Earthrise* and *Kingdom*. "He's not just a mustache-twirling villain. He wanted to do something good."

Megatron truly believed he had Cybertron's best interests in mind with his power grab, so he always viewed the ends as justifying the means, no matter how horrific. But despite his ghastly actions, in *Kingdom*, Megatron makes the decision to set aside the enmity between the Decepticons and Autobots and joins them to fight off the evil that threatens every character's existence.

THIS PAGE: In Megatron's eyes, everything is a zero-sum game. To him, there can only be one victor.

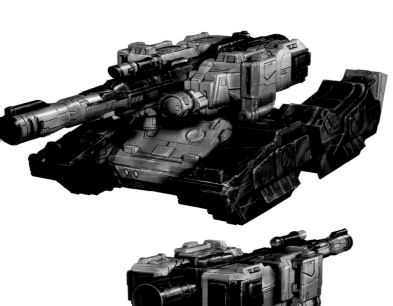

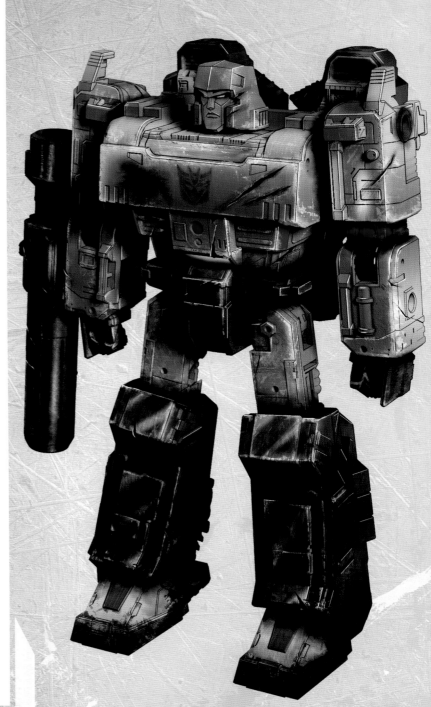

Default Smile

Angry Surprised

Sad

TOP LEFT: Megatron's vehicle mode.

CENTER: Megatron's facial expressions.

TOP RIGHT and **RIGHT:** Various views of Megatron's bot mode.

LEFT: Megatron wears the Matrix of Leadership.

JETFIRE

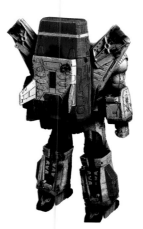

Jetfire begins the series as the leader of the Decepticon air force known as the Seekers. Unlike Starscream and the others, he is not motivated by bloodlust or a need for vengeance. He views technology as a religion and considers it the only path to peace. Jetfire begins to second-guess his allegiance to Megatron when he witnesses Ultra Magnus's dedication to his code of honor; when given the opportunity, Magnus refuses to pull the trigger and shoot Megatron in the back even though it could turn the tide of the war—because to do so would violate his warrior's code.

When Magnus is murdered by Megatron, Jetfire realizes Megatron's revolution—born out of a desire for equality—has been corrupted into a naked power grab. Jetfire turns his back on the Decepticons and switches his allegiance to the Autobots.

The Autobots don't trust the former Seeker at first, but he quickly proves his worth when he helps Optimus fight off Megatron.

A gifted fighter who values technology above brute strength, Jetfire is capable of great speed when he converts into a fighter jet. He also has an energy sword on his right hand and carries a battery of missiles while in jet form.

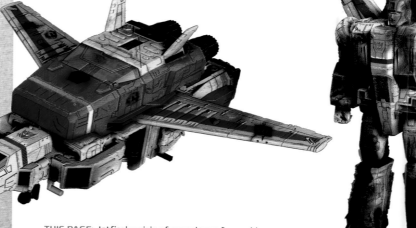

THIS PAGE: Jetfire's crisis of conscience forces him to leave the Decepticons. When Optimus asks for his reasoning, Jetfire's answer is clear: "I won't help Megatron wipe out an entire population."

STARSCREAM

As the new leader of the Seekers, Starscream grudgingly accepts Megatron's command while plotting to undermine him at every turn.

During the events of *Kingdom*, retrieving the Golden Disk and accessing the knowledge embedded within it shakes Starscream to his core and forces him to look beyond his personal ambition. He is the first to truly understand Unicron's plan and comes to the grudging conclusion that the knowledge on the disc will be put to better use in the hands of the Autobots. For the first time, he chooses to put the greater good of Cybertron ahead of his own interests.

"Starscream's my favorite character because to me, he has always had the potential for one of the deepest character arcs," says writer Mae Catt, who saw him as an avatar that allowed the series to explore what it means to be a victim of abuse. In the fifth episode of *Kingdom*, Starscream finally stands up to Megatron and says, "He thinks I'm weak, but I'm not. I'm not just another victim." That line of dialogue is Starscream for the first time acknowledging the cruelty that has been part of his history with Megatron. When Megatron tells him that he can't do anything right, it gives Starscream the chance to finally prove him wrong.

"I can fly," the Seeker responds, and ends the battle by knocking Megatron off the *Nemesis*. It is a moment of empowerment for Starscream, one that may point to a different direction for him in the future.

THIS PAGE: The events of *Kingdom* force Starscream to adopt a role he's never held in any iteration of the *Transformers*: the voice of reason.

SKYWARP

One of the more sadistic Seekers, Skywarp enjoys the violence and bloodshed of the civil war. He has the ability of limited teleportation.

When he and Jetfire discover the Autobots' secret hideout, Jetfire realizes this knowledge will lead to genocide. Skywarp doesn't care, leading the two of them to battle—but Jetfire leaves Skywarp mortally wounded. Before he dies, Skywarp manages to reach Starscream and Megatron to inform them that Jetfire has betrayed the Decepticons. Skywarp's death and Jetfire's mutiny lead to Starscream's promotion as leader of the Seekers.

BELOW: When Skywarp is shot, his core short circuits.

THUNDERCRACKER

Along with Skywarp, Thundercracker is one of the Seekers' two seconds-in-command. A soldier known for his trademark sonic boom, Thundercracker is considered the "muscle" of the Seekers, specializing in aerial assault. He views the Seekers as being the elite among Transformers robots due to their ability to fly.

ABOVE: One of the fiercest Decepticons, Thundercracker wields fear as a weapon.

SHOCKWAVE

Whereas Megatron's ruthlessness is fueled by madness and a misguided sense of what is best for Cybertron, his top scientist is driven only by warped curiosity and evil ambition. Shockwave is logical and lethal, devising machinery and schemes to help the Decepticons' cause. His obsession with forbidden technology leads to his plan to use the AllSpark to reformat the Autobots, an idea so extreme even Megatron initially resists it.

"For Megatron, Shockwave is a necessary evil. He doesn't trust him," says writer Gavin Hignight. "In many ways, he's smarter than him. To get these high-concept plans to work, he needs Shockwave. He's very much like [*Star Trek*'s] Spock, dictated by logic, but he's an evil Spock. Everything and everyone is an equation for him."

Shockwave becomes the de facto ruler of Cybertron after his dark technology enables Megatron to go into space to pursue the Autobots.

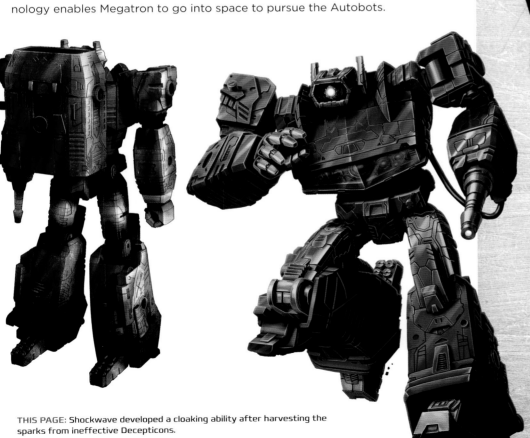

THIS PAGE: Shockwave developed a cloaking ability after harvesting the sparks from ineffective Decepticons.

ASTROTRAIN

Astrotrain's primary task is to handle transportation and logistics for the Decepticons. He wishes he could see more combat but understands his role is to fly his teammates around, which is why he's part of the group that accompanies Megatron on the *Nemesis* in search of the AllSpark.

BELOW: Astrotrain is a Triple Changer, meaning he can convert into his bot mode and two vehicle modes that allow him to travel by land and air.

BARRICADE

Barricade is a former police officer who was once stationed in Praxus, a city on Cybertron. He long ago left behind the ethos to "protect and serve" and instead aligned with Megatron and his Decepticons, adopting a new mantra to "punish and enslave."

He is a hunter and tracker who relentlessly pursues his targets on behalf of Megatron and enjoys taunting his opponents as a form of psychological warfare, leading them to make mistakes.

Barricade first appeared in the first live-action *Transformers* film. *War for Cybertron Trilogy* marks his animation debut.

ABOVE: Barricade's vehicle form is modeled after a black-and-white police car, though modified with a large blaster positioned above the lights.

IMPACTOR

Impactor has a tank cannon on his shoulder and wields a large blaster in his left hand. His right hand has been replaced with his signature weapon, the harpoon.

Having been forced to work in the Energon mines for much of his life, Impactor feels a duty to fight for the rights of Cybertron's lower classes. After he is wounded during a battle in *Siege* and left for dead by the Decepticons, Ratchet finds him and saves him.

Fiercely loyal, Impactor decides to help the Autobots repair the Spacebridge because of the debt he feels he owes Ratchet. His working-class upbringing puts him at odds with Mirage, whom Impactor considers just another spoiled, Energon-sipping Autobot elitist.

In the climactic battle of *Siege*, Impactor sacrifices his life in order to save Ratchet so that he can open the rift through which the Autobots can escape. "With Impactor, it's not hard to write a character like that, because they make a very important decision for all the right reasons," says writer Brandon Easton.

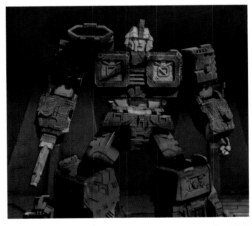

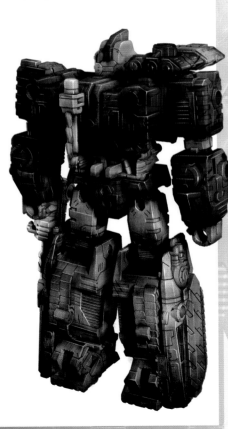

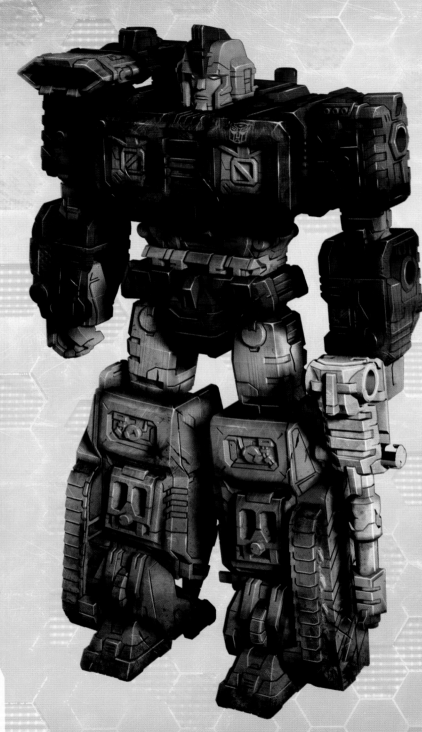

THIS PAGE: Impactor's design is based on military tanks.

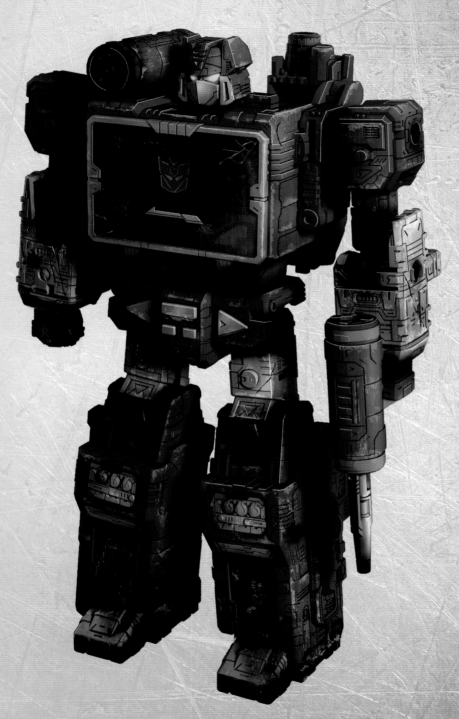

SOUNDWAVE

Soundwave is Megatron's trusted lieutenant. He uses his servants, Laserbeak and Ravage, for espionage assignments. He views data as the ultimate power and thus pursues it relentlessly. Friends and enemies fear the secrets the Decepticon spy has amassed by stealing signals and messages.

LASERBEAK

Laserbeak's bot form is a bird of prey, and his ability to fly allows him to be an effective spy and occasional assassin who serves Soundwave and his schemes. He is always directly linked to Soundwave and shares his master's disregard for life. Laserbeak is one of three different Decepticons whose alternate form is a cassette tape. Buzzsaw and Ravage are the other two who appear in *War for Cybertron Trilogy*.

RAVAGE

The Decepticon scout Ravage is loyal to Soundwave first and foremost. Ravage prefers to let his actions speak for him, staying quiet and focusing on infiltration and sabotage. Ravage's primary shape is a mechanical hound. He is a highly skilled asset. His greatest weakness is bright light, which can temporarily blind him.

LEFT and TOP: The spymaster Soundwave is a considerable threat due to his genius at decoding secrets and his signature shoulder cannon.

CENTER: Laserbeak in his bot and cassette forms.

ABOVE: Ravage in his bot and cassette forms.

REFRAKTOR

As part of the Decepticons' infantry unit, Refraktor specializes in reconnaissance and intel-gathering through his array of spy technology. He believes careful observation provides the upper hand in any confrontation.

BELOW: Refraktor is a foot soldier who will not hesitate to engage in hand-to-hand combat, as Mirage learned during the ambush at Iacon in *Siege*.

SPINISTER

Spinister can shift modes into an attack helicopter, making him one of the more dangerous Decepticons, as he can cause significant damage while airborne.

 More independent than other Decepticons, Spinister is an enigma to most, preferring to keep his distance from the others. Spinister is gravely wounded in *Siege* when Optimus Prime impales him on a metal spike but ultimately manages to survive.

ABOVE: When in vehicle mode, Spinister's dual-barreled blaster and particle-beam cannon make him a dangerous enemy from above.

SCRAPFACE

A loyal Ground Force Infantry Raider on the frontlines of the war, Scrapface's perspective changes after he is captured by fellow Decepticon troops so his Energon can be harvested to power Project Nemesis.

After Elita-1 and her unit save him, Scrapface joins the Resistance. He is killed when the explosives planted by the Autobots inside Kaon Arena detonate.

BELOW: Scrapface repays Elita-1 and the Autobots for saving him from Project Nemesis with a rescue of his own. "It's our turn to save you," he tells her.

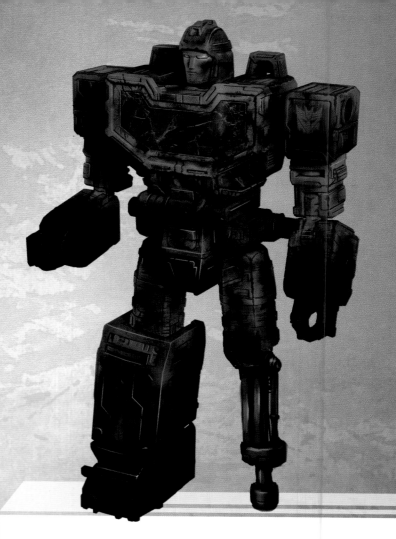

SHAMBLE

When we meet Shamble during *Earthrise*, he is a damaged robot supervising the factory in Sector 12 of Cybertron. The Decepticon's spirit is strong, as is his loyalty to Megatron, whom he has supported since Megatron's days of fighting in the gladiator pits.

Despite that, Megatron has the factory taken offline and sentences the Decepticon workers to death so their sparks can be harvested for Project Nemesis. Shamble dies alongside his fellow workers in a chamber of the factory.

ABOVE: Shamble assures Megatron, "No matter what, you can count on us, Lord Megatron." Shamble's loyalty to the Decepticon cause is repaid with treachery when Sector 12 is taken offline.

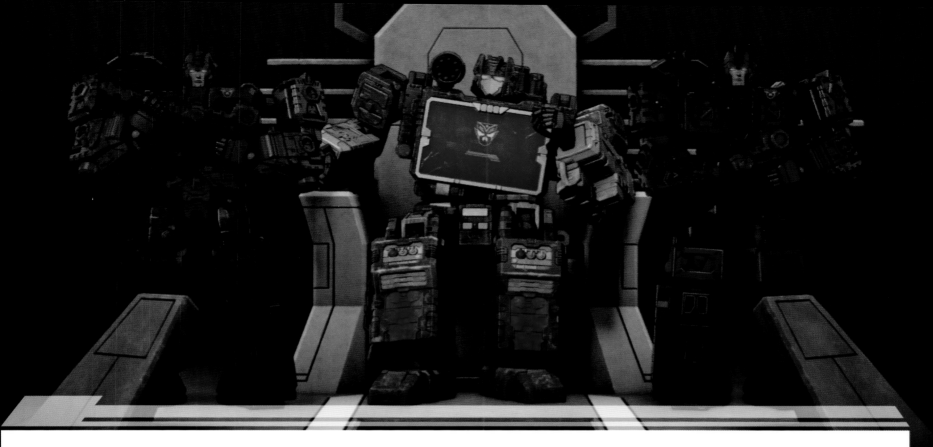

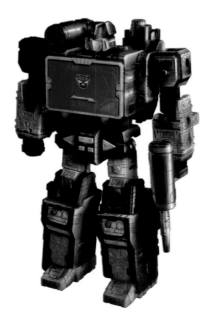

SOUNDBLASTER

Soundblaster is a mercenary and underground black-market operator who prefers living in the gray area surrounding the Autobots and Decepticons' civil war. He controls a large stash of Energon that has helped him establish a criminal empire on Cybertron. Dealing with Soundblaster is dangerous business; if he doesn't like the way a transaction is going, the robot on the other end of the deal could wind up dead.

Created by Shockwave as a clone of Soundwave, Soundblaster is sensitive about his origins and does not like that he is considered a "failed experiment." His squad of hired robot muscle captures Bumblebee, Arcee, and Cog as they try to steal Energon during *Siege*, but they are able to escape Soundblaster's base of operations, the Dome, when Shockwave's virus disrupts systems across the planet.

BUZZSAW

In G1 continuity, Buzzsaw has been a Decepticon bird of prey who can turn into a condor cassette. In *Siege* he is part of Soundblaster's crew of mercenaries at the Dome.

TOP and LEFT: Soundblaster may not like to talk about his origins as a Soundwave clone, but he has no qualms about using the same surveillance techniques to get an edge on his enemies.

ABOVE: Buzzsaw's bot form.

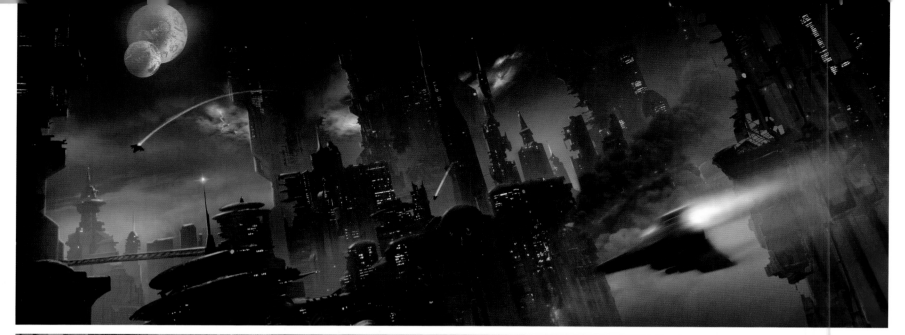

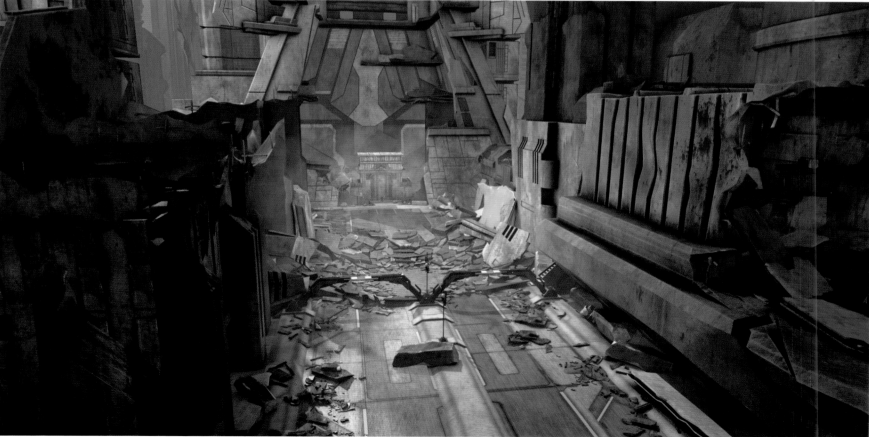

LOCATIONS

IACON CITY RUINS

Depicting Cybertron, the ravaged home world of the Transformers robots, was one of the centerpieces of the first season of the *War for Cybertron Trilogy*. The Polygon Pictures team in Japan, led by supervising director Takashi Kamei, tackled their assignment of designing a postapocalyptic world by first imagining what life on the planet looked like during more peaceful times. They envisioned a grand society full of culture and architecture.

"We spent a lot of time talking a lot about what Cybertron might have been before the war began," says art director Yoshimitsu Saito. "We thought there might have been a highly evolved civilization where they enjoyed all types of entertainment, had residential areas, and were living peaceful lives. Based on the ideas we had for that, we then started on the journey of creating the destroyed version of that world."

"Our Cybertron is like Europe during World War II," says supervising producer Matt Murray. "Everything is kind of destroyed, but you can still see the remnants of the world that existed before all hell broke loose."

"Polygon just knocked it out of the park," says Netflix's Ted Biaselli when discussing the aesthetic choices for Cybertron in the series.

The animators wanted to maintain a visual continuity with the designs of Cybertron from the G1 animated series, but with enough room to allow for creative flourishes. "For the Cybertron locations and buildings, we tried to evoke a sense of the G1 show with certain shapes and designs, but we didn't want to go full G1 because then [our show] wouldn't be distinct," Saito says. "For those locations, we spent a lot of time trying to create a unique experience that draws a lot from what we saw in the original G1 series."

OPPOSITE TOP: Early concept art showing the Seekers patrolling the skies above the city.

OPPOSITE BOTTOM: The Decepticons lay a trap for the Autobots in the ruined Iacon streets during *Siege*.

RIGHT: Soaring skyscrapers were part of the vision the series' creative team had for the sophisticated society that existed on Cybertron before the war.

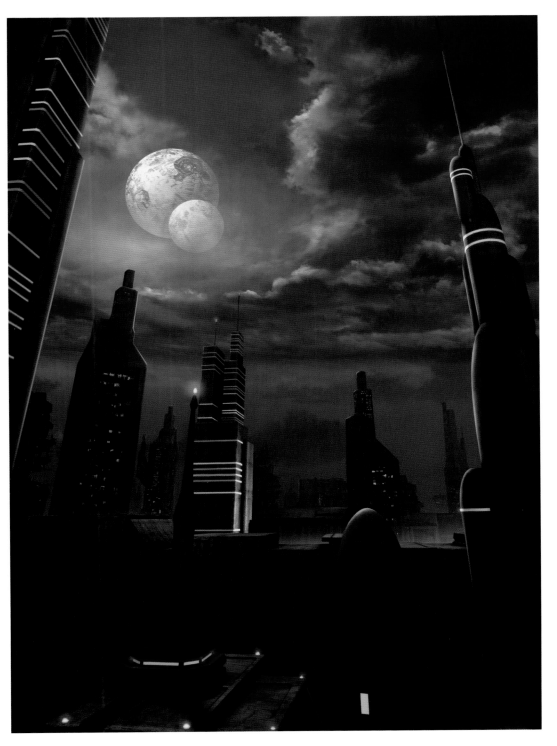

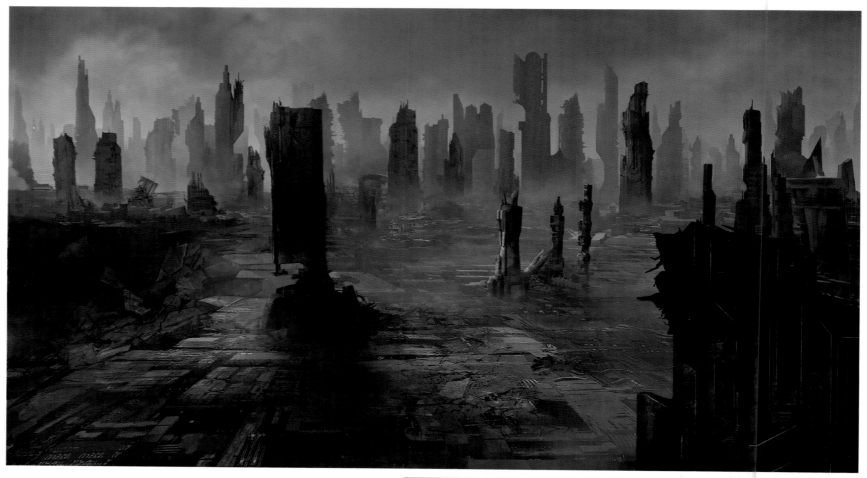

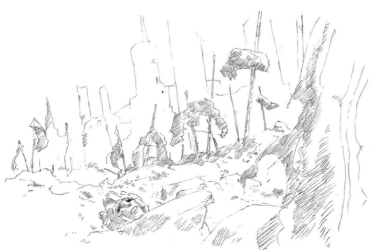

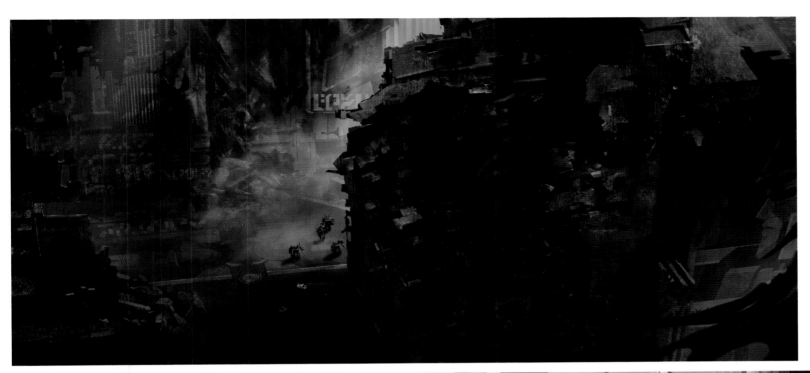

OPPOSITE TOP: The Autobots hide in plain sight among the skeletal remains of Cybertron thanks to cloaking technology.

OPPOSITE BOTTOM: Rough sketch and a more detailed rendering of the dismembered Autobots hung on pikes outside the Iacon City Ruins.

THIS PAGE: Early designs and additional views of Iacon City during the day and at night.

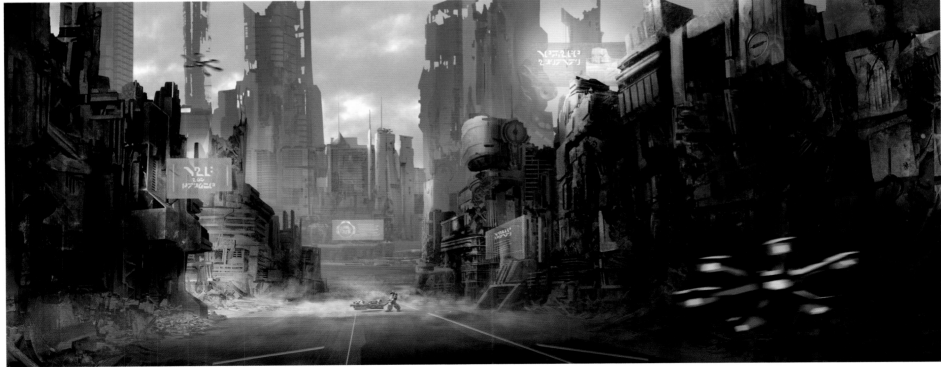

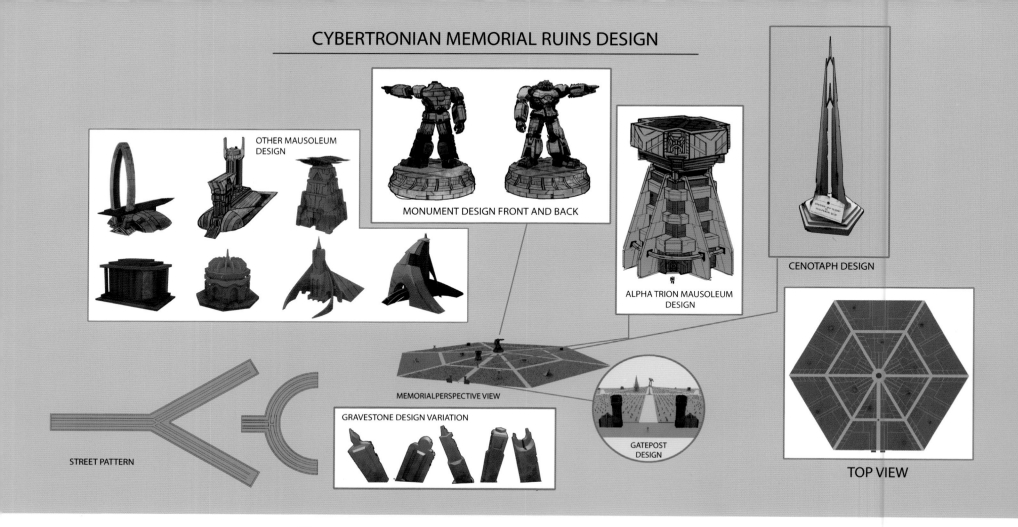

OTHER MAUSOLEUM DESIGN

MONUMENT DESIGN FRONT AND BACK

ALPHA TRION MAUSOLEUM DESIGN

CENOTAPH DESIGN

MEMORIALPERSPECTIVE VIEW

GRAVESTONE DESIGN VARIATION

GATEPOST DESIGN

STREET PATTERN

TOP VIEW

TOP: The numerous elements that came together to create the Tarn-Hauser Gate and Alpha Trion memorial.

RIGHT: An early sketch of a statue depicting one of the ancient Cybertronian heroes.

TARN-HAUSER GATE

Given that *Siege* takes place amid a destructive civil war, the Polygon team took inspiration from war movies such as *Saving Private Ryan* and *Dunkirk* when designing the bombed-out buildings and debris-laden streets of Cybertron. "I wanted to convey a sense of the culture that had been lost in the war," says showrunner F.J. DeSanto. "I wanted to show who these citizens of Cybertron were beforehand. That's why one of my favorite sets is the Alpha Trion Memorial [located at the] Tarn-Hauser Gate, where Ultra Magnus is killed. We wanted it to be a war memorial, and we worked really hard on that. We went through multiple iterations to get it just right."

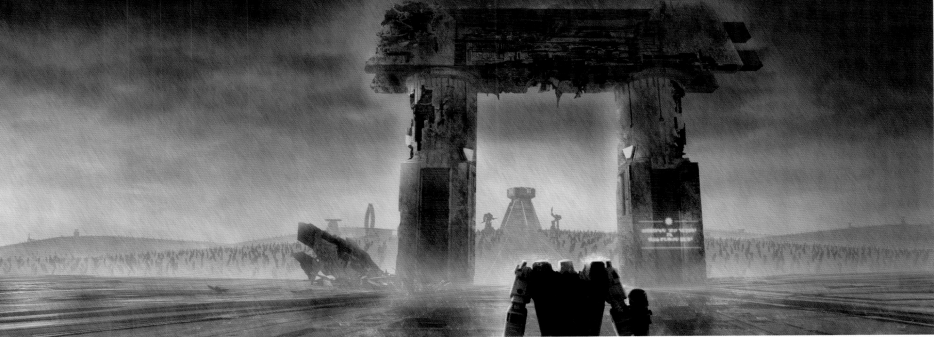

TOP: A detailed look at two of the statues surrounding the site. The statues depict the heroes of Cybertron's past.

ABOVE: The Cybertronian writing glowing on the memorial reads, "Remember the Battle of Tarn-Hauser Gate."

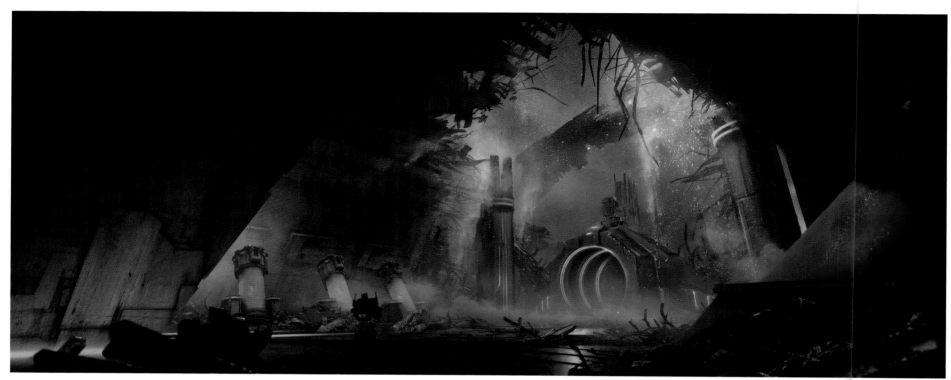

SPACEBRIDGE

Some of the creative decisions Polygon's animators made influenced the story, such as with the Spacebridge that Bumblebee and Wheeljack stumble upon in the series' first episode.

"It's not explained in the show because time was short and we had to cram a lot of detail into each episode, but we actually designed that as a smaller spacebridge that was used by just a few robots," says Saito. "The reason we designed it like that is, before the war, during the times of peace, we assumed that robots would use these smaller spacebridges to travel to other worlds on vacation, or to transport materials between planetary systems."

That dedication to providing context for their design work is what helped elevate the series' animation. "That Spacebridge was a really important piece of machinery during the Golden Age of Cybertron that they used as a transportation hub, and now it's basically in ruins," says Murray. "Polygon did an amazing job designing what was a crucial set piece, since we used it in the first and last episodes of *Siege*."

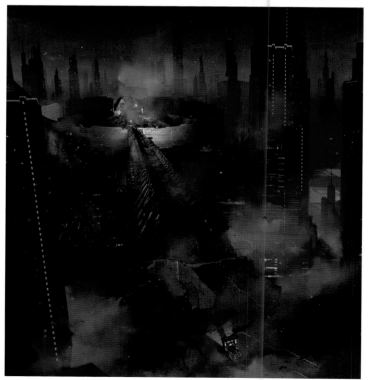

TOP: Concept art depicting the interior of the Spacebridge.
RIGHT: Optimus Prime approaches the Spacebridge to rescue Wheeljack and Bumblebee.

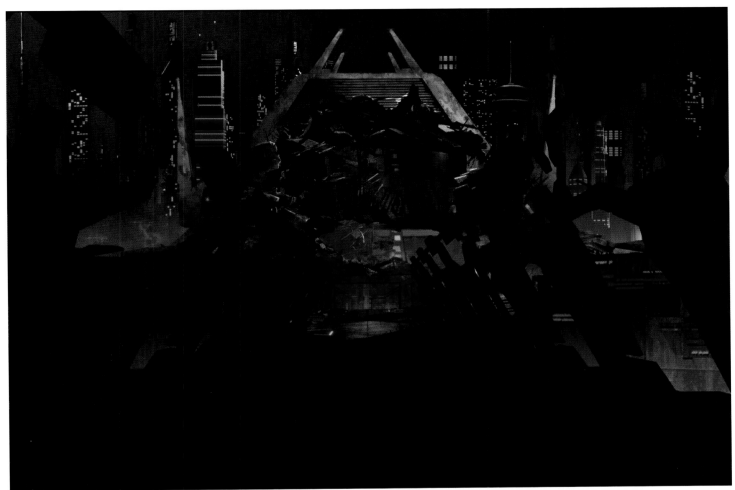

LEFT: The highway to the Spacebridge is littered with debris.

BELOW: Early production art of the destroyed Spacebridge.

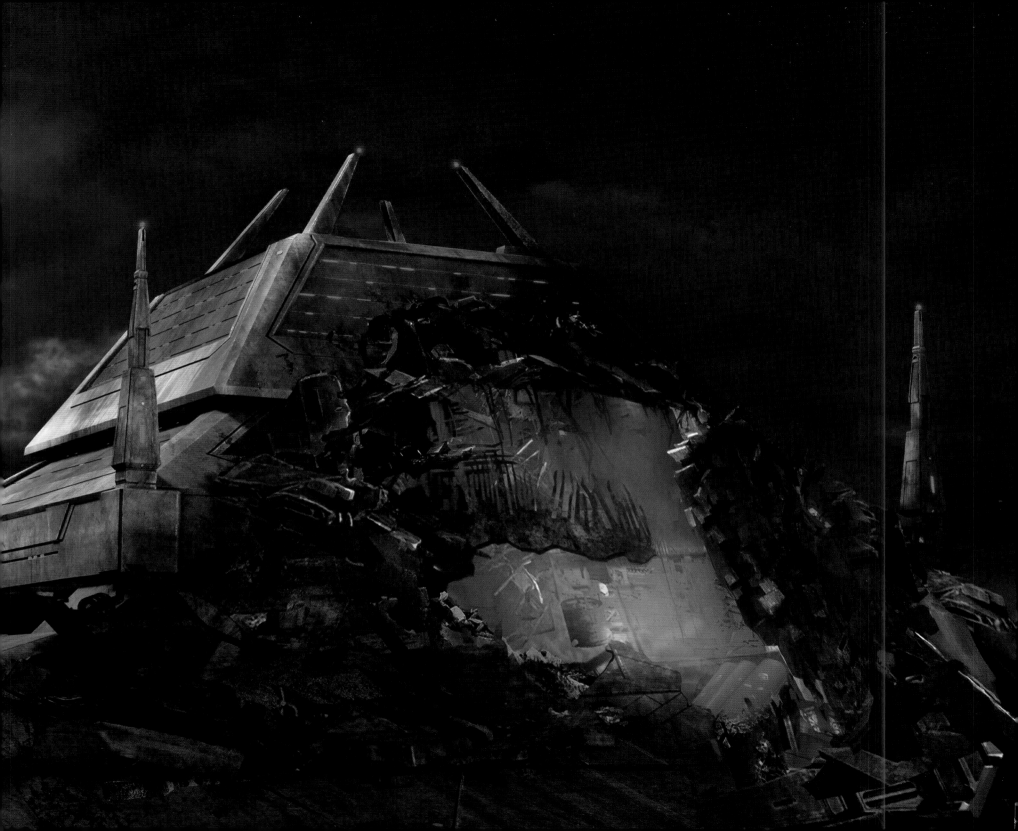

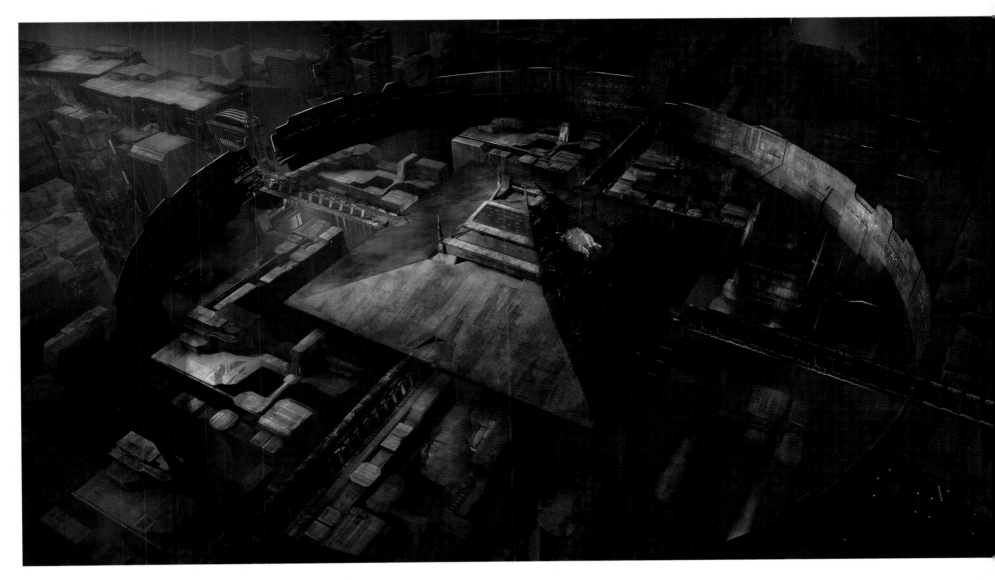

OPPOSITE: The Spacebridge is lit by a red light to indicate it is not functional.

ABOVE: A gaping hole in the backside of the Spacebridge is evidence of how the Decepticons destroyed Cybertron's off-world transportation portals.

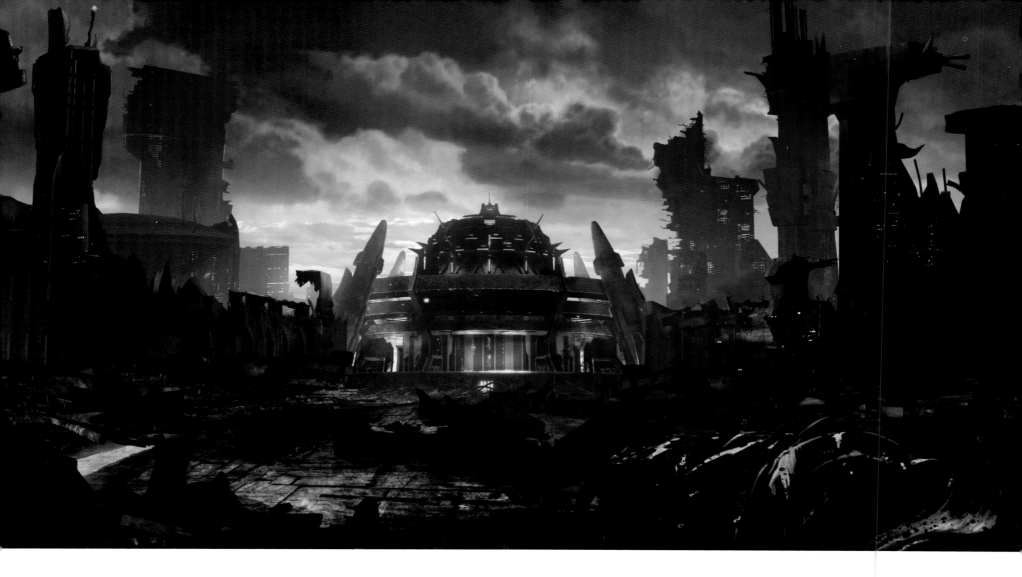

KAON ARENA

When it came to the design of Cybertron, size truly mattered. "The main approach we took was to make the locations as big as possible," says Kamei.

DeSanto echoes those sentiments. He wanted to play with the scale of the structures that would make up Cybertron to convey not just the size of the Transformers bots, but also how large their world was. "I wanted everything they designed to be practical, but I wanted the scope of the show to be big. On Cybertron, everything is built to scale for them, designed for the proportions of Transformers robots existing in this universe," he says. "When you see places like the Arena and the *Ark*, the reason we made them so big is because I knew we were going to use these locations for action set pieces."

Just how big is the Cybertron Arena where Megatron delivers his propaganda speeches? Saito and his animators based its size on the distance covered by the Yamanote train line, one of the busiest commuter lines in Tokyo that circles the city. "The Arena was designed to essentially be as big as the space covered by that line," Saito says. "It's around sixty-three square kilometers, which is larger than the island of Manhattan. That's how big the Arena on Cybertron is."

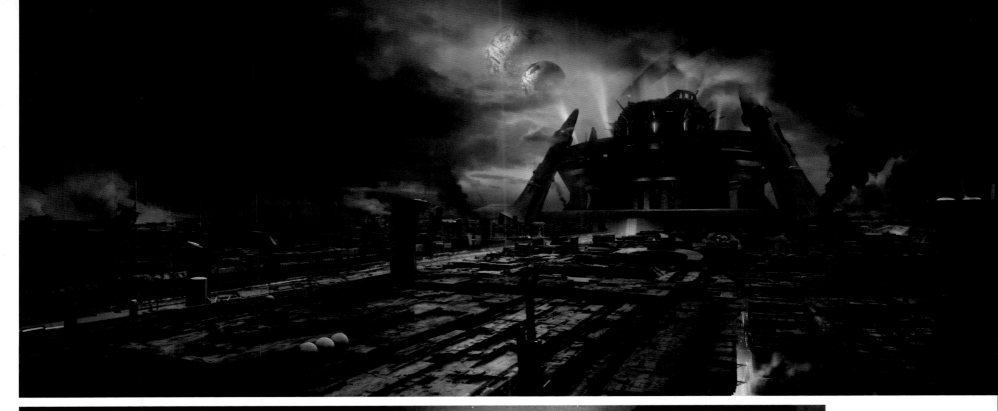

OPPOSITE: The Kaon Arena where Megatron once fought in the gladiatorial pits now serves as his seat of power as ruler of Cybertron.

ABOVE: An alternate view of the Arena.

LEFT: Concept painting shows Megatron's imposing throne and the Decepticon flags lining the interior walls of the Arena.

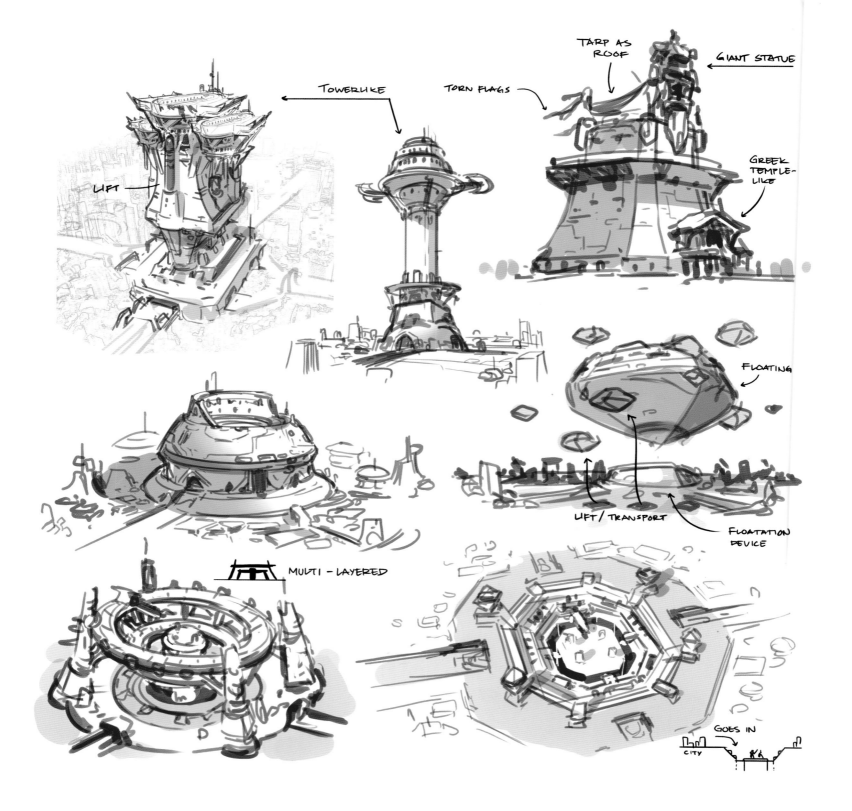

TARP AS ROOF

GIANT STATUE

TOWERLIKE

TORN FLAGS

GREEK TEMPLE-LIKE

LIFT

FLOATING

LIFT / TRANSPORT

FLOATATION DEVICE

MULTI-LAYERED

GOES IN

CITY

74

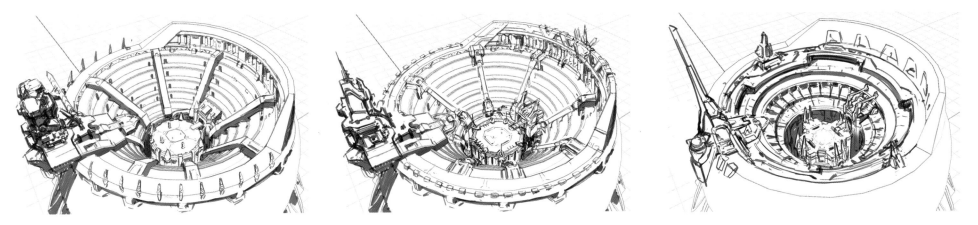

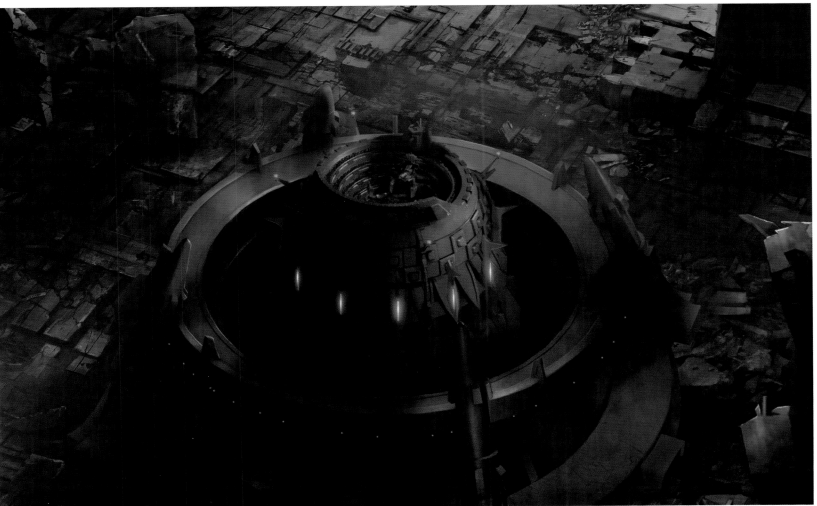

OPPOSITE: Alternate concept sketches for the Arena.

TOP: Architecture of ancient Greece influenced other design flourishes of the enormous space.

LEFT: The Colosseum in Rome inspired the structural design of the Arena.

THEATER

Some of the set designs for Cybertron resembled gray, damaged steel from the Soviet Union. Locations such as the theater, the ruins, and especially the prison camp were given imposing, weathered aesthetics.

The great Theater of Cybertron is now a field hospital run by Ratchet, but the opera house layout and the remaining design elements serve as a reminder of Cybertronian culture.

ABOVE: Exterior design of the theater.

OPPOSITE TOP: Concept art depicting the environment around the theater.

OPPOSITE BOTTOM LEFT: A view of Ratchet's makeshift hospital inside the theater.

OPPOSITE BOTTOM RIGHT: Early ideas for the theater's exterior design.

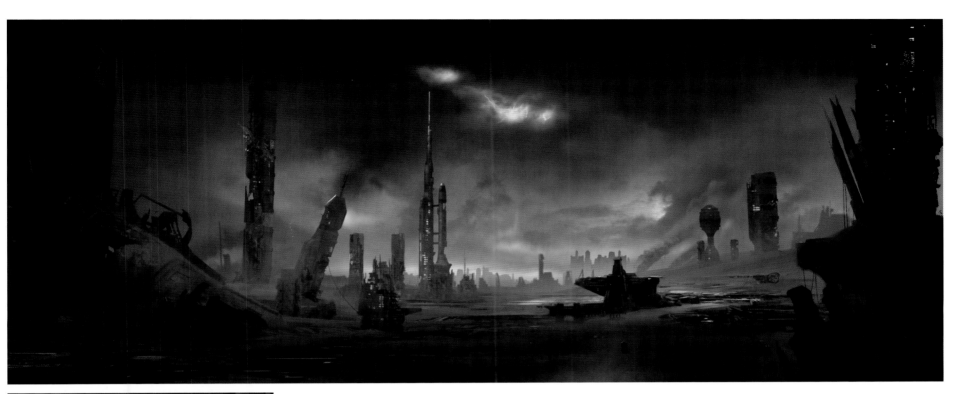

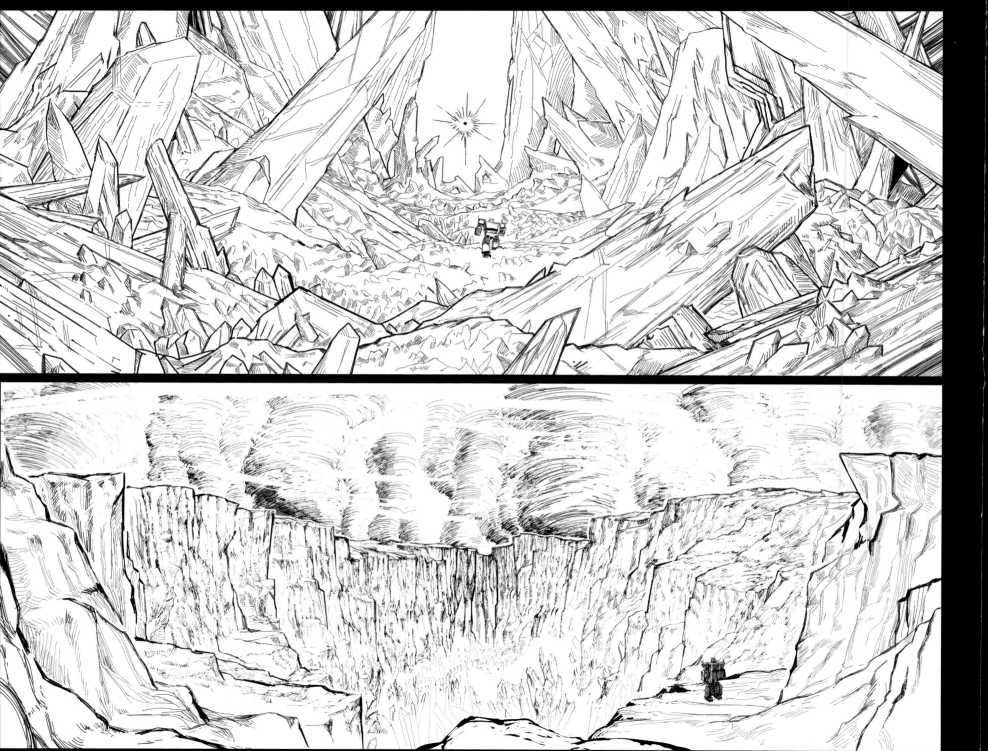

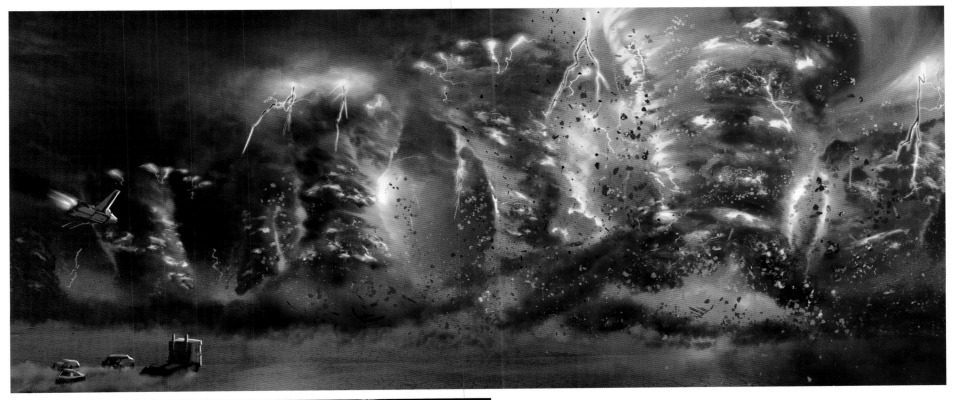

SEA OF RUST

The Sea of Rust is a dangerous location where few dare to go. Obscured by swirling tornadoes, the entrance is a jagged fissure that leads to a cavernous ravine filled with sharp crystals. With Jetfire's help, the Autobots dare to navigate this hazardous place to secure the AllSpark.

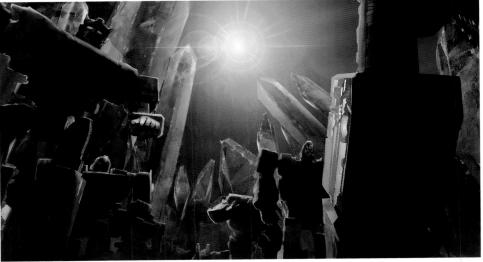

OPPOSITE: Line drawings depicting the ravine in the Sea of Rust.

TOP: The Sea of Rust was designed to feel like a dry lake bed with swirling black tornadoes filled with metal shrapnel.

ABOVE: The Sparkless rise to stop the Autobots.

SOUNDBLASTER'S DOME

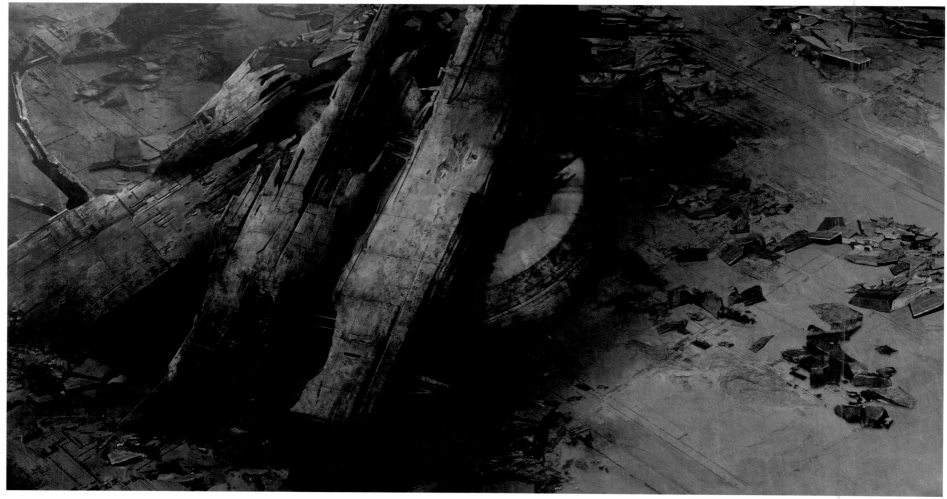

ABOVE: Soundblaster's Dome, which houses his black-market operation, lies hidden beneath and surrounded by debris and wreckage.

RIGHT: Color designs for Soundblaster's Dome.

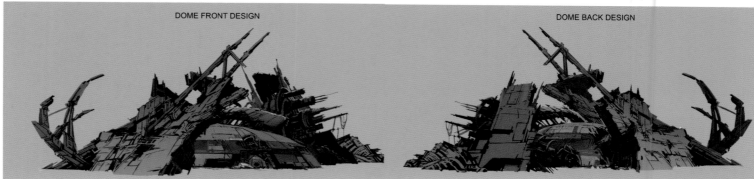

DOME FRONT DESIGN

DOME BACK DESIGN

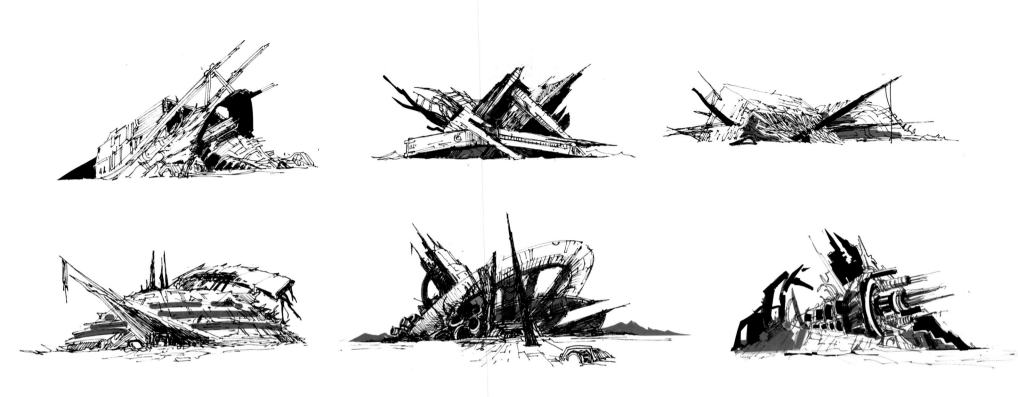

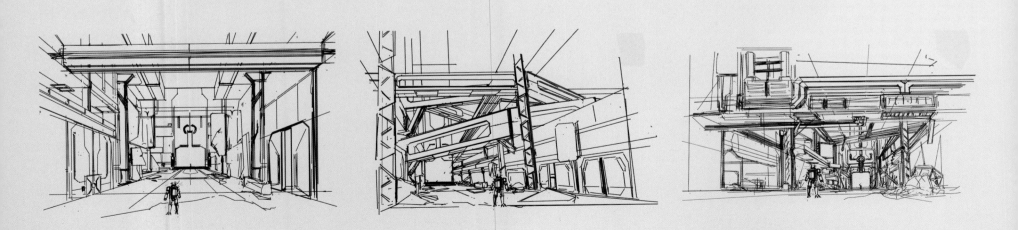

TOP: Preliminary sketches show the evolution of the dome's design.

ABOVE: Interior sketches for Soundblaster's Dome.

SECTOR 12

ABOVE: Concept art of Megatron looking down at the Sector 12 factory.

LEFT: The factory has been operational for many years, and many buildings have fallen into disrepair.

THE *ARK* ON CYBERTRON

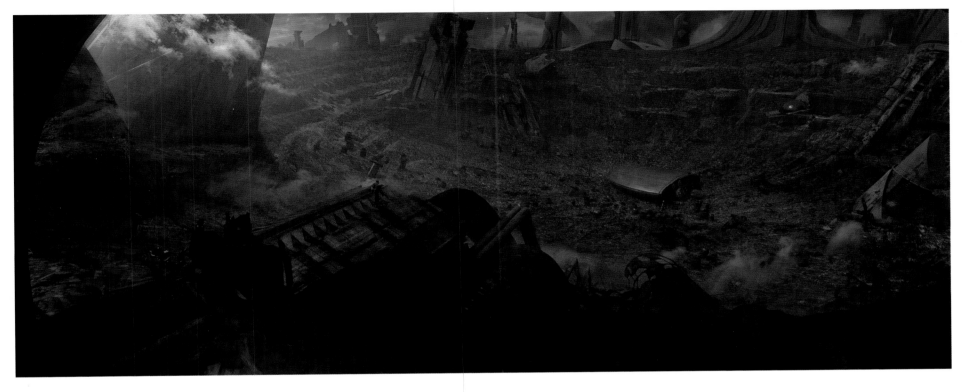

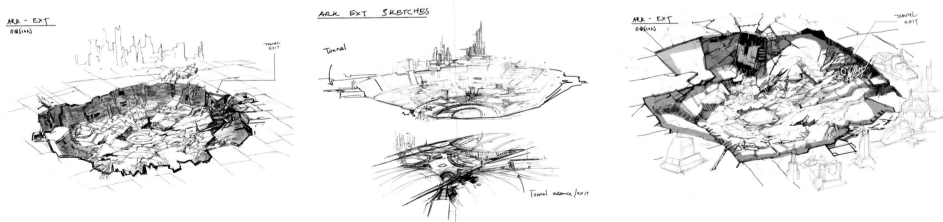

ARK - EXT
ABSION

Tunnel
Exit

ARK EXT SKETCHES

Tunnel

Tunnel entrance/exit

ARK - EXT
ABSION

Tunnel
exit

TOP: The *Ark* is accessed via underground tunnels and is camouflaged so the Decepticons cannot find it.

ABOVE: Sketches depicting the crater hiding the *Ark*.

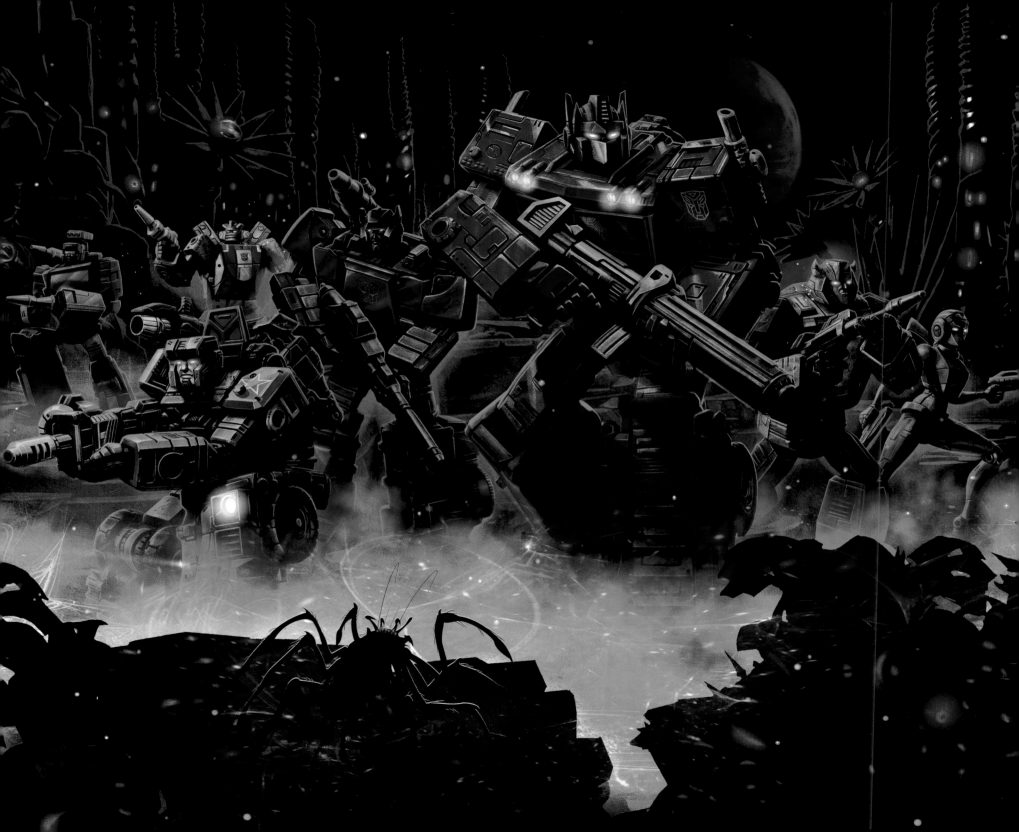

CHAPTER 3

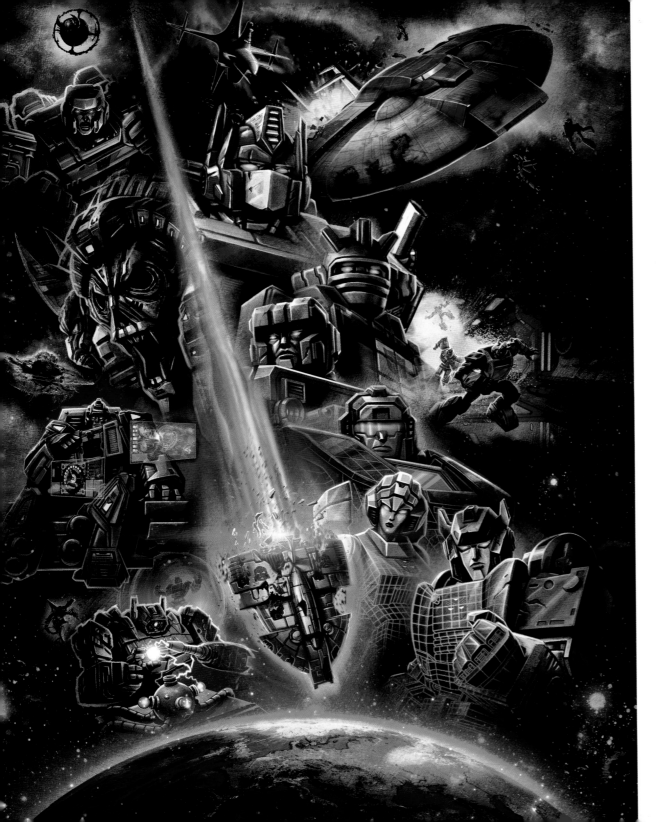

Whereas the first chapter of *War for Cybertron Trilogy* is about the staggering costs of war, *Earthrise* embraces exploration, both personal and interstellar, as its theme. The Autobots are on a quest through the dark regions of space on the *Ark*, searching for the AllSpark. Without it, their home planet is slowly dying as the Energon supply is exhausted.

Optimus Prime and the others run into new adversaries as their mission takes them across the galaxy. "In many ways, *Earthrise* is the *Empire Strikes Back* of the *Transformers* franchise," says writer Tim Sheridan. "It's about the emergence of these characters into the people they're going to be."

The first episode of *Earthrise* spends all but the final minute of the episode on Cybertron. Elita-1 leads a strike force made up of the Autobots who stayed behind—Impactor, Chromia, Ironhide, Jetfire, Red Alert, and Mirage—as they free Autobots imprisoned by Megatron's forces. They soon discover the Decepticon leader is putting some of his own kind in shackles as part of Project Nemesis. To power the massive ship, Megatron has ordered Shockwave to harvest Energon from captured Autobots as well as the frailest Decepticons. In his desperation, Megatron has turned into what he once rebelled against; the enslaved has become the enslaver. "This is where Megatron really crosses the line and turns into pure evil," says writer Gavin Hignight.

But there are still moments that offer insight into whom Megatron once was, before his lust for power corrupted him. During a conversation with Elita-1 after she's been captured, he refers to her as "Ariel," which in *Transformers* canon was her name before she was

PAGE 84: The Autobots explore an alien environment.

LEFT: Promotional artwork for *Earthrise*, season 2 of *War for Cybertron Trilogy*.

OPPOSITE: Concept painting showing Elita-1 and her Autobot strike force witnessing the harvesting system of Shockwave's Project Nemesis.

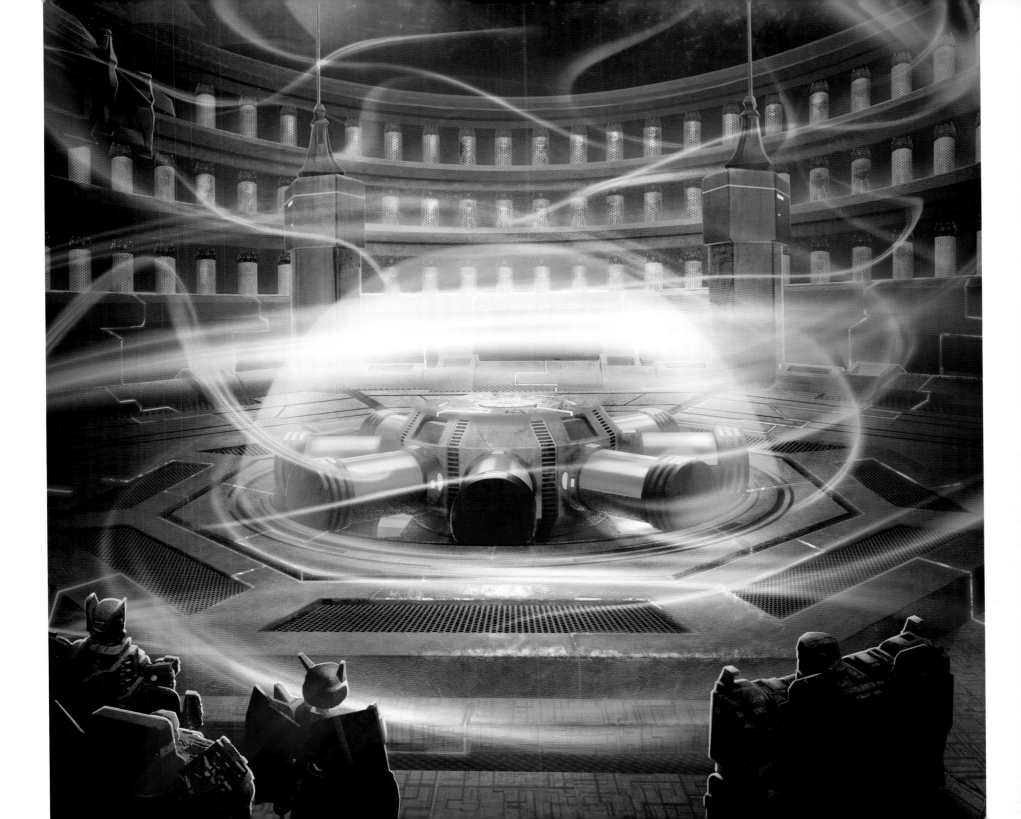

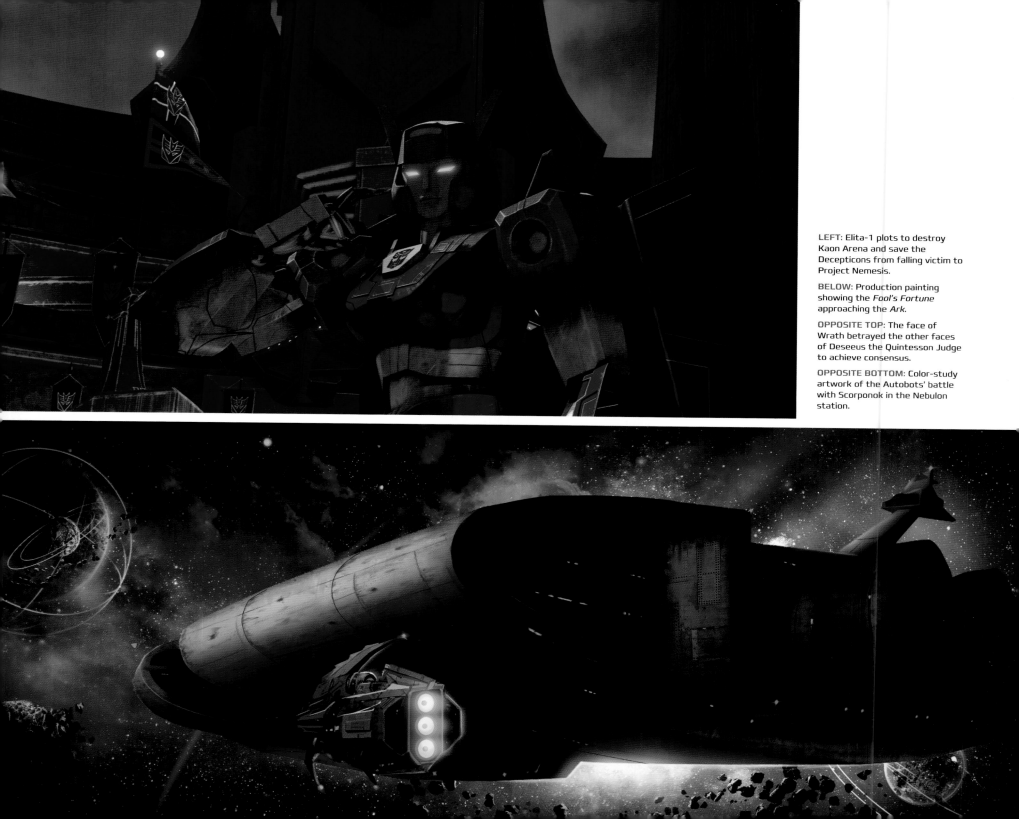

LEFT: Elita-1 plots to destroy Kaon Arena and save the Decepticons from falling victim to Project Nemesis.

BELOW: Production painting showing the *Fool's Fortune* approaching the *Ark*.

OPPOSITE TOP: The face of Wrath betrayed the other faces of Deseeus the Quintesson Judge to achieve consensus.

OPPOSITE BOTTOM: Color-study artwork of the Autobots' battle with Scorponok in the Nebulon station.

reconstructed into a warrior robot. It's a subtle allusion to a past life before the civil war, when Megatron and Elita-1 were friends...and perhaps something more.

In space, the explosion of the Spacebridge sends the *Ark* to the opposite side of the universe from the AllSpark. For a while, the ship floats aimlessly, the Autobots inside knocked unconscious by their chaotic exit from Cybertron. This serves as the perfect opportunity for the mercenary Doubledealer and his faction of bounty hunters to enter the scene. They board the disabled ship and take Optimus and the others prisoner. The mercenaries take the Autobots to a dead-tech planet called Chaar, where the client who placed a giant bounty on their heads awaits: a Quintesson named Deseeus.

Deseeus is a representative of the race that long ago created and subjugated the Autobots and Decepticons. The arrogant and dangerous Quintessons have a long history within the *Transformers* franchise, having antagonized the Autobots in various ways going all the way back to G1 and most recently in the animated series *Transformers: Cyberverse*. Deseeus ultimately betrays the Mercenaries, who in turn help the Autobots escape in an act of revenge.

Once freed, Optimus and his team discover the location of the AllSpark and head to the Nebulon station, a facility that's trapped inside a spacebridge. There they encounter the massive and insane Scorponok. The Decepticons appear as well, having tracked the Autobots to the space station, and Optimus and Megatron are forced into a truce to deal with the immediate threat of Scorponok.

It is during this battle that Optimus truly comes into his own as a leader, with Bumblebee asserting himself as his trusted lieutenant. Optimus takes command without hesitation, and he makes the honorable decision to save Megatron after he is mortally wounded, proving that he has come a long way from the hesitant Autobot struggling to get his footing in *Siege*.

"Writing him in season 1, especially after coming off *Transformers: Cyberverse* where he's very realized, was frustrating," Hignight admits. "The truth is, Megatron was making better choices than Optimus. *Earthrise* is really where we see Optimus start to turn into the character we know so well."

The middle chapter of the trilogy also takes us into the Dead Universe, a mysterious realm first introduced in the *Transformers* comics published by IDW. A familiar face is a reluctant resident there—the disgraced Autobot Sky Lynx. He was exiled to the dead dimension by Alpha Trion for his naked ambition and hubris.

The encounter provides a glimpse into Optimus's early years, when he was just Orion Pax. "Who was Prime before he was Prime, before he was chosen to be the leader? That was the question we had," says DeSanto. "How do we explore that? That's what the flashbacks in the Dead Universe episode of *Earthrise* are about."

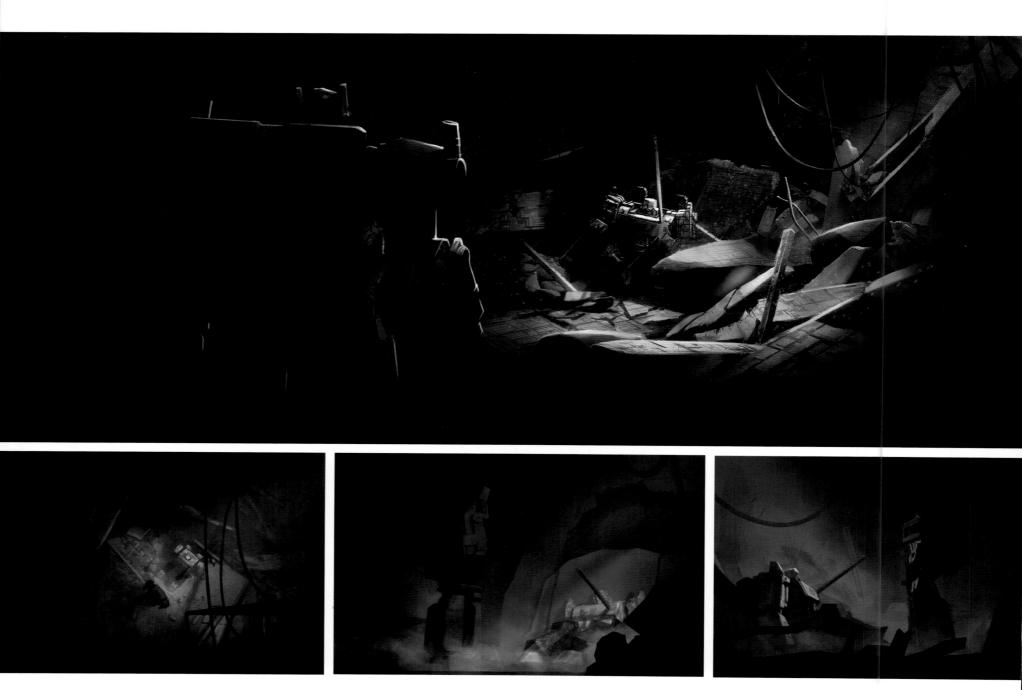

TOP: Early concept art of the moment when Optimus admits to a gravely injured Megatron in episode 4 of *Earthrise* that he was wrong to remove the AllSpark from Cybertron.

ABOVE and OPPOSITE: Color-study art and storyboards detailing the sequence between the two onetime friends turned bitter rivals.

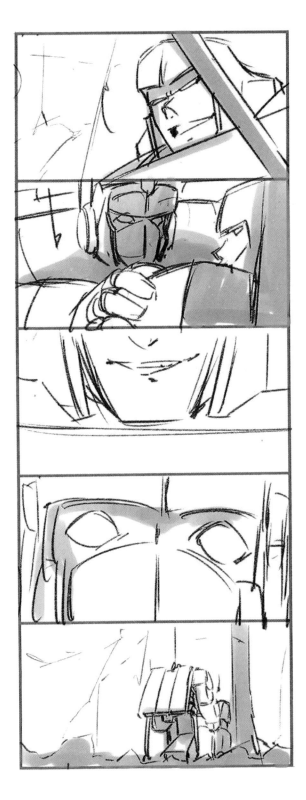

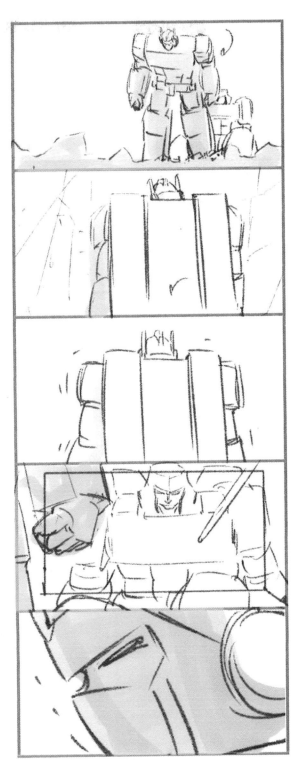

The Dead Universe marks a turning point for Megatron as well.

The Decepticon leader meets Galvatron, who is trying to manipulate Megatron into shaping a future that benefits his plans. We get an all-too-quick glimpse of Unicron, the planet-destroying robot who controls Galvatron, in the season's final episode. Coming face-to-face with his future self (though Megatron doesn't yet know it) was the first concrete sign that *War for Cybertron Trilogy* was introducing the multiverse concept into the *Transformers* universe. The series was designed as a prequel that would fall in line with the G1 continuity, but given the vast amount of canon that has been established over the past three decades across various mediums, some liberties needed to be taken in order to not undermine past events.

Supervising producer Matt Murray notes that certain elements in *Siege* already diverge from the original G1 continuity, such as the fact that Ultra Magnus dies in that first season. "In my mind, everything that happens after the AllSpark is taken off Cybertron is part of a new divergent timeline that then branches out and becomes its own thing," he says.

The Dead Universe would then become the hub for the timeline divergence, in addition to providing the opportunity to put the Autobots and Decepticons in place for the third and final installment of the *War for Cybertron Trilogy*. After an explosive battle between the two factions in space, Optimus Prime makes the daring decision to ram the *Ark* into the *Nemesis* and force both vessels to crash-land on the planet below—prehistoric Earth. That sets the stage for a meeting in the third season that *Transformers* fans have waited to see for decades.

Sheridan says a common question fans ask him is about the title of the second season: "'Why is it called *Earthrise* if they don't get to Earth until the end of the thing?' I get that, but for me, it was all about the journey and how they get there."

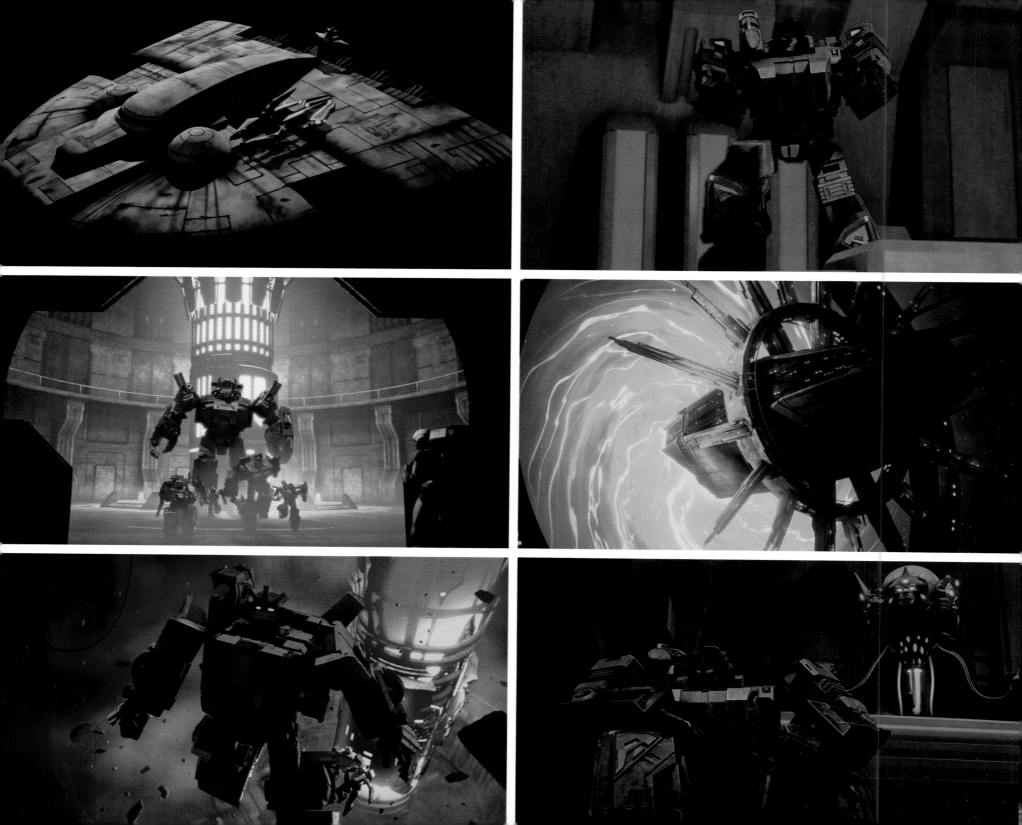

CHARACTERS

Earthrise introduces a diverse cast of characters who are motivated by desires unrelated to the Cybertronian civil war. These new characters expand the universe far beyond the Autobots and Decepticons, setting the stage for the shocking revelations of the third season.

The appearance of Deseeus in *Earthrise* bridges the past and present of *Transformers* and the history of Cybertron. Deseeus embodies the arrogance of his race, proclaiming himself the "breaker of shackles" who gave the Transformers the power that would eventually lead to their independence. "He was the Quintesson responsible for introducing the concept of conversion to the Cybertronians," notes writer Tim Sheridan. "He was a renegade, as he says in the series, and he was someone who the other Quintessons had a real problem with."

The five rotating faces of Deseeus represent Death, Wrath, War, Wisdom, and Judgment. To make a decision, the faces must reach a consensus. That leads to one of the more unsettling moments in the series, when Deseeus takes extreme action to reach "consensus" in episode two of *Earthrise*.

"I was fascinated by the idea of a Quintesson who was crippled by the idea of having to reach consensus among his different faces and personalities," recalls Sheridan. "What would he do then? I said he would just take a blow torch and slice off four of his faces, and that would be consensus to this guy. Everyone got really excited about that imagery, and I was really happy that it made it into the show."

Earthrise saw the introduction of a new element into *Transformers* mythology: the Mercenaries faction. We meet the first bounty hunter in *Siege* when we see Soundblaster involved in a black-market Energon transaction with Bumblebee. "Throughout human history, any time there's a conflict, there are people who find a way to make money off of suffering and war, and Soundblaster is one of them," says season 1 writer Brandon Easton. "I wrote him as an opportunist in the midst of a civil war."

Executive producer F.J. DeSanto agreed. He saw the Mercenaries as an opportunity to illuminate the gray area in the Cybertronian war—the people who have no allegiance to a particular side in the fight and just want to make a profit. DeSanto could barely contain himself after Hasbro first showed him the insignia that came to represent the Mercenaries faction.

"Clearly, this is the thing I'm most proud of with the show because I always talk about it," he jokes. "I wanted them to represent the underworld of the *Transformers* universe. I saw them as the *Transformers* equivalent of the *Star Wars* underworld on Tatooine, with Boba Fett and Jabba the Hutt. And Bumblebee would be the conduit for that."

THESE PAGES: Still images from *Earthrise*.

"I think one of the cool aspects of the story is that Bumblebee knew these guys, and he was willing to trade with them," observes writer Gavin Hignight about the connection between the fan-favorite character and the underground group of war profiteers. "That made him more interesting and layered than we've seen him previously."

The introduction of the Mercenaries served to widen the scope of the civil war on Cybertron and show that while the Autobots and Decepticons are fighting for control, there is another faction that is simply out to make a profit. "The biggest regret I have is that we didn't have the real estate to tell more stories of Doubledealer and his crew," admits Sheridan. "That was why I felt it was important to bring all the Mercenaries back in the finale of *Earthrise* and have a little bit of fun with it."

War for Cybertron Trilogy has an enormous cast of characters. One set of characters that didn't make it into the series would have been part of a sequence Sheridan tried desperately to make happen. It involved a special strike team of Transformers bots stationed on the Autobot command post Moonbase One. "I wanted to have a cavalry faction of Autobots who were going to come in at a decisive moment in *Earthrise*," he says. "And the group was going to be led by Springer from *The Transformers: The Movie*. When I pitched the idea, F.J. laughed and said, 'Never going to happen, man. We don't have that kind of money left in the budget.' So that was that."

SKY LYNX

Sky Lynx is one of the greatest and most ambitious warriors in Cybertron's long history. He is roughly three times the size of Optimus Prime, his outer hull can withstand heavy bombardment and extreme temperatures, and he is capable of long-range interplanetary flight.

For his arrogance, Alpha Trion deemed Sky Lynx unworthy of holding the Matrix of Leadership and banished him to the Dead Universe using the Staff of Solus.

The Sky Lynx who Optimus encounters in the Dead Universe is a vastly different being from the boastful robot G1 fans remember. An eternity in that phantom plane has humbled him. Sky Lynx

shows Optimus what the future will look like if he cannot conquer his self-doubt. It is Sky Lynx who gives him the spark he needs to start becoming the leader the Autobots need him to be.

"That's the importance of his encounter with Sky Lynx," says F.J. DeSanto about the lieutenant commander's role in the story. "Optimus needed to see who he's really supposed to be."

For Optimus, the encounter with Sky Lynx convinces him that he must come to terms with his decisions and regrets if he is to escape the Dead Universe and become the leader Alpha Trion believed he could be. "The future is unwritten," Sky Lynx tells him as he glimpses a vision of the future

where Optimus is dead—a scene that is a callback to 1986's *The Transformers: The Movie*.

For the banished Autobot, helping Optimus find his true path sparks an epiphany. He realizes that perhaps this was Alpha Trion's plan when he banished him all those years ago and that this may be the hero's quest he has sought for so long.

Sky Lynx is killed in episode five of *Earthrise* as he jumps in front of an energy beam fired by Megatron toward the *Ark*. The valiant warrior is vaporized by the blast, but he buys the Autobots enough time to escape. In death, Sky Lynx finally finds his redemption.

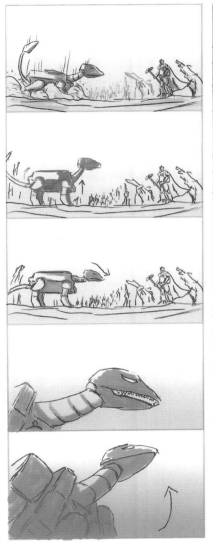

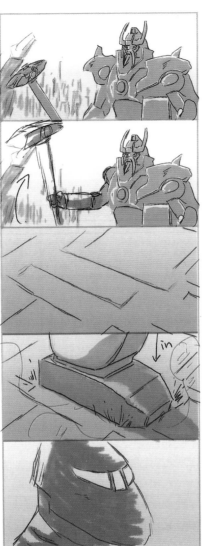

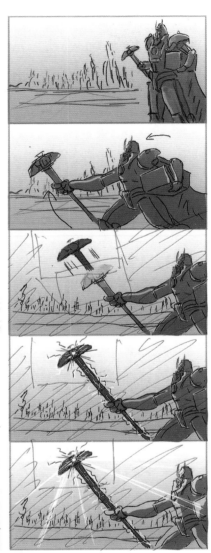

OPPOSITE: In the Dead Universe Sky Lynx tells Optimus, "You must stay true to whom the Matrix has chosen. For if you don't, a much darker future awaits."

LEFT: Storyboards and final images depicting the flashback sequence in which Alpha Trion sends the power-hungry Sky Lynx to the Dead Universe. The storyboard process was essential to the production timeline according to supervising director Takashi Kamei: "We worked closely with the storyboard artists to fit everything we could in the twenty-two-minute framework."

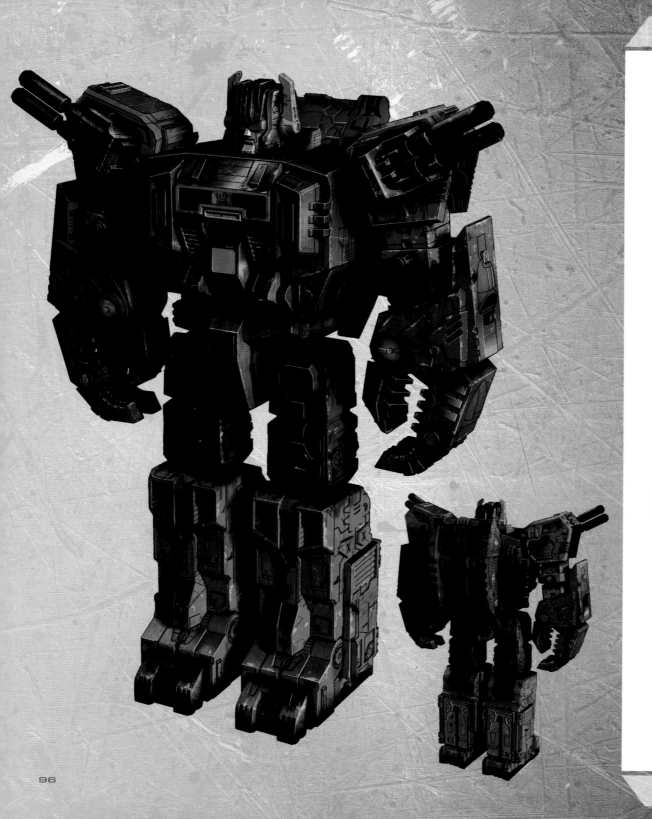

SCORPONOK

The massive scorpion robot is much too powerful for even the combined might of the Autobots and Decepticons. When he converts into scorpion mode, Scorponok overwhelms both factions with his raw strength and his electro-stinger. His armor is nearly impenetrable, and his only major weakness is the head area.

During his battle with Optimus and Megatron, Scorponok reveals he is the last of his kind, as his people were killed off over time by the Quintessons.

The name of the space station where Scorponok is discovered, the Nebulon, is a reference to the origins of the Headmaster technology on the planet Nebulos. In G1 canon, Scorponok first appeared as a leader of the Decepticon Headmasters. The Headmasters were created when a smaller, typically organic being converted into the head of a larger robot.

LEFT: Scorponok bears his own logo, showing he is neither Autobot nor Decepticon.

ABOVE: A color-study image showing Optimus trying to subdue Scorponok during the battle on the Nebulon station.

OPPOSITE LEFT: A storyboard depicting Optimus battling Scorponok.

OPPOSITE RIGHT: Scorponok's scorpion mode.

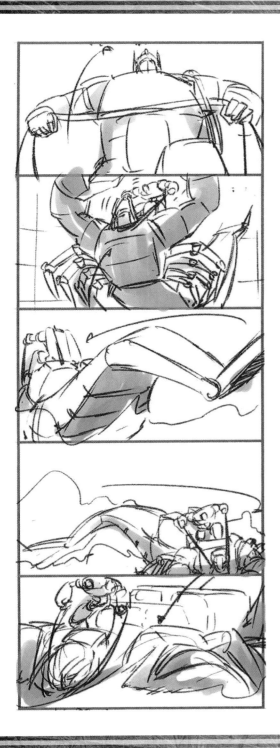

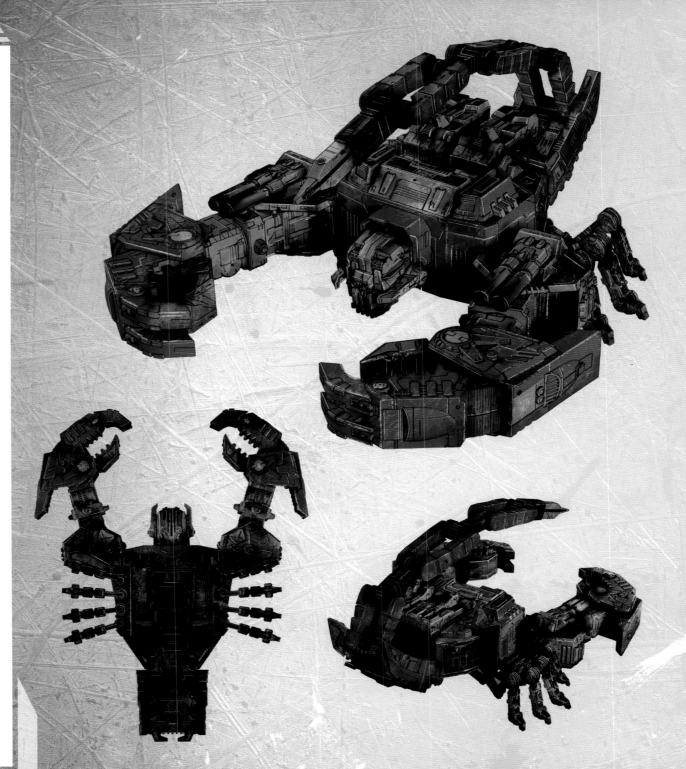

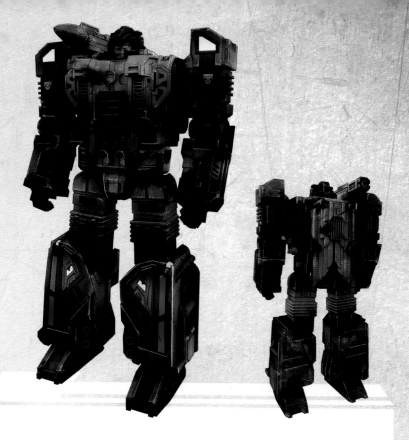

DOUBLEDEALER

Doubledealer is one of the rare characters who have landed in both the Autobot and Decepticon camps over the years. His only loyalty is to himself. "There are no factions out here," he proudly declares in the second episode of *Earthrise*.

Doubledealer is a walking arsenal. His numerous weapons include a hand blaster and his primary weapon, a destructor missile.

He will not hesitate to cut a backroom deal to double-cross a client if it means a larger payday. But Doubledealer gets a taste of his own medicine when Deseeus reneges on paying him for capturing the Autobots. Later, the Quintesson takes control of Doubledealer's mind and forces him to follow the Autobots through the Dead Universe and into the atmosphere above Earth.

ABOVE: Doubledealer's agreement with Deseeus to capture the Autobots in exchange for Energon ends in catastrophe when the Quintesson leaves him for dead on the *Fool's Fortune*.

BUG BITE

A member of Doubledealer's mercenary crew aboard the *Fool's Fortune*, Bug Bite's appearance in the trilogy is a detour from his past history. Here, he is a Cybertronian gun-for-hire with a distinctive hand cannon. In previous iterations of the franchise, he was portrayed as a GoBot Renegade impersonating a Decepticon. In *War for Cyberton Trilogy*, Bug Bite is killed along with Exhaust when Cog fires on them and sends them tumbling helplessly out into space.

BELOW: Bug Bite did not seem to mind that Deseeus had taken command of the Mercenary faction. "I kind of like the new paradigm," he says shortly before he's shot out into space.

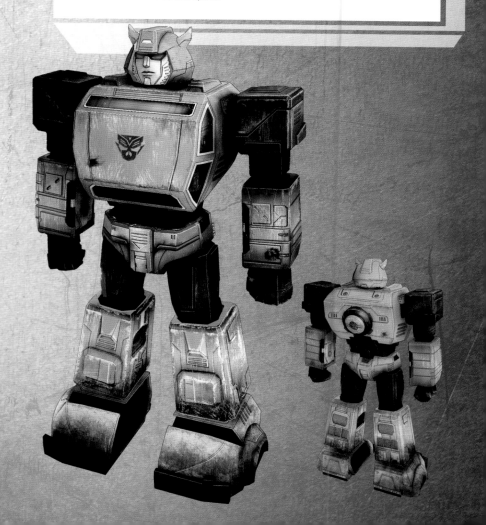

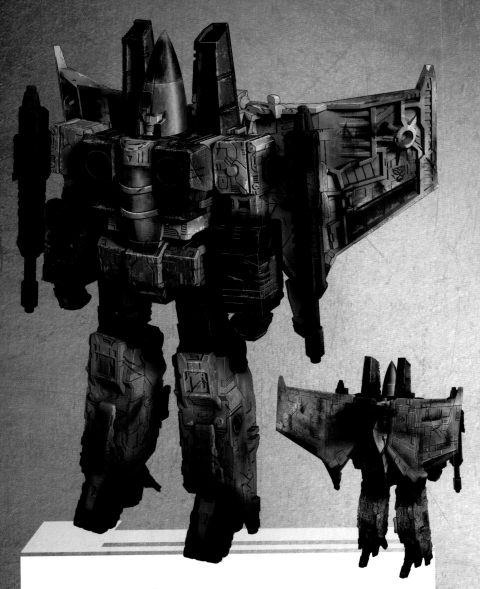

EXHAUST

Previous versions of Exhaust have typically depicted him as one of the Decepticons' espionage operatives, but in *Earthrise* he is part of the Mercenaries faction.

Armed with a cannon and shoulder-mounted missiles, Exhaust is an imposing threat who never hesitates to take a shot, even if an ally may get caught in the crossfire. Having stayed on the *Fool's Fortune* after Deseeus took control of Doubledealer's mind, Exhaust is later shot and blown out into space by Cog.

BELOW: When in vehicle mode, Exhaust is a race car whose design is inspired by an Italian sports car.

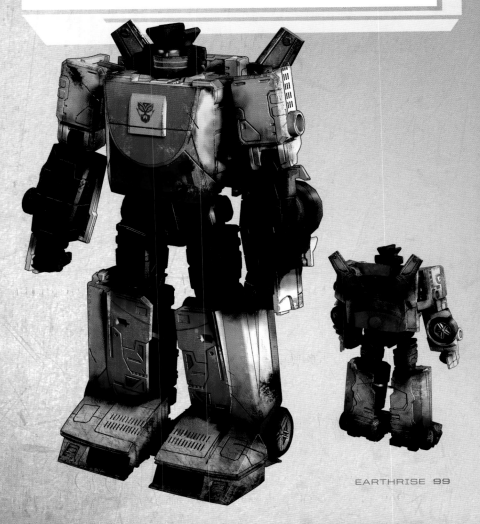

DIRGE

G1 fans may recall Dirge was a conehead Transformers robot and a member of of the Seekers. In *Earthrise*, Dirge is part of Doubledealer's Mercenary faction and a copilot of the *Fool's Fortune*. After Deeseus takes command of Doubledealer's mind as part of his revenge scheme against the Autobots, Dirge leaves the crew to go off on his own.

ABOVE: Dirge converts into a fighter jet when in vehicle mode.

RAMJET

Although we don't see him convert into aerial mode in *Earthrise*, Ramjet's design is similar to those of the other Seeker Elite. He abandons Doubledealer's organization once Deeseus takes control of the mercenary's mind.

THIS PAGE: Ramjet and Thrust's design is a nod to the so-called "conehead" design they (and Dirge) had as the original G1 Seekers.

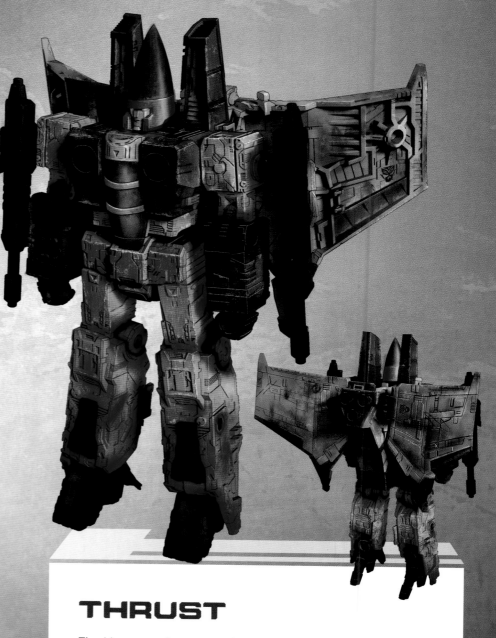

THRUST

The Mercenary known as Thrust can shift modes into a fighter jet. Armed with shoulder-mounted blaster weapons, he is a shoot-first, ask-questions-later type of character. His design is a revamp of a G1 Decepticon of the same name.

DESEEUS

Deseeus is a Chief Quintesson Judge, part of the highly advanced species that created and ruled over the Transformers robots. The manipulative and scheming Deseeus views himself as a benevolent god, but to Optimus, he represents a vision of failed godhood. The multifaced Quintesson is clearly unbalanced, with the differing personalities battling for control.

After the face of Wisdom calls for a consensus to determine whether to pay Doubledealer his fee for capturing the Autobots, it is the face of Wrath who ultimately takes control by cutting off the four other faces to reach a consensus of one.

After the Autobots and the Mercenaries band together to escape his ship on the planet Chaar, Deseeus returns in the penultimate episode of *Earthrise*. Having taken command of Doubledealer's mind, he tries to destroy both the Autobots and Decepticons but ultimately fails. He leaves Doubledealer for dead and mortally wounds the Autobot Cog. Deseeus is last seen evacuating the *Fool's Fortune* just before it explodes above Earth.

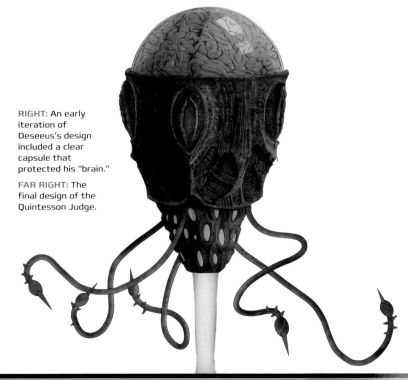

RIGHT: An early iteration of Deseeus's design included a clear capsule that protected his "brain."

FAR RIGHT: The final design of the Quintesson Judge.

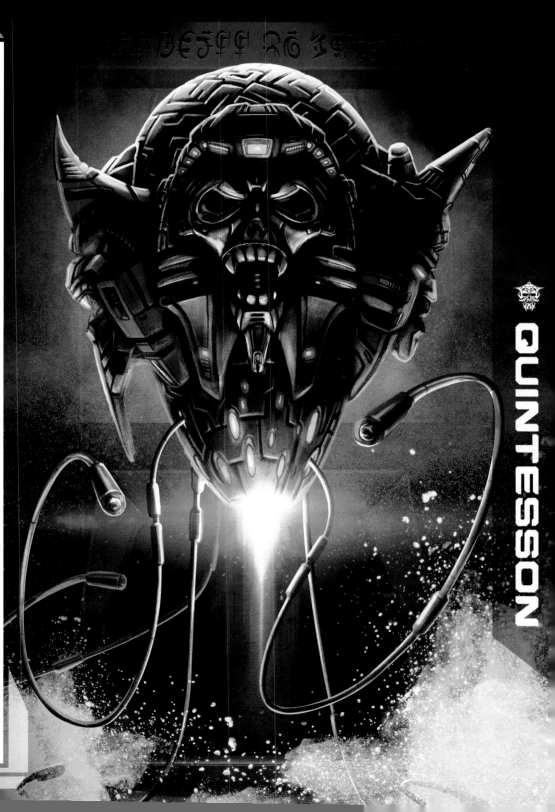

QUINTESSON

WISDOM
INSP: THIRD EYE - TEMPLE

DEATH
INSP: DEATH HEAD - SKULL

WAR
INSP: HEAD TO HEAD - TURBULENCE

JUDGEMENT
INSP: SCALE - BALANCE

WRATH
INSP: MULTI DIRECTIONAL CHAOS - BLADES

V1: DECONSTRUCTED
QUINTESSON WWDWJ

LEFT: The different faces of Deseeus are represented in the Quintesson icon.

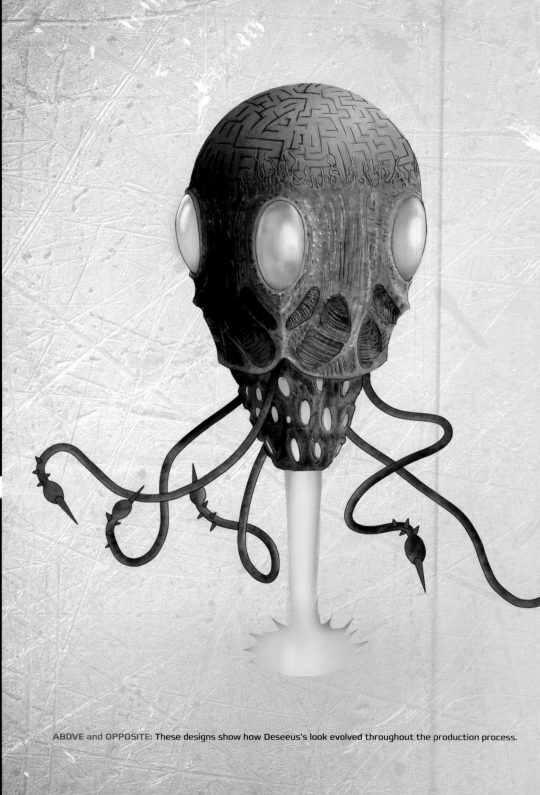

ABOVE and **OPPOSITE:** These designs show how Deseeus's look evolved throughout the production process.

102

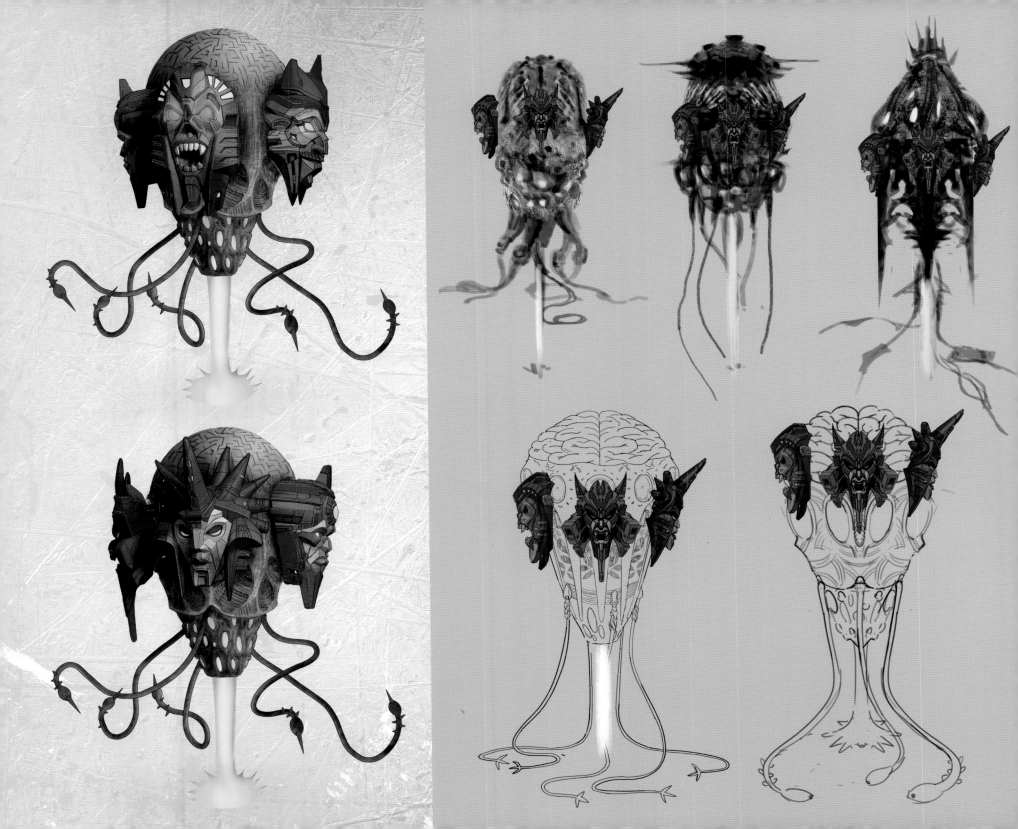

LOCATIONS

SPACE

The second chapter of *War for Cybertron Trilogy* devotes much of its time to space travel as the Autobots search for the AllSpark. While the rubble-strewn landscape on Cybertron is revisited when the story shifts back to explore Elita-1 and her team's continuing resistance, much of *Earthrise* takes place in space and on alien planets. The designers at Polygon Pictures used vivid colors to convey a more adventurous tone inspired by *Star Trek* and, perhaps more appropriately, *Lost in Space*. Even the vast desolation of the Dead Universe, a key setting this season, is more colorful than most anything seen in *Siege*. In *Earthrise*, the Dead Universe exists on a separate plane of reality and serves as a prison for those banished there.

OPPOSITE: Concept art showing Megatron barking orders to Soundwave on the bridge of the Nemesis.

THIS PAGE: The interstellar theme of *Earthrise* allowed for the use of a brighter color palette compared to the bleakness of *Siege*, as seen in these paintings with the *Nemesis*, *Ark*, and *Fool's Fortune*.

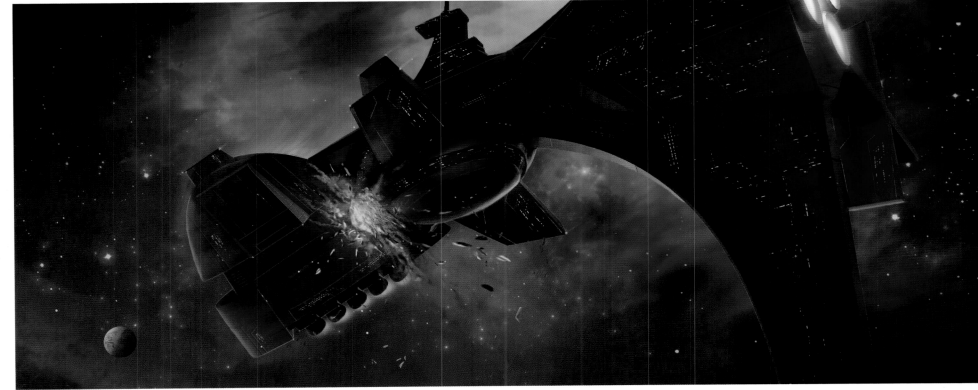

THE ARK

Much like the Arena was a focal point of *Siege*, the *Ark* is a centerpiece of the second chapter. The Autobots' ship is appropriately huge. The opening sequence of episode 3 of *Earthrise* gives us a sense of scale: the camera starts on Optimus Prime and Bumblebee standing on the ship's exterior, then pans out to show the *Ark*'s massive size. "When we created the *Ark* and the *Nemesis*, we built them to scale as much as possible, so we have exact measurements for them," says supervising director Takashi Kamei. According to the Polygon crew, the *Ark*'s dimensions are 936 meters long and 220 meters tall.

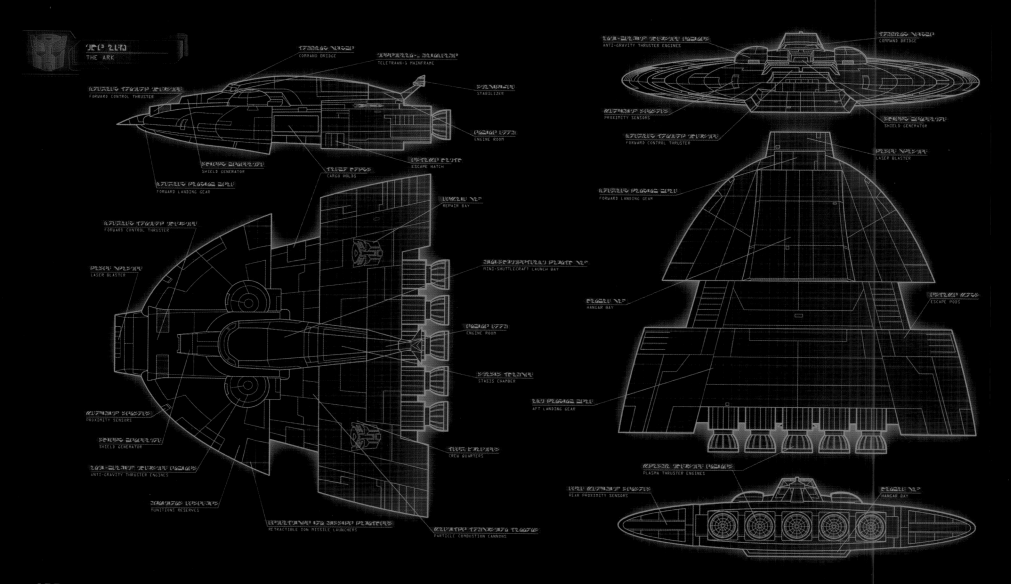

2km

1km

0km

Nemesis
L 1300m H 2000m

Ark
L 936m H 220m

Fool's Fortune
L 235m H 100m

OPPOSITE: Schematics for the *Ark*.

THIS PAGE: This diagram shows the dimensions of the ships featured in *Earthrise*.
The Decepticon vessel clearly dwarfs the other two ships.

ABOVE LEFT: The main corridor of the *Ark* is lit with yellow emergency lighting as there is not enough Energon to properly power the ship.

ABOVE RIGHT: The ship's bridge.

RIGHT: A sketch of the Autobots entering the *Ark*.

OPPOSITE: Concept rendering of the *Ark* after it crash-landed on prehistoric Earth. Traveling through the Dead Universe created a divergence in the timeline, something writer Tim Sheridan describes as "a real linchpin for us in terms of understanding our place in the *Transformers* multiverse."

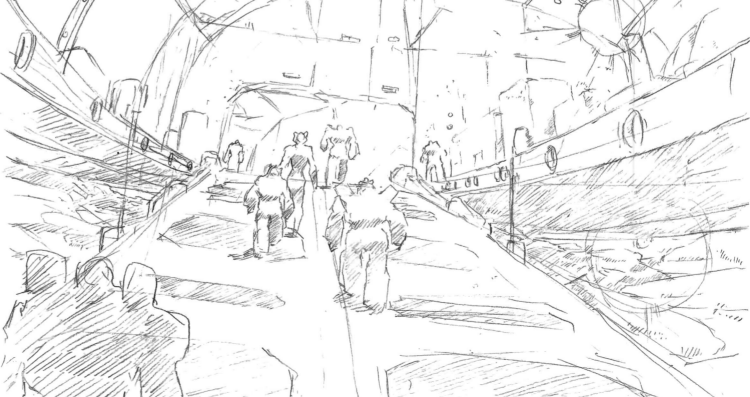

THE *NEMESIS*

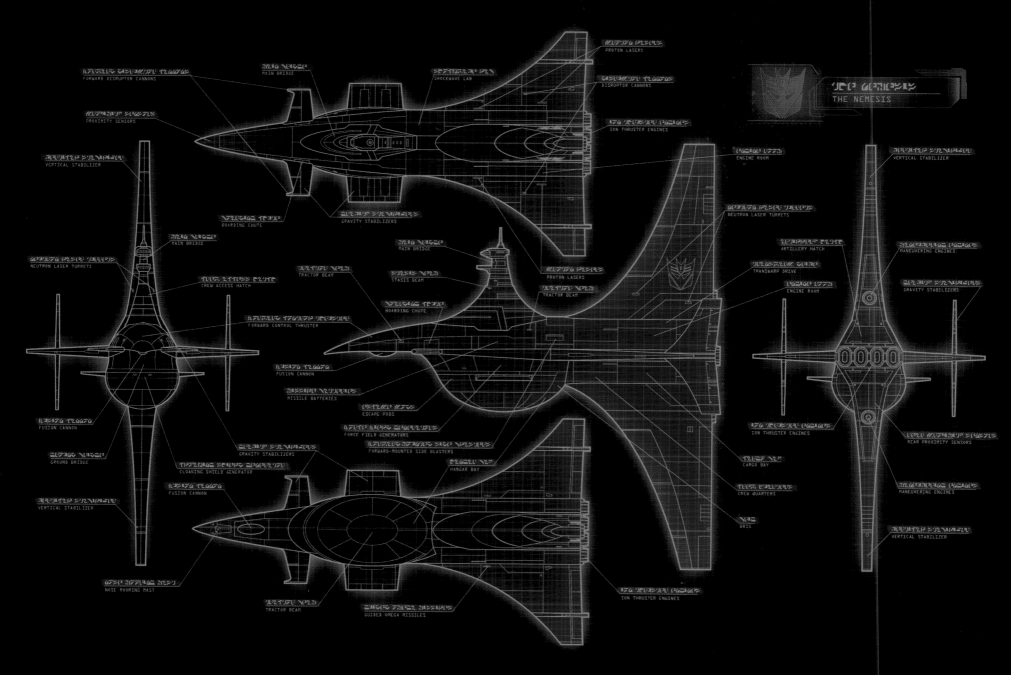

PROTON LASERS

MAIN BRIDGE

SHOCKWAVE LAB

DISRUPTOR CANNONS

FORWARD DISRUPTOR CANNONS

ION THRUSTER ENGINES

THE NEMESIS

PROXIMITY SENSORS

ENGINE ROOM

VERTICAL STABILIZER

VERTICAL STABILIZER

NEUTRON LASER TURRETS

BOARDING CHUTE

GRAVITY STABILIZERS

MAIN BRIDGE

NEUTRON LASER TURRETS

MAIN BRIDGE

TRACTOR BEAM

STASIS BEAM

PROTON LASERS

ARTILLERY HATCH

MANEUVERING ENGINES

CREW ACCESS HATCH

TRACTOR BEAM

TRANSWARP DRIVE

FORWARD CONTROL THRUSTER

BOARDING CHUTE

ENGINE ROOM

GRAVITY STABILIZERS

FUSION CANNON

MISSILE BATTERIES

ESCAPE PODS

FORCE FIELD GENERATORS

ION THRUSTER ENGINES

FUSION CANNON

FORWARD-MOUNTED SIDE BLASTERS

REAR PROXIMITY SENSORS

GROUND BRIDGE

GRAVITY STABILIZERS

HANGAR BAY

CARGO BAY

CLOAKING SHIELD GENERATOR

MANEUVERING ENGINES

VERTICAL STABILIZER

FUSION CANNON

CREW QUARTERS

BRIG

VERTICAL STABILIZER

NOSE MOORING MAST

TRACTOR BEAM

GUIDED OMEGA MISSILES

ION THRUSTER ENGINES

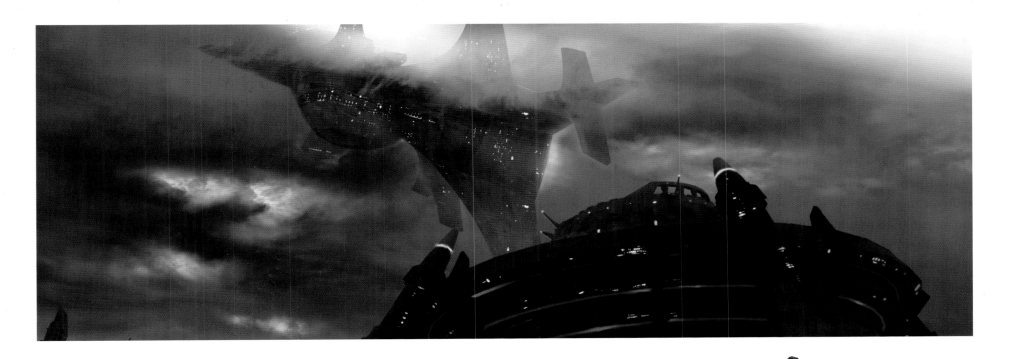

NEMESIS BRIDGE INTERIOR DESIGN
Isometric view

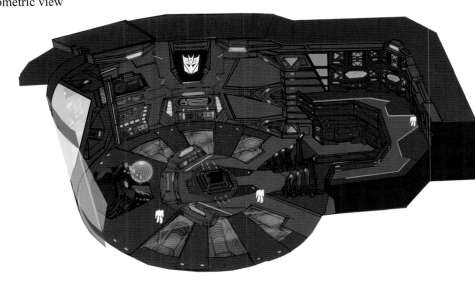

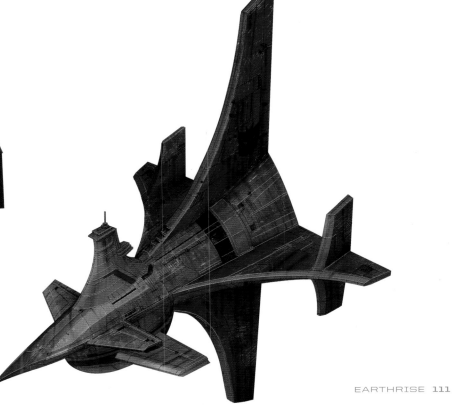

OPPOSITE: Blueprints for the *Nemesis*.

TOP: The *Nemesis* hovers above the Arena before leaving Cybertron.

ABOVE LEFT: The interior design of the bridge of the *Nemesis*.

ABOVE RIGHT: Additional view of the *Nemesis*.

FOOL'S FORTUNE

The *Fool's Fortune* is the spacefaring vessel of the Mercenary faction led by Doubledealer. It is a smaller, more nimble ship with vertical fins, a rear thruster, and extensive weaponry—the sort of ship built for people who need to make a quick exit. The *Fortune* takes on heavy damage from strikes by the *Ark* and the *Nemesis* during the season finale of *Earthrise*, and damage to its warp actuator leads to its eventual explosion.

THIS PAGE: The *Fool's Fortune* is 235 meters long and 100 meters high. The ship is small but is outfitted with a large engine to help it move quickly.

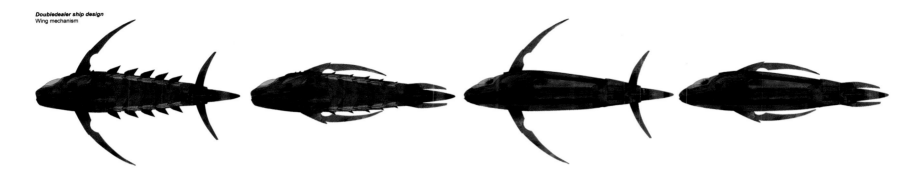

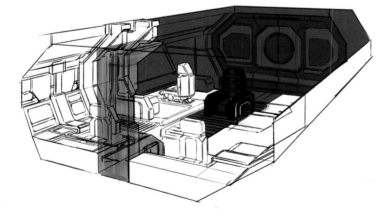

TOP: Concept images detailing the wing mechanism of Doubledealer's ship.

ABOVE: The interior of the *Fool's Fortune*.

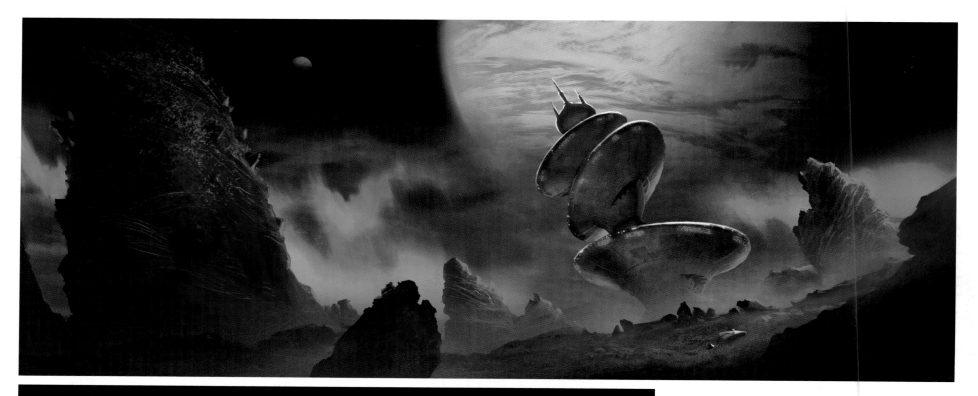

CHAAR

The designers took full advantage of all the interstellar travel in *Earthrise* to create compelling locations, including the barren, wind-sheared planet of Chaar. Once the home of the exiled Decepticons in G1 continuity, it is now the location of the Quintesson Judge Deseeus's vertical palace, where Doubledealer takes the captured Autobots.

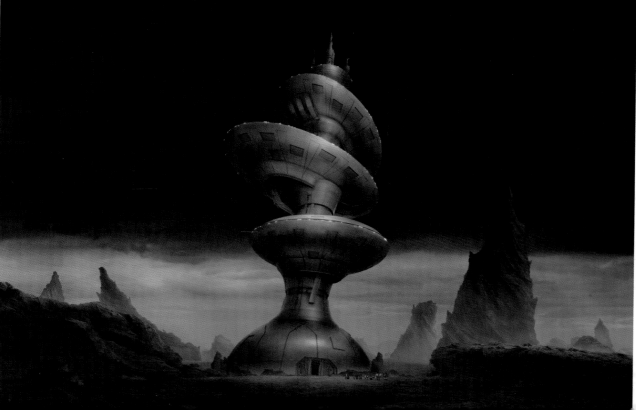

ABOVE: This concept painting shows a more vivid color scheme for the arrival of the *Fool's Fortune* and the captive Autobots on Chaar. The designers would go with a more muted color scheme for the final version, seen LEFT.

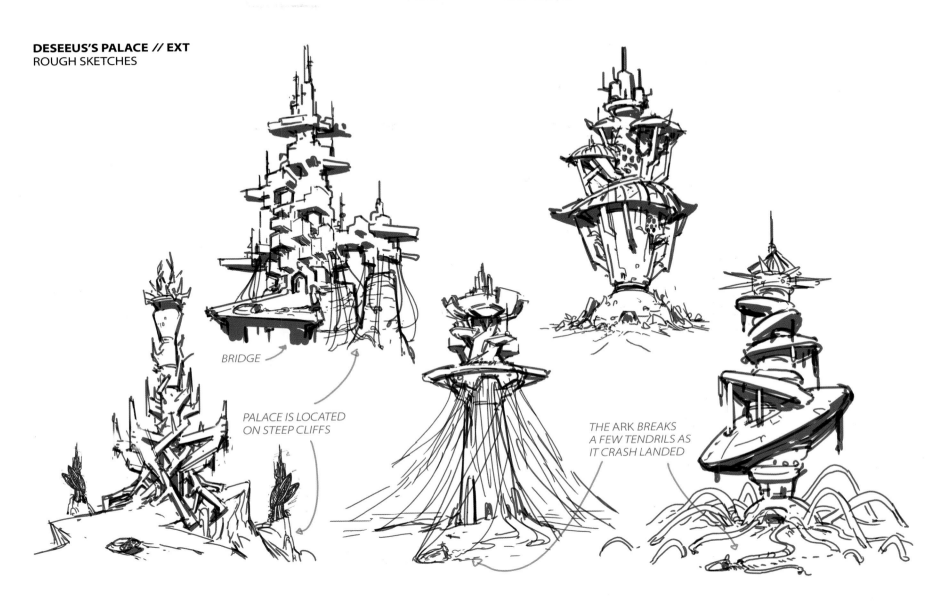

BRIDGE

PALACE IS LOCATED
ON STEEP CLIFFS

THE ARK BREAKS
A FEW TENDRILS AS
IT CRASH LANDED

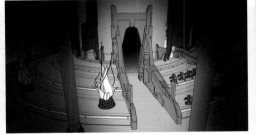
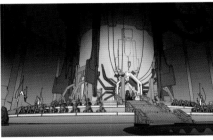

THIS PAGE: Iterations on the exterior and interior of Deseeus's palace on Chaar.

NEBULON SPACE STATION

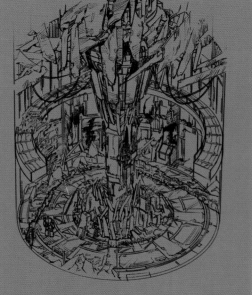

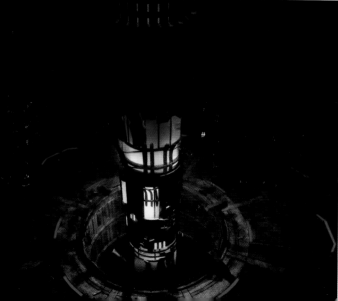

The Nebulon space station, which is trapped between the spacebridge and the Pastel Colony planet, incorporates some of the cold steel aesthetic from Cybertron into its sturdy design. The dark corridors and doorways inside the station help cloak Scorponok from the Autobots. But at the same time, the station uses luminescent lighting to showcase the spacebridge, accentuating the the season's theme of space adventure.

The bright, lush colors of the Pastel Colony planet on the other side of the spacebridge provide Optimus and Bumblebee with a glimpse of a brighter future—a much-needed bit of hope.

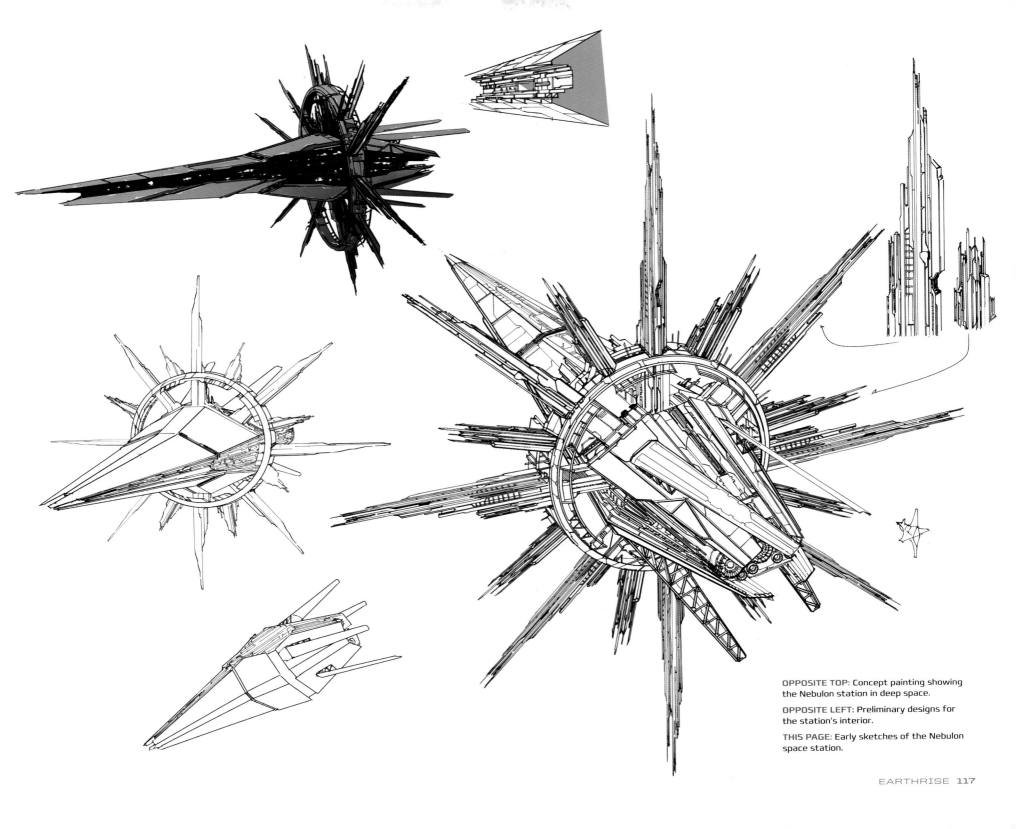

OPPOSITE TOP: Concept painting showing the Nebulon station in deep space.

OPPOSITE LEFT: Preliminary designs for the station's interior.

THIS PAGE: Early sketches of the Nebulon space station.

PASTEL COLONY PLANET

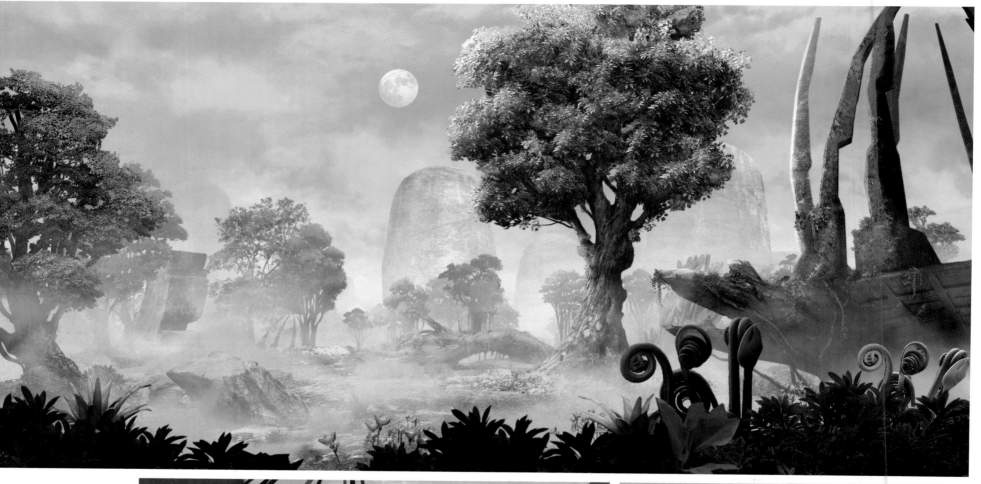

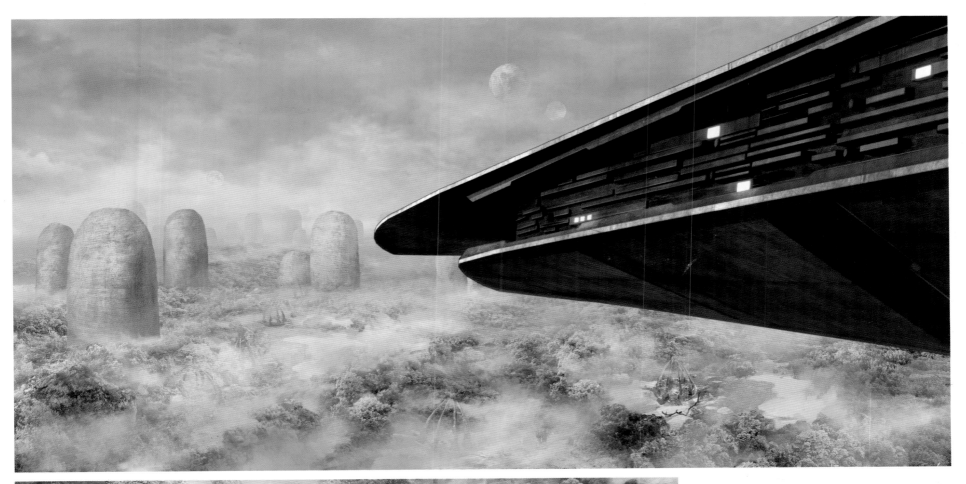

THESE PAGES: Background paintings of the Pastel Colony planet on the other side of the spacebridge.

LEFT: The ruined city located below the tip of the space station in early designs is suggested to be Scorponok's home.

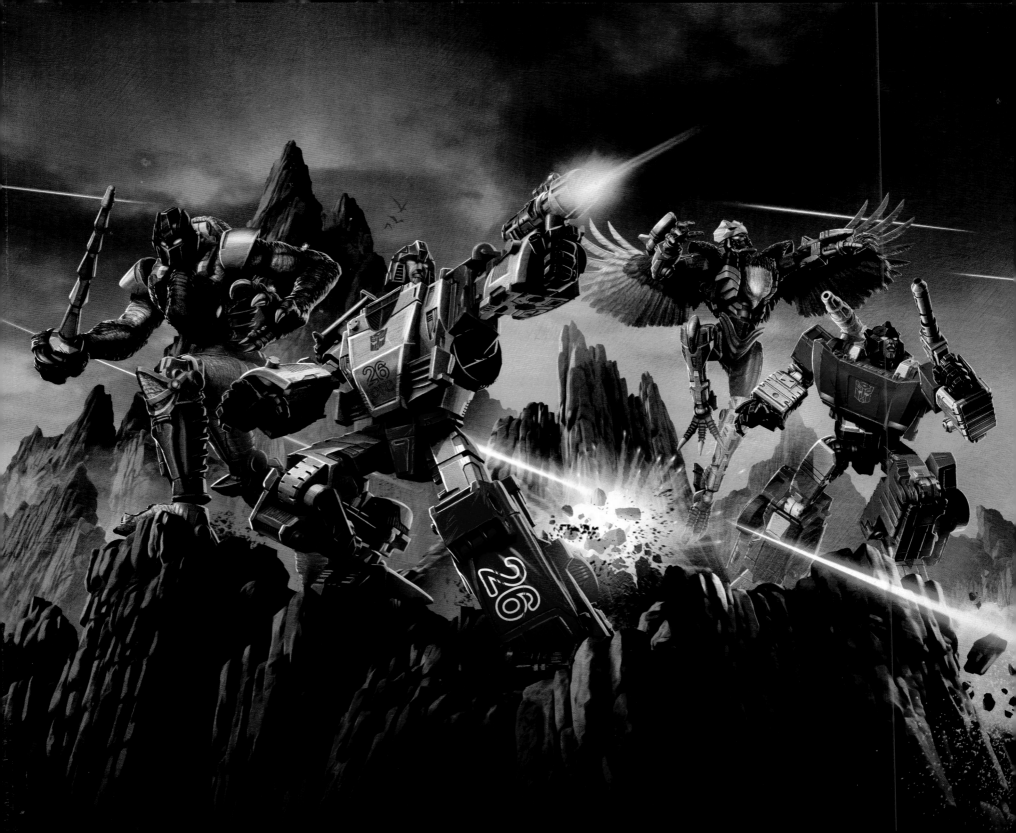

CHAPTER 4

TRANSFORMERS
KINGDOM
WAR FOR CYBERTRON

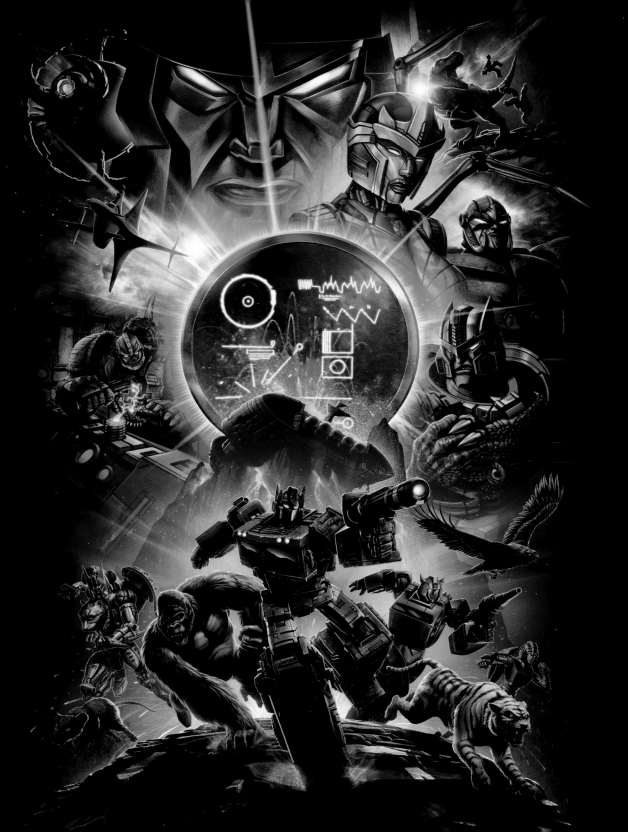

The final installment of the trilogy begins on prehistoric Earth, where the *Ark* has crashed into the base of a volcano. As the Autobots try to collect their bearings, they are attacked by a pack of powerful beasts. It is only when the gorilla shifts modes that the Autobots realize they have encountered fellow Transformers robots: the Maximals!

It's a historic moment in the franchise: the first time the G1 characters interact with the Maximals and Predacons from the beloved 1990s *Beast Wars* spinoff series. This major event was far from the only item on the *War for Cybertron Trilogy* team's to-do list. The final chapter would involve not just the Autobots, Decepticons, and their bestial descendants, but also classic *Transformers* villains Galvatron and Unicron. Somehow, they had to tie all of this together.

"For as many bells and whistles as we had in this show, from the *Beast Wars* characters to the AllSpark, the Golden Disk, the Matrix of Leadership, all of that stuff," notes writer Tim Sheridan, "as exciting as all that was, we had to figure out what the human story was inside *Kingdom* and ultimately *War for Cybertron*."

Hasbro had big plans to celebrate the twenty-fifth anniversary of *Beast Wars*, which included the debut of a new line of toys. "We knew from a marketing standpoint that we wanted to mark the anniversary of *Beast Wars* and that it would be part of the third year of this trilogy," remarks Tom Marvelli. "But in the early stages of this, I said to everybody, 'We've got to make people care about this.'"

PAGE 120: Toy packaging art featuring Maximal Grimlock, Autobot Mirage, Maximal Skywarp, and Autobot Sideswipe.

LEFT: Promotional image for *Kingdom* announcing the long-awaited return of the *Beast Wars* characters.

OPPOSITE TOP: Concept painting of Cheetor viewing the crashed *Ark* inside the volcano.

OPPOSITE LEFT: Color-study image of the *Nemesis* on a collision course with prehistoric Earth at the beginning of *Kingdom*.

OPPOSITE RIGHT: The Golden Disk is the key to Galvatron's plans to free himself from Unicron's influence.

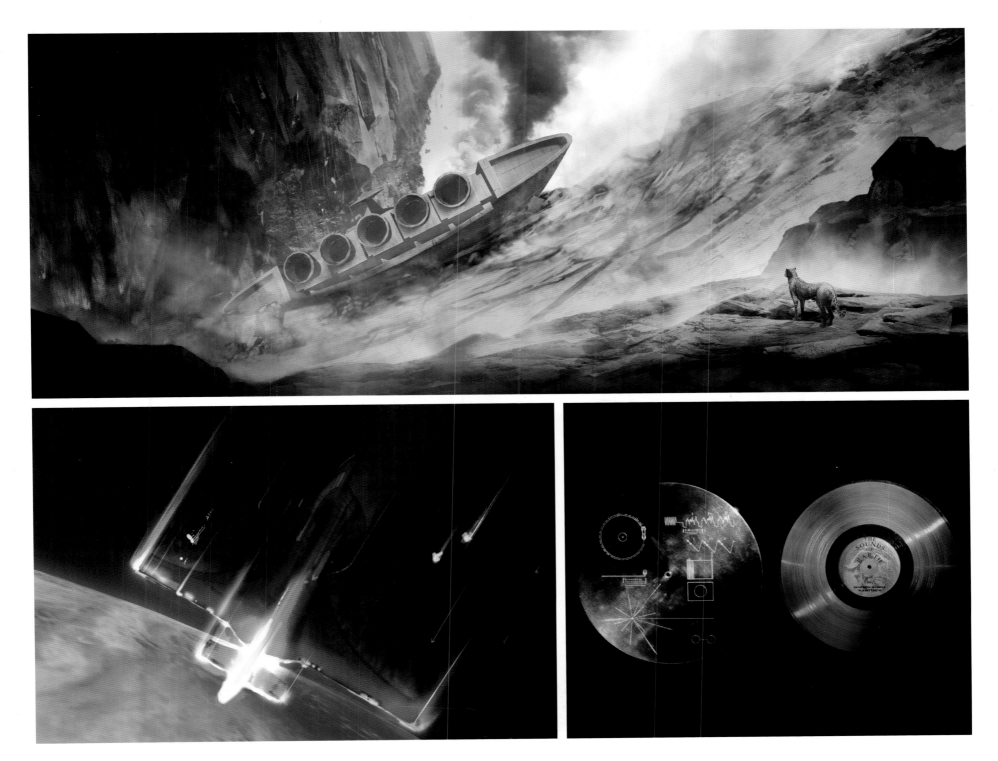

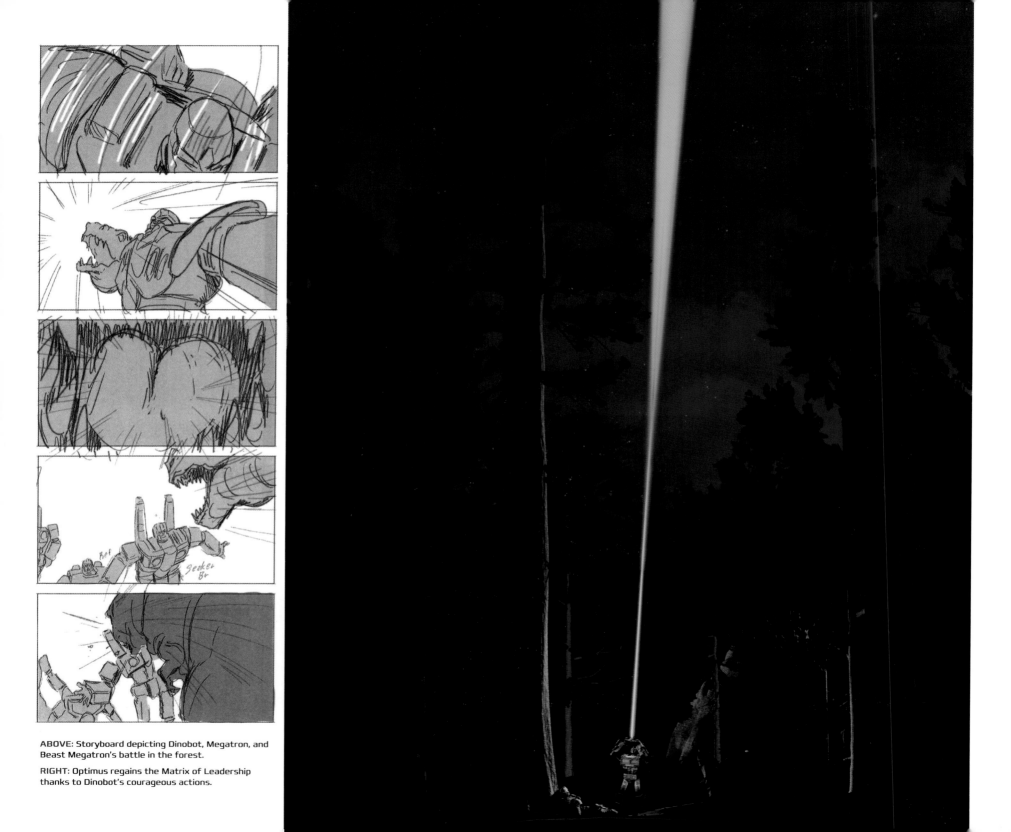

ABOVE: Storyboard depicting Dinobot, Megatron, and Beast Megatron's battle in the forest.

RIGHT: Optimus regains the Matrix of Leadership thanks to Dinobot's courageous actions.

"WE ARE THE RESULTS OF YOUR WAR. WE MIGHT AS WELL PARTICIPATE IN IT." — OPTIMUS PRIMAL

That story would start with Optimus Prime facing the consequences of his reckless actions: by taking the AllSpark off planet, he has doomed future generations like the Maximals, who are forced to grow up on a dead planet. Now he must right those wrongs and win over the Maximals, including Optimus Primal.

Part of the challenge was offering a portrait of the *Beast Wars* characters that rang true to their original iterations and that introduced new fans to that part of the *Transformers* legend. "The original Transformers bots have the benefit of many versions of themselves over the last forty years, including the movies," writer Mae Catt says. "We all kind of know who Optimus Prime is, but the *Beast Wars* characters have not been as saturated in our culture."

Catt, whose first exposure to *Transformers* was through *Beast Wars*, felt a responsibility to get it right. "I felt like there was less wiggle room to go off-book for some of them," she says. "So being able to bring them back to television was intense, exciting, and also a little intimidating."

The third episode of *Kingdom* features a callback to perhaps the most famous episode of the original *Beast Wars* series. In "Code of Hero," Dinobot dies after a taking on the entire Predacon force on his own. In *Kingdom*, he comes to realize that Megatron is not worthy of the Matrix of Leadership and takes on both Megatrons and Soundwave. After a valiant battle, he manages to take the Matrix back. The fierce Dinobot is able to return it to Optimus before he dies in the same noble manner as he did in the original series.

As the show builds to its climax, the Autobots, Maximals, Decepticons, and Predacons approach the AllSpark's location in a hidden temple, where protective mechanisms activate and create turmoil for anyone who gets too close. Many characters experience hallucinations showing them the elements at the core of their struggles: Megatron sees his future self, Galvatron, who's been trying to manipulate him

ABOVE: Production painting of Rattrap and Optimus Primal as they prepare to rescue Airazor from the *Nemesis*.

to change what is to come. Optimus Prime sees Alpha Trion, while Starscream sees a crown and cape signifying his rise to power in a scene that references the 1986 *Transformers* animated movie. As Starscream communicates with the manifestation of the AllSpark, he discovers the symbiotic relationship between the AllSpark and the Transformers robots. The AllSpark needs to return to Cybertron, or it will die.

Inside the temple, Optimus is confronted by Megatron. The battle between the former brothers-in-arms is brief and only ends when Optimus realizes that what the AllSpark-created "ghost" of Elita-1 says is true: "The only way to stop the fighting is to stop fighting." Optimus hands the Matrix back to Megatron, but it rejects him, and as the Matrix returns to Optimus Prime, the sparks from the Transformers help rejuvenate the AllSpark in an attempt to save it.

The Autobots win the final battle against the Decepticons and Predacons, but upon returning to Cybertron, Optimus comes face-to-face with the consequences of his actions as he stands over the lifeless corpse of Elita-1 in a frozen wasteland. It is

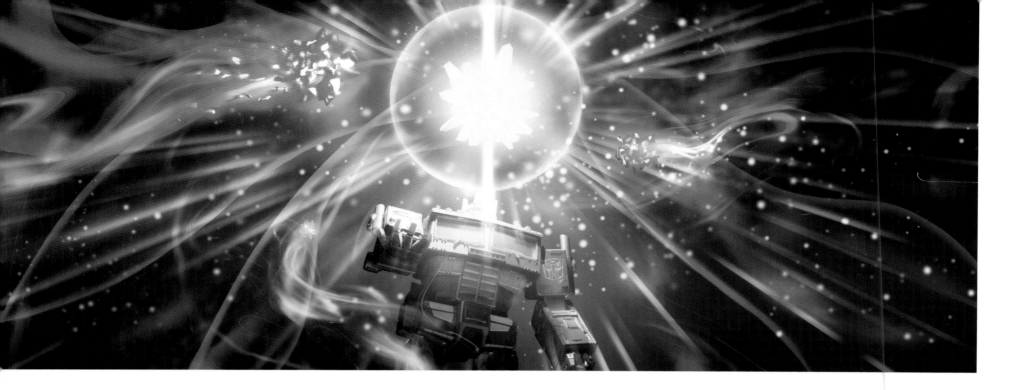

"'TIL ALL ARE ONE."

— OPTIMUS PRIME

left to Bumblebee to remind Optimus that he is the Autobots' leader and that his soldiers are looking to him for guidance as they try to rebuild Cybertron.

"We could argue that it was the wrong decision, and he has to live with that," says Catt. "But I think being Optimus Prime, he believed the consequences of ejecting the AllSpark would still be better than the alternative because they would be around to ensure it's better. One of his more magical attributes is that in the face of hopelessness, he will be the one that still has hope."

That hope is threatened again when Galvatron and Nemesis Prime make their final move to steal the AllSpark, which they intend to use to destroy Unicron. To the twisted future iterations of Megatron and Optimus, their freedom is worth more than the salvation of Cybertron. Ultimately, the Autobots, Decepticons, Maximals, and Predacons choose to set aside their differences to fight for the right to rebuild Cybertron. With the help of the sparks from those who had been left behind, they are victorious, and the rebirth of Cybertron begins.

"The ending of *Kingdom* was really about death and resurrection," notes Sheridan. "It was also about giving a glimmer of hope, literally, with those sparks and what they can mean. It became much more spiritual than I think any of us thought it was going to be when we first started working on it."

For now, the Cybertronian war is over as the Autobots and Decepticons go their separate ways to rebuild their world.

When production began on *War for Cybertron Trilogy*, DeSanto and his team weren't sure how they were going to get all the way from *Siege* and the ruins of Cybertron to prehistoric Earth and meeting their descendants. In the original 1996 *Beast Wars* series, the original Transformers are in stasis on the *Ark*, hibernating for eons before they wake up in 1984, activating the G1 timeline. The Maximals and Predacons, who traveled back in time through a time-and-space phenomenon while searching for Energon, never interact with their ancestors.

The Dead Universe, an essential component of the fifth episode of the *Earthrise* season, provides

a window of opportunity to make this work. The dead dimension serves as a way station to get the Autobots and Decepticons to Earth in accordance with the timeline of the series, but instead of crash-landing and going into stasis, they remain active and awake. This allows them to come into contact with the *Beast Wars* characters, who, just as in the original series, have traveled back in time. That action helps create the so-called *Transformers* multiverse.

"All of us saw the Dead Universe as an opportunity to reimagine the timeline and give us a way to make sense of it," says Sheridan. "I approached it as simply a part of the *Transformers* multiverse, where it's as close as we've ever gotten to G1, but it is still in a slightly different place now because the divergence happened from the timeline."

"We are in totally new territory once the Autobots and Decepticons crash-land on Earth and it's not 1984, because that means G1 as we know it didn't happen exactly as before," explains Catt. She uses a *Back to the Future II* reference to elaborate on her point. "The Maximals and Predacons are in the 'evil Biff' timeline where everything went wrong and nothing went right, and Optimus Prime was never able to recover the AllSpark and bring it back to Cybertron."

"The Maximals and Predacons returning to Cybertron in the series finale isn't totally unfamiliar. They grew up in a postapocalyptic world much like that one," notes Catt. "What's exciting for them is that this time they get to participate in the rebuilding beyond whatever comes after our series concludes."

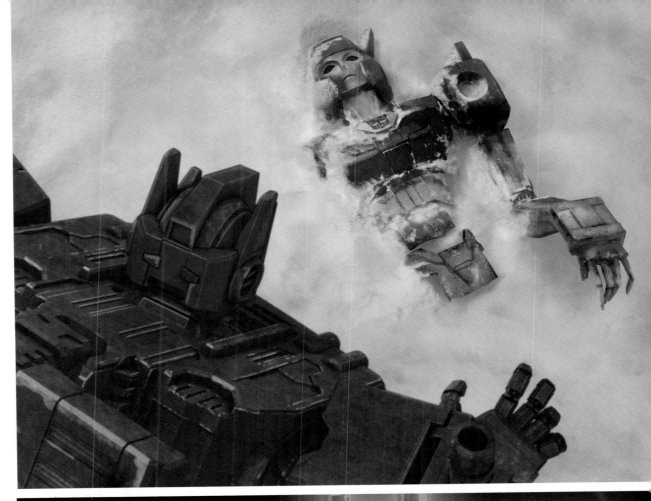

OPPOSITE PAGE: Concept painting of Optimus in the AllSpark Temple when the sparks of Autobots and Maximals restore the AllSpark to life.

TOP: Optimus is devastated when he finds the body of his beloved Elita-1 upon his return to Cybertron. "Elita-1 served as sort of the voice of reason, the counterpoint to both sides of the war. It makes her death all the more poignant," says executive producer F.J. DeSanto.

BOTTOM: The sparks of deceased bots return to power the AllSpark.

CHARACTERS

Orchestrating the first in-universe encounter between the G1 Transformers bots and the *Beast Wars* characters was a daunting task from both a storytelling and animation perspective. When it came time to design the looks of the Maximals and Predacons that would be part of *Kingdom*, the animators at Polygon Pictures once again started with the basic elements.

"We first received the designs from Hasbro and then used those to create our own designs for our artists to create the 3D models," art director Yoshimitsu Saito remembers.

The original *Beast Wars* series featured what was at the time groundbreaking CG animation. Technology has improved dramatically since then, but creating the techno-organic design of these characters remains a technical challenge. "Because the *Beast Wars* characters have organic parts along with metallic elements," Saito says, "we had a lot of meetings with our team just to discuss which parts should be organic and which should be metallic. I remember having a really hard time with that."

Because *Kingdom* would feature the first scenes where the G1 and *Beast Wars* characters interact, supervising director Takashi Kamei had to make some creative decisions to maintain an aesthetic consistency.

"We felt it would be a little strange or awkward for the *Beast Wars* characters to have soft fur, like actual animals, when they stand next to the others, who are all metallic, hard-surface characters," Kamei says. "So we decided to go with a more sculpted approach for the *Beast Wars* characters. In beast mode and robotic mode, you can see the [sculpted fur] so that when they stand next to the Autobots or Decepticons, there's an aesthetic consistency."

Prepping the characters for their CG-animated battles involved meticulous preparation and the creation of motion cycles—a technique used in animation to create sequences that can be repeated. "In *Kingdom* there are a lot of battle scenes where the Maximals and Predacons are fighting in their beast modes as well as the robot modes," says Saito. "So we created a lot of motion cycles for the beast movements to make it look as realistic as possible."

Kamei notes that his animators also didn't have the luxury of much reference material for capturing the characters in beast mode. "The Autobots and Decepticons turn into actual vehicles that exist, so we have lots of reference material for them," he says. "For the *Beast Wars* characters, we [had to buy] a lot of animal toys and figures from a toymaker to see how the figures looked in real life. [We used them as reference material for] the character models to have a consistent design."

The writers relished the chance to bring the G1 Transformers robots and Beast Wars characters together. Mae Catt, who joined the show's writing team for the

OPPOSITE: Key art featuring Megatron and the Predacons.

ABOVE: The unlikely partnership between Blackarachnia and Starscream is borne out of mutual distrust… and respect.

PAGE 130–131: Packaging art featuring the Autobots, Maximals, Decepticons, and Predacons.

third season, enjoyed creating what she jokingly calls "the contractually obligated showdown" between the Autobots and Maximals.

"I was so incredibly excited to write that. Tim Sheridan says this a lot—he equates what we do on *Transformers* as, 'I'm a kid and I get to play with the toys,'" says Catt. "And this is very true for the fights where it was just very natural for me to be like, 'Well, the cats have to fight. Cheetor and Tigatron have to fight Ravage, Laserbeak has to fight Airazor, and you have to have a showdown between the Optimuses. I enjoy action writing, and I enjoy trying to come up with fun and unique ways that characters can express how they're feeling and where they are in their journey through their fighting."

Catt took particular joy in minding the details of the skirmish between the two Primes. "I remember there was a moment where I texted F.J. DeSanto and asked him if I could have the weapons that the *Beast Wars* characters had in their show. And he answered back, 'What do you mean?' And I just said, 'Optimus Primal will need his scimitars. I need scimitars to clash with Prime's ax so badly!'"

Additionally, there are several team-ups that occur between the two generations of *Transformers*. For example, Rhinox, the Maximals' resident genius, and the Autobot tinkerer Wheeljack work together as they try to repair the *Ark*. Perhaps the most interesting alliance is between the two scheming opportunists, Starscream and Blackarachnia. Neither can be trusted, but they align based on their shared lust for power and their lack of faith in both Megatrons.

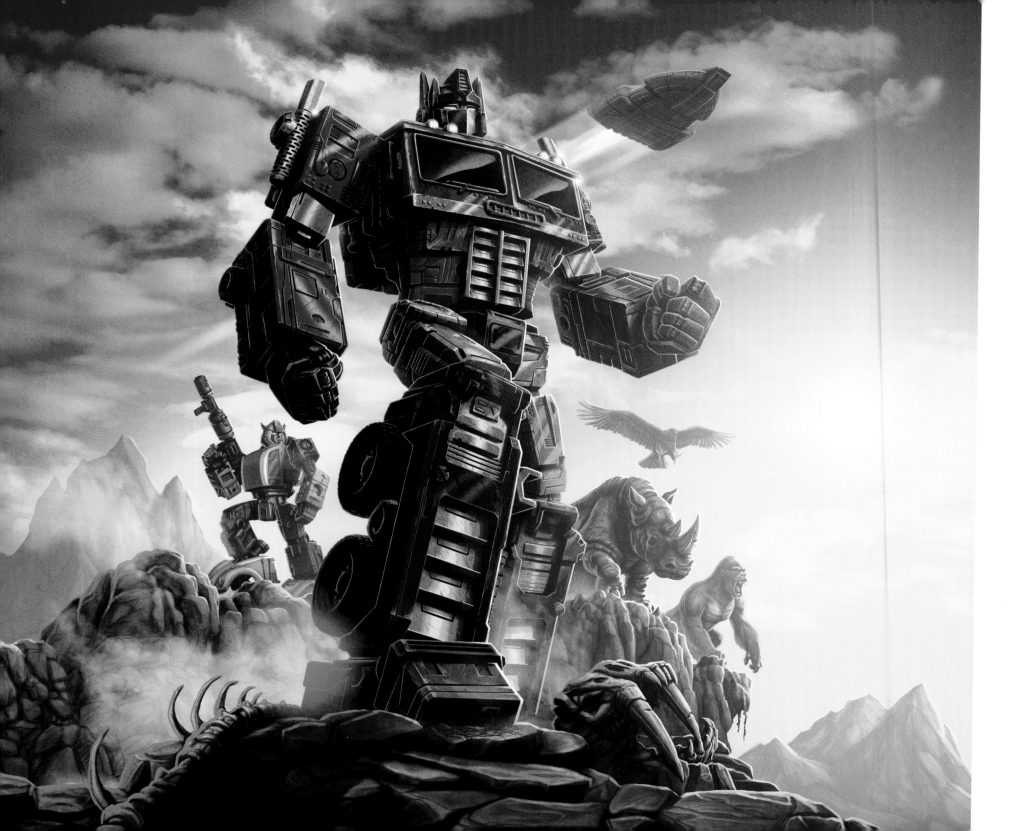

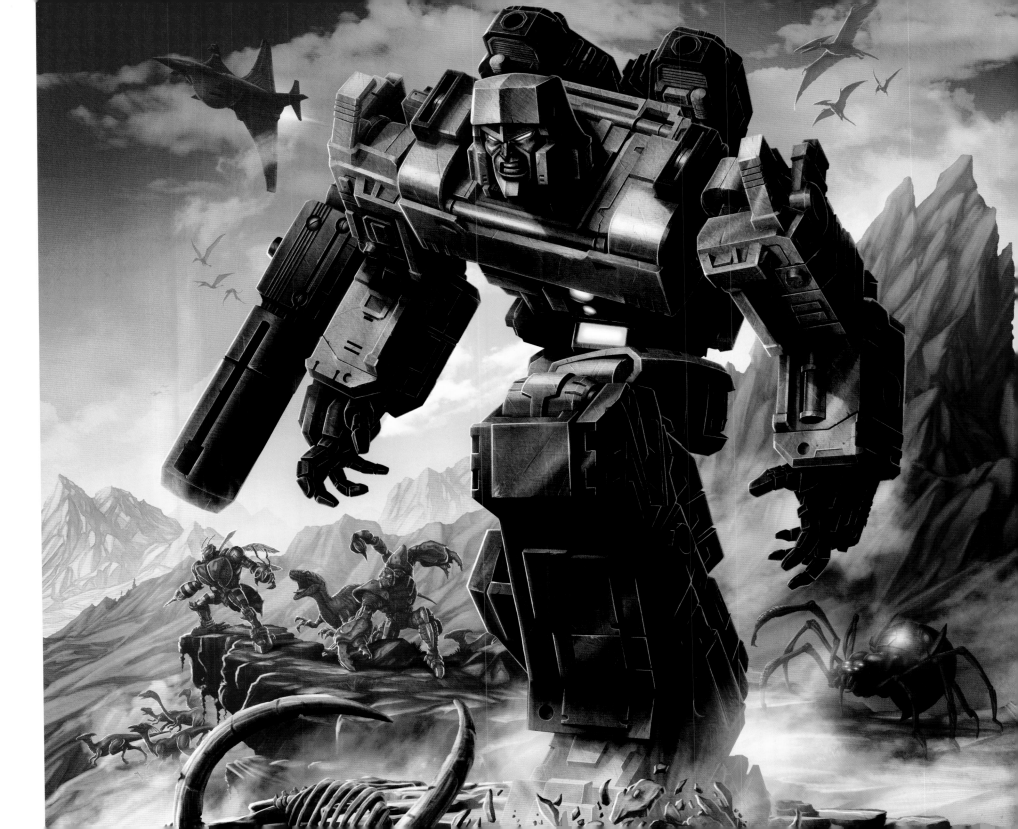

OPTIMUS PRIMAL

In the *War for Cybertron Trilogy* timeline, Optimus Primal is a battle-hardened leader of a depleted Maximal unit that is down to its final six survivors. When he converts into his gorilla beast mode, he is an immensely powerful and relentless fighter. His scimitars are his primary weapons when he is in bot form.

Much like his ancestor, he is bound by honor and loyalty and will not hesitate to sacrifice himself for his friends. He also respects opponents who fight with valor, a fact underscored when he bids a warrior's farewell to Dinobot after his heroic sacrifice.

He is initially suspicious of Optimus Prime, believing him to be Nemesis Prime. Eventually, Primal comes to view his Autobot ancestor with great respect. After passing through Dinobot's "spark ghost," he finally understands the AllSpark's importance and is convinced to help return it to Cybertron.

Despite the risks of returning to a Cybertron that is not the place of his birth, Primal tells Optimus that the journey is worth the risk.

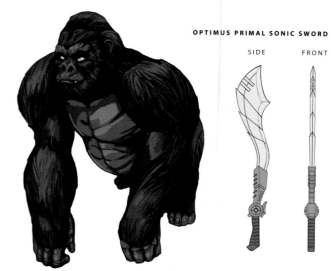

OPTIMUS PRIMAL SONIC SWORD

SIDE FRONT

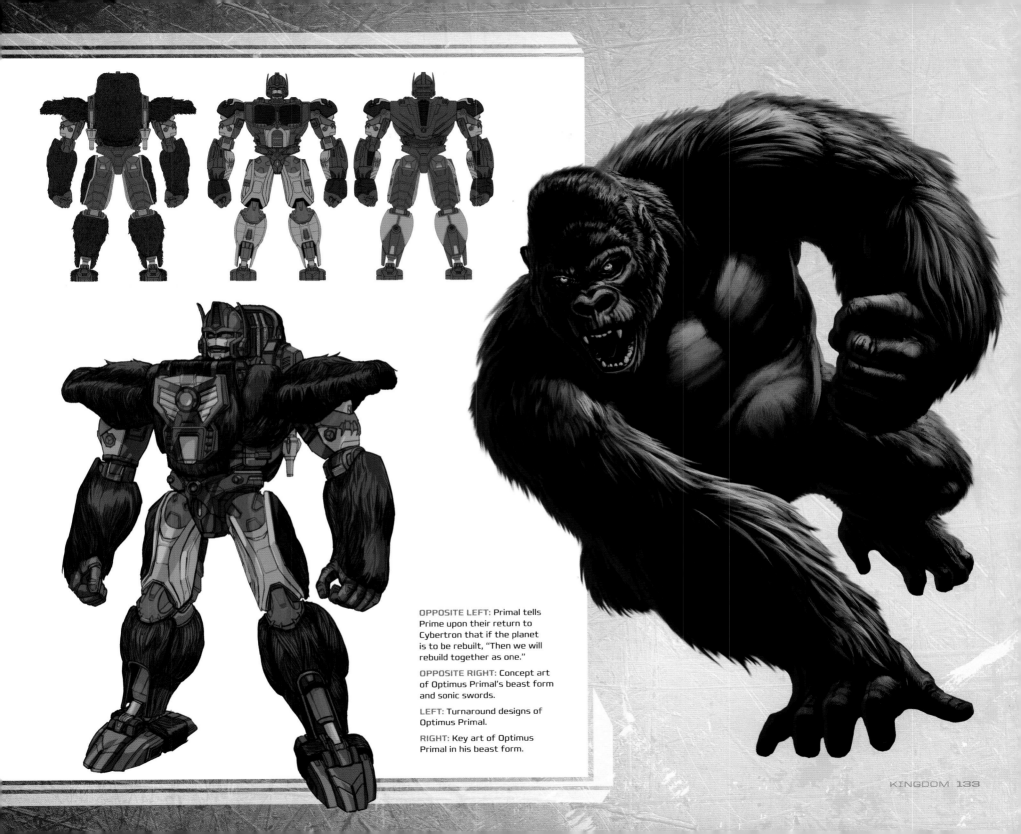

OPPOSITE LEFT: Primal tells Prime upon their return to Cybertron that if the planet is to be rebuilt, "Then we will rebuild together as one."

OPPOSITE RIGHT: Concept art of Optimus Primal's beast form and sonic swords.

LEFT: Turnaround designs of Optimus Primal.

RIGHT: Key art of Optimus Primal in his beast form.

AIRAZOR

Airazor provides ample bravery and a healthy dose of levity to the Maximals. Her alternate beast mode is a peregrine falcon, giving her the ability of flight. With her sharp vision, it makes her an essential recon and surveillance asset.

In *Kingdom*, Airazor acts as the Maximals' conscience. Her relationship with the Predacons' Blackarachnia provides one of the series' most fascinating subplots. The characters' antagonistic relationship evolves into a grudging respect and even a potential emotional attraction.

"I had an automatic affinity for Airazor back in *Beast Wars*, even if she wasn't in the show that often," says season 3 writer Mae Catt. "At the start of this show, I remember telling everyone that whatever we do, we have to make Airazor as cool as humanly possible because she deserves it. And that ended up coming into play with the interesting ways we connected her with Blackarachnia."

LEFT: Airazor feels especially close to Rhinox and Cheetor because they helped her get online after her stasis pod was damaged upon landing on Earth.

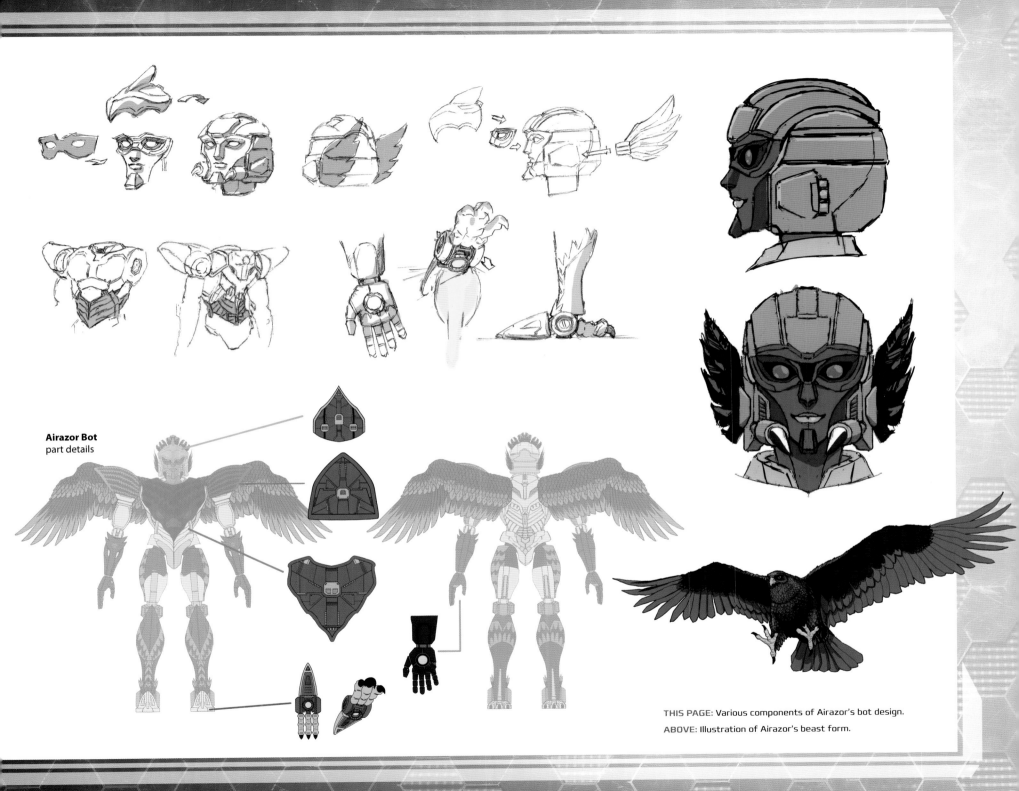

Airazor Bot
part details

THIS PAGE: Various components of Airazor's bot design.

ABOVE: Illustration of Airazor's beast form.

CHEETOR

The youngest member of the Maximals is exuberant and impulsive. He is the fastest Maximal on land, a reflection of the fact that his beast mode is that of a Cheetah.

The combination of inexperience and youthful overconfidence can land Cheetor in trouble, which is why Optimus Primal has made it his mission to watch over the young Maximal.

CHEETOR BOT
BEHIND FURS AND PLATE DESIGN

chest outer frontside chest outer back

chest middle frontside chest middle backside

FAR LEFT: Cheetor sees Optimus Primal as a role model, a responsibility the Maximals' leader takes very seriously.

LEFT and ABOVE: Concept art detailing Cheetor's construction.

RATTRAP

The diminutive Maximal Rattrap is a skilled stealth operative who is as savvy as he is sarcastic. Despite his small stature, he has the respect of the other Maximals, and he considers Rhinox his best friend.

In *Transformers* canon, the G1 Autobot Arcee is Rattrap's great-aunt. "One of my only regrets from working on *War for Cybertron Trilogy* is not figuring out some way to make a reference to their family connection," admits Catt.

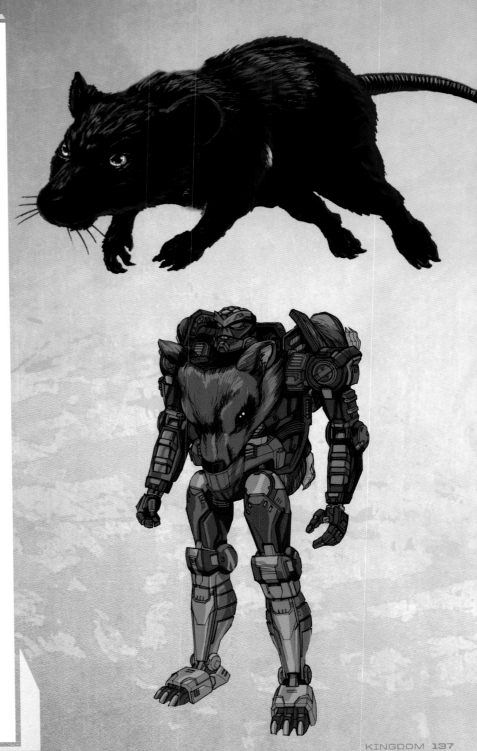

THIS PAGE:
Rattrap's beast mode suits his personality. While he can hold his own in a fight, he prefers to sneak around unseen.

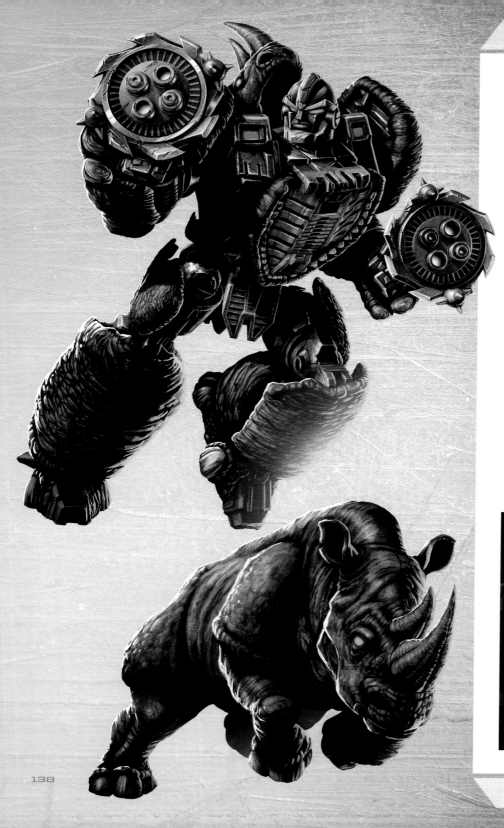

RHINOX

A well-balanced blend of brawn and brains, Rhinox is the Maximals' chief science officer. His technological genius is so vast that seeing him figure out the *Ark*'s controls rendered Wheeljack speechless.

When the situation calls for brute strength, Rhinox's beast mode as a rhino combined with his courage result in a physically imposing Maximal. In bot form, his triple-plated armored form and dual chain guns make him just as formidable.

THIS PAGE: Rhinox's twin chain guns enjoy near-legendary status with *Beast Wars* fans, who have nicknamed them the "chain guns of doom."

TIGATRON

Tigatron is the Maximals' recon expert when he is in his white tiger beast mode, as he can operate quickly and quietly in Earth's jungle terrain. While he is a capable fighter who won't hesitate to shift modes for battle, Tigatron has always lamented the cost of war. More animal than Transformer, he feels a connection to the Earth that none of the other Maximals have.

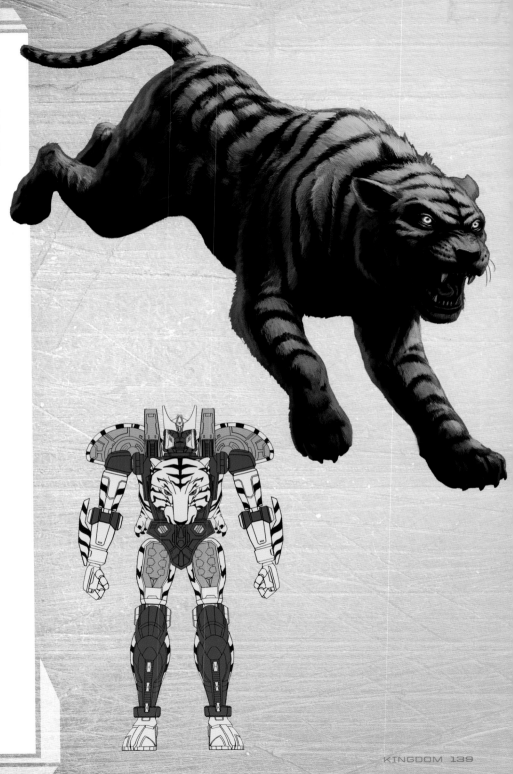

THIS PAGE: Tigatron's beast mode is well suited for prehistoric Earth.

BEAST MEGATRON

Beast Megatron leads the Predacons, but he is happy to cede authority to the G1 Megatron when the Autobots and Decepticons crash-land on prehistoric Earth. Beast Megatron idolizes his ancestor and works tirelessly to gain his approval. He is the alpha of the Predacons, especially when he shifts modes to a *Tyrannosaurus rex*.

Though he possesses the Golden Disk, he hands it over to G1 Megatron in order to prove his loyalty. Beast Megatron has deciphered parts of the Disk and learned that this particular place in time is where they would encounter G1 Megatron. He views his ancestor as the best chance to undo the damage done to their species and save the future.

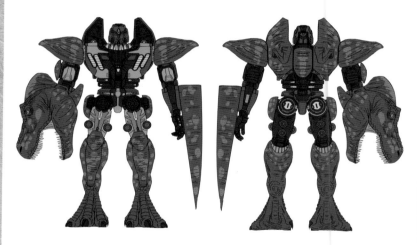

THIS PAGE: "I am the embodiment of Optimus Prime's failures. I am living proof that you were right all along."
— Beast Megatron

BLACKARACHNIA

Blackarachnia always looks out for herself, which is how she winds up in an alliance of convenience with Starscream. Both can barely suppress their resentment of their respective Megatrons, so they decide to unite and plot their own scheme to steal the Golden Disk.

The Predacon's beast mode is a black widow spider. Her eight legs, cunning, and ruthlessness are a dangerous combination. Her synthetic webbing is versatile enough to work as circuitry, which is how she is able to hack the Disk and access the memoirs of Megatron within it. As a master manipulator, she is able to trick Starscream into fighting Beast Megatron so she can siphon some of his Energon in order to access the Golden Disk.

Blackarachnia ultimately chooses to fight alongside the Maximals to help return the AllSpark to Cybertron. With Airazor guarding her blind side, she hacks into the *Nemesis*, disabling its weapons. Her valor almost ends in sacrifice when she is blown off the ship, but Airazor saves her. In that moment, Blackarachnia lets her defenses down and, with a gentle kiss, thanks Airazor for the rescue. Blackarachnia's flirtation has culminated in genuine affection for an adversary she not only admires but may even harbor stronger feelings for.

This moment signifies how far the character of Blackarachnia has come since her debut in the original *Beast Wars* series. "Through the lens of the 1990s, she was very progressive for the role she was fulfilling," says writer Mae Catt. "But the new version ended up being somebody who is incredibly powerful and knows it. She also came out extremely queer, which is quite an accomplishment, I would say."

THIS PAGE: Blackarachnia is a clever member of the Predacons. As she says to another member of her team, "Everything's a game, Dinobot. You just don't know how to play."

DINOBOT

Dinobot is the Predacon's elite operative. He excels in various forms of hand-to-hand combat. In beast mode, he is a velociraptor. Perhaps his best weapons are his warrior's mentality and his code of honor. When he comes to understand what the Megatrons intend to do with the AllSpark, he realizes he must do everything in his power to stop them.

Though Dinobot ultimately falls to the combined attacks of both Megatrons, he succeeds in wresting the Matrix of Leadership from the Decepticon leader. His selfless act helps keep the Autobots' hopes of saving Cybertron alive.

Dinobot's efforts to change the future continue beyond his death. It is his "spark ghost" that opens the eyes of his one-time enemy Optimus Primal and convinces him the AllSpark must be returned to Cybertron. When the Transformers unite on their home planet to fight off Galvatron and Nemesis Prime, Dinobot's "spark ghost" stands alongside the sparks of Elita-1 and Jetfire to help reignite the AllSpark and save Cybertron.

"I was excited to see the redemption story of Dinobot play out with a more contemporary tone," says senior brand manager Kelly Johnson. "With the current world temperature, I felt his arc would resonate well."

THIS PAGE: Dinobot's sacrifice in *Kingdom* is a key turning point in the search for the AllSpark. "I'm not pure-sparked, nor wise or heroic, but I've tried to live my life well," he says.

SCORPONOK

Scorponok is not the smartest of the Predacons, but he is fiercely loyal to Beast Megatron. Though he is considered Beast Megatron's second-in-command, he is insecure in his position and must assert himself to his teammates, who regard him with disdain.

THIS PAGE: Scorponok gets little respect from his fellow Predacons because of his low intelligence.

TELETRAAN I

Teletraan I is the sentient computer that operates the Autobots' Deep Space Interceptor, the *Ark*. When the Autobots are pinned down by Megatron and the *Nemesis* in the penultimate episode of *Kingdom*, the *Ark* shifts modes into a colossal "Ark bot" that cripples the Decepticons' ship.

Teletraan I glimpses possible futures while passing through the Dead Universe, including one reality where the *Ark* can convert. With this new knowledge, Teletraan I collects additional information and devotes resources to making the shift possible in its current timeline.

Longtime *Transformers* fans may notice a resemblance to another giant figure from the franchise's past: the godlike Transformer robot the Last Autobot, who appeared in the ongoing Marvel Comics series of the 1980s.

THESE PAGES: This concept art shows the *Ark* in both its ship and powerful bot form.

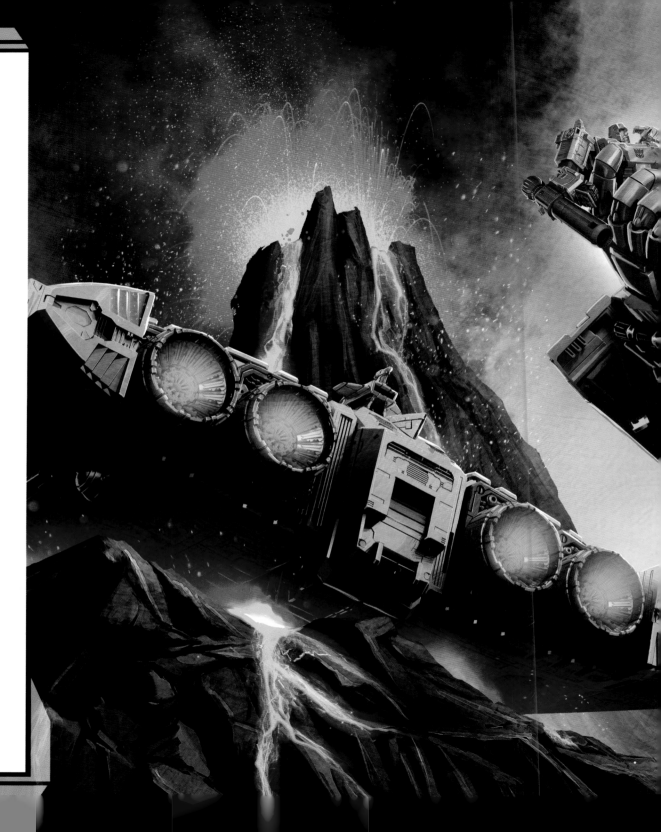

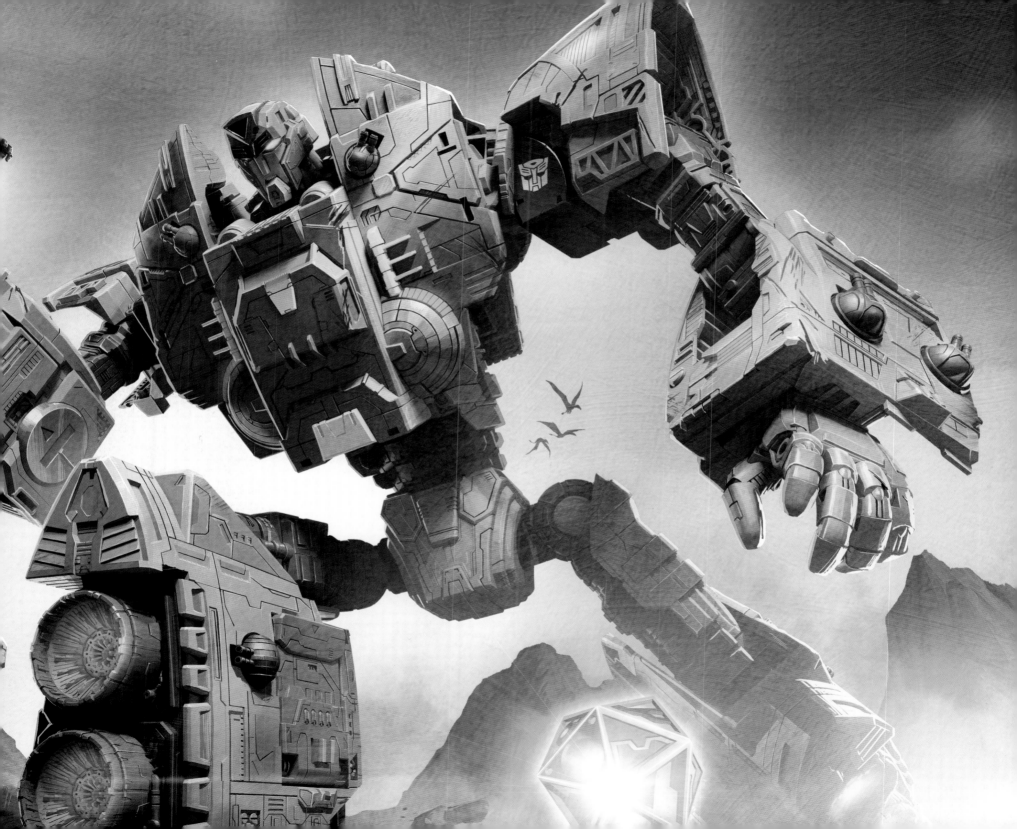

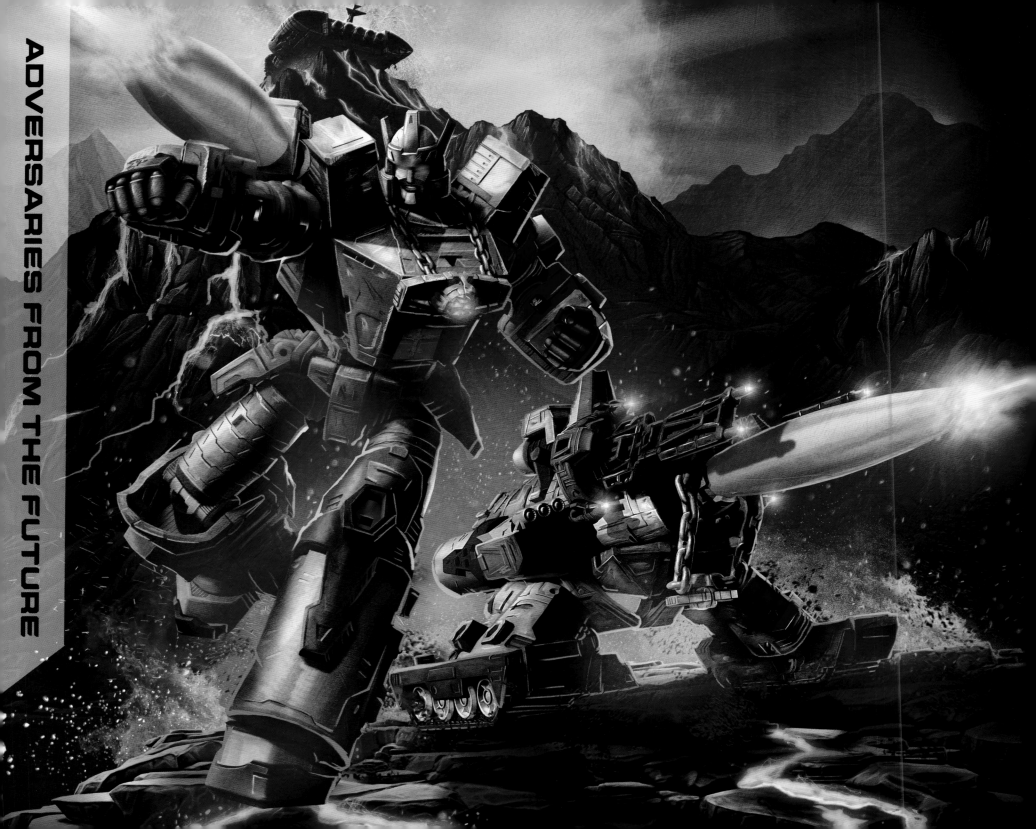

ADVERSARIES FROM THE FUTURE

GALVATRON

Galvatron is not only the evolutionary descendant of Megatron—he also exhibits his ancestor's arrogance and utter ruthlessness. As the keeper of the Golden Disk, he is driven to madness by the knowledge that he lives at the whim of Unicron. Ultimately, this madness is the reason he hatches a plan to travel back in time via the Dead Universe to convince Megatron to obtain the AllSpark so it can be used to kill Unicron.

In Galvatron's mind, setting Cybertron on a course for destruction is a price he'll gladly pay to be free from eternal servitude. "Galvatron is a tool of Unicron, and he can't stand it," says writer Tim Sheridan. "His entire plan is about going back to get Megatron to destroy Unicron so he won't have to be in his service anymore."

The producers and animators at Polygon were determined to hew as closely as possible to the G1 design of Galvatron, though that approach presented certain challenges. "Our original approach was to take the design of Megatron and the G1 version of Galvatron and blend them together," says art director Yoshimitsu Saito. "But when we did this, we noticed that Galvatron's silhouette is actually quite round, while Megatron's is blocky and angular. It was really difficult to maintain Megatron's elements in the Galvatron design, so we had to work really hard to make it [fit]."

OPPOSITE: Packaging art showing Galvatron in bot and vehicle mode.

THIS PAGE: Galvatron is a gifted manipulator, and he uses that ability to press the right buttons to get a suspicious Megatron to do his bidding.

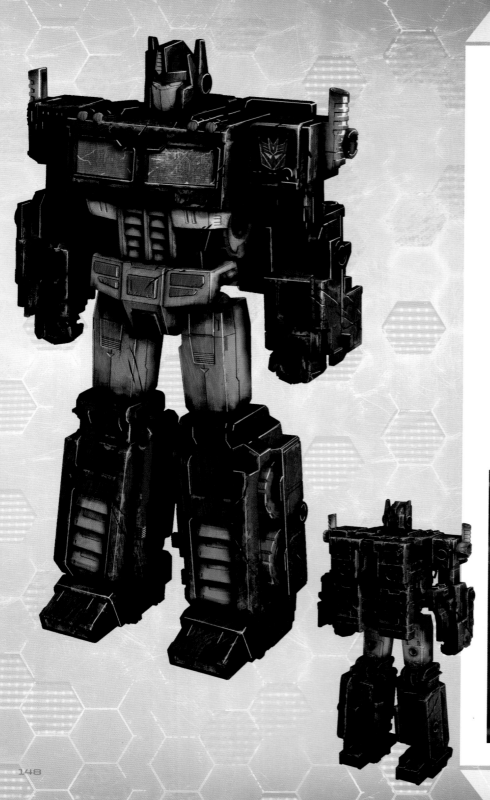

NEMESIS PRIME

According to the production team, Nemesis Prime—the evil and distorted version of Optimus Prime—came into existence as the result of an alternate timeline that resulted in a dystopian future. "The Nemesis Prime we designed has a background story where he fails in his mission to bring the AllSpark back and also loses Elita-1," says art director Yoshimitsu Saito.

"In our universe, when Optimus failed to bring the AllSpark back to Cybertron, the planet was ruined," said Matt Murray. "Nemesis Prime and Galvatron both emerged as a result and became the heralds of Unicron."

This villainous version of Prime was reformatted and enslaved by Unicron. Along with Galvatron, he has been a constant threat to the Maximals, which is why Optimus Primal calls Optimus Prime "Nemesis" during their first encounter.

His visual design reflects the apocalyptic future he came from and the violence he was surrounded by. "We also imagined him being in a lot of battles that our current Optimus wasn't," says Saito. "So we tried to add different types of damage to his body. Battle scars, if you will, that are different from the Optimus we have here."

Nemesis Prime conspired with his fellow herald Galvatron to travel through the Dead Universe to tamper with the past so that they could be free of a lifetime of servitude. It was seeing this distorted version of himself during his encounter with Sky Lynx that helped Optimus Prime reaffirm his mission to return the AllSpark to Cybertron.

THIS PAGE: As Optimus Prime's evil doppelganger, Nemesis Prime has an almost identical build and weapons system. However, he always uses his laser cannon on his right hand at full power, hoping to inflict maximum damage on his targets.

UNICRON

The planet-devouring menace of Unicron appears fleetingly in *War for Cybertron Trilogy*, but his presence looms large.

Unicron is a god of chaos, a towering presence in the *Transformers* mythology from his first appearance in the 1986 movie. He is a massive robot who can convert into a planet-sized entity and consume the energy of entire worlds. He is an immortal. Dark Energon is the lifeblood that runs through his robotic veins.

Galvatron and Nemesis Prime travel across time in hopes of manipulating Megatron into stealing the AllSpark, believing it can be used to kill Unicron.

The plan ultimately fails, but instead of killing his two heralds for their treachery, Unicron brings them back to life, only to reformat them. Their travels through the Dead Universe have given Unicron new ideas to further his plans for universal destruction.

Indeed, Unicron's final words in *War for Cybertron Trilogy*—"I shall begin again"—are meant to be a harbinger of what could come next. It took writer Tim Sheridan eleven rewrites to land on the appropriate coda for the series.

"The concept of reformatting Galvatron and Nemesis Prime was something that appealed to me because not only was it a reference to the stuff that I love from my childhood, but it also sets up the possibility for the future," said Sheridan. "What does Galvatron get reformatted into? I liked leaving that question lingering out there."

THIS PAGE: Unicron is the largest Transformer in existence. His only known weakness is the Matrix of Leadership.

LOCATIONS

EARTH

The arrival of the Transformer robots on prehistoric Earth signals the dawn of a new era. The jungle setting is meant to evoke a sense of minimalism when compared to the the vastness of space and the extensive ruins found on Cybertron, but there are several impressive set pieces that play important roles in the final chapter.

Before the production team could worry about the architecture, the animators took the same approach they did when constructing the look and feel of Cybertron: they put their imaginations to work envisioning what the ancient supercontinent of Pangea looked like. "Because it was taking place on a prehistoric Earth," says Polygon Pictures' Takashi Kamei, "we imagined all the land masses were still connected. There aren't too many big oceans in that prehistoric world."

OPPOSITE and ABOVE: The divergent timeline in *War for Cybertron Trilogy* brings the Autobots and Decepticons to prehistoric Earth instead of Portland, Oregon in 1984, as occurred in the G1 cartoon.

RIGHT: Preliminary digital art featuring Dinobot recovering after being knocked senseless when he, Starscream, and Blackarachnia got too close to the AllSpark's location.

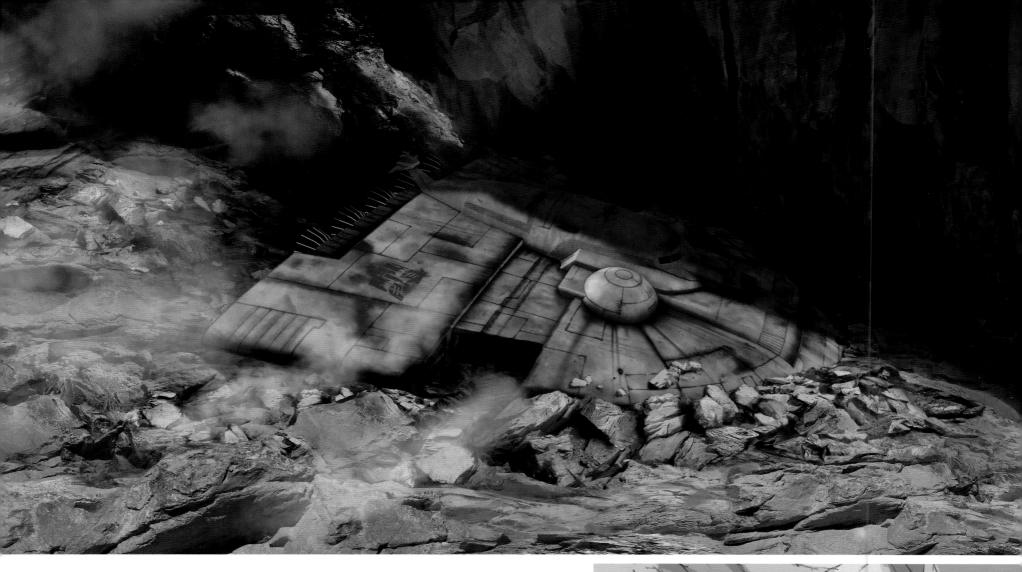

ARK CRASH SITE

To maintain a certain sense of continuity with the original *Transformers* series, the animators intended to have the *Ark* crash near what would become Portland, Oregon, in the distant future. That was where the original Transformers awoke from their four-million-year hibernation in G1.

Polygon's team instead decided to take a few liberties with locations and distance. "A lot of the action that happens with the AllSpark and the AllSpark Temple in *Kingdom* happens in Tibet," Kamei notes.

Other sequences with the Maximals and Predacons set in the forest are pinpointed in the area that would eventually be known as the Andean region of Ecuador, or the Highlands.

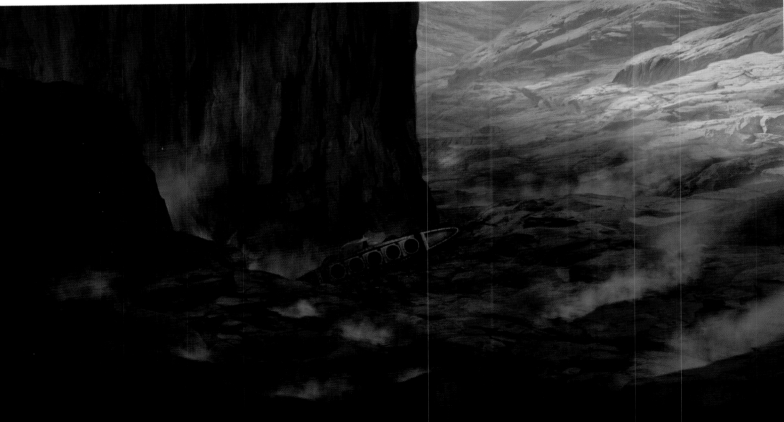

OPPOSITE PAGE and ABOVE: A finished image and initial sketches featuring Cheetor discovering the *Ark*.

LEFT: A matte background painting showing a different angle of the ship's volcanic crash site.

NEMESIS CRASH SITE

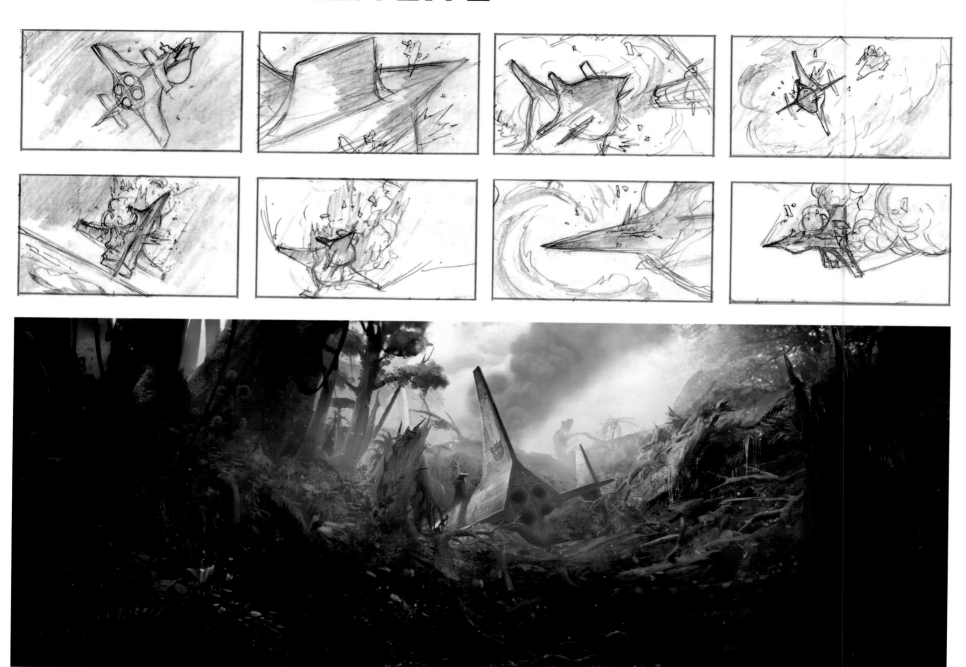

TOP: Storyboards depicting the firey descent of the *Nemesis* through Earth's atmosphere.

ABOVE: Concept painting of the Decepticon ship after it crash-landed in the jungles of the Ecuadorian Highlands.

ECUADORIAN HIGHLANDS

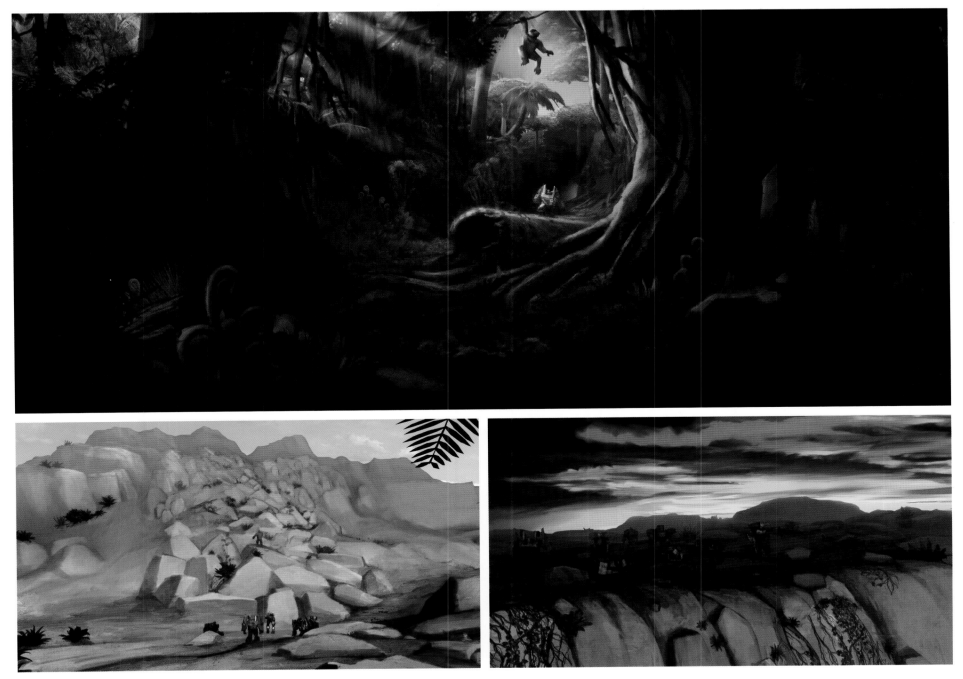

THIS PAGE: The varied locations of Earth provided designers a chance to create rich environments with diverse terrain that proved challenging for some Autobots to navigate.

TIBET

TOP and LEFT: Two production paintings with vastly different color palettes show Megatron's shuttle approaching the AllSpark Temple in the highlands of Tibet.

OPPOSITE: The distance from Portland, Oregon to Tibet is over 6,800 miles. However, the production team assumed the continents were connected as a single supercontinent in the time of *Kingdom*. This meant the characters had much less ground to cover to reach the AllSpark Temple.

THE ALLSPARK TEMPLE ON EARTH

Perhaps the most impressive designs in *Kingdom* are those of the AllSpark Temples on Earth and Cybertron. Both are cavernous structures that evoke strength and a sense of protection, almost like cocoons. The Temple on Cybertron—the site of the final showdown between the united Transformers bots against Galvatron and Nemesis Prime—resembles a citadel at the center of the wasteland that Cybertron has become. As snowstorms lash the dying planet, the return of the AllSpark to the Temple initiates a rejuvenation and rebirth of Cybertron that brings with it light, calm, and hope.

LEFT: Sketch of the final approved design for the AllSpark Temple on Earth.

TOP: The Matrix of Leadership returns to Optimus Prime as Optimus Primal stands by his side within the temple.

OPPOSITE: Concept art featuring Optimus Prime and Megatron having their final confrontation at the steps of the altar inside the AllSpark Temple.

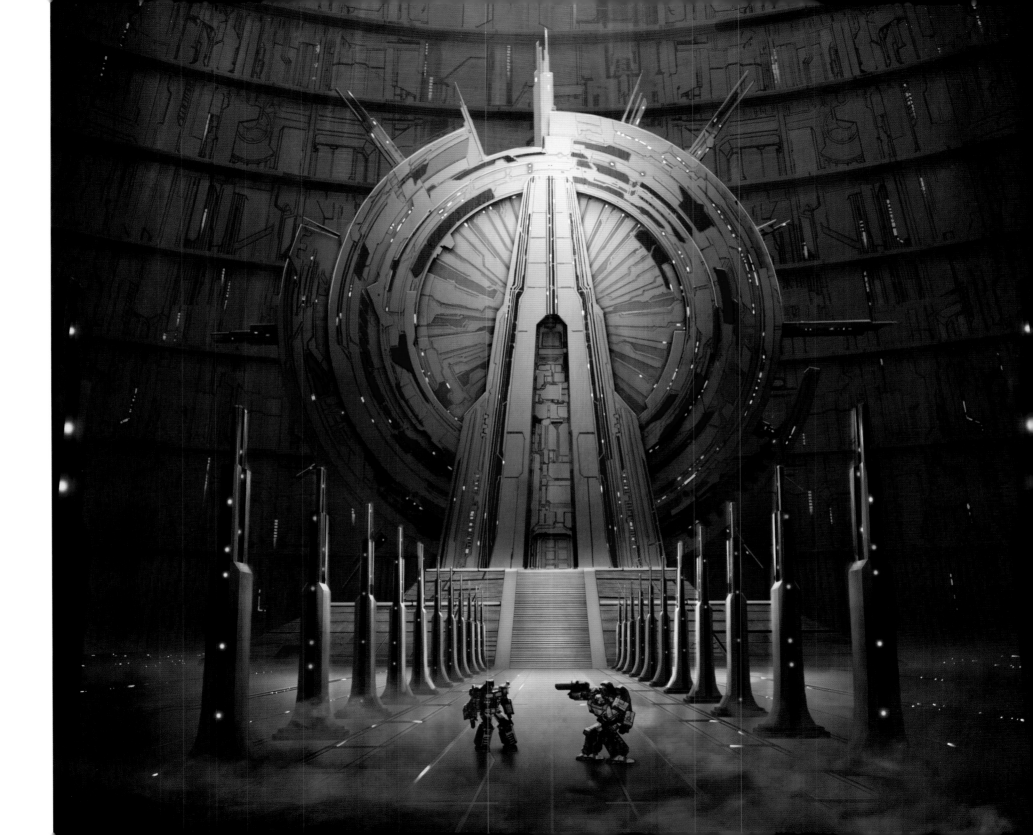

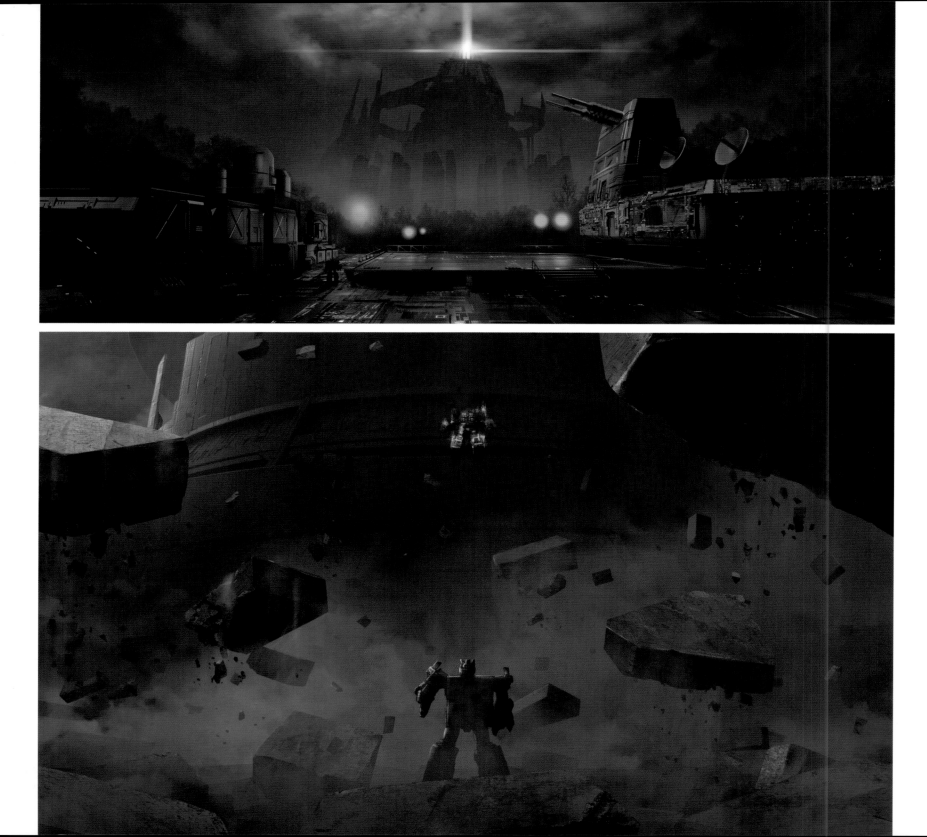

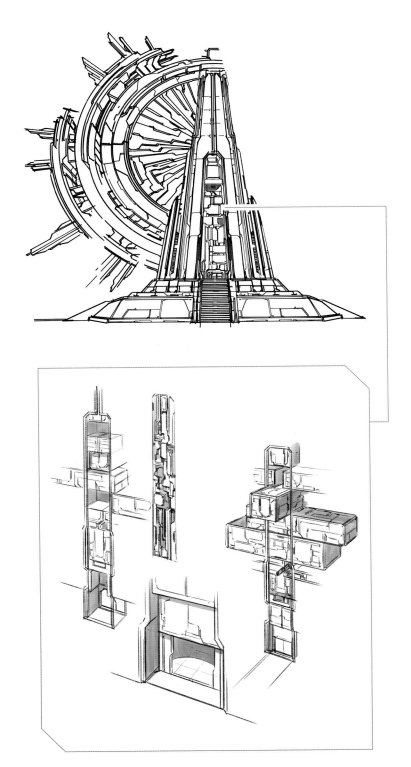

OPPOSITE TOP: The exterior of the Tibetan AllSpark Temple.

OPPOSITE BOTTOM: Early production rendering of the AllSpark (taking the form of Ultra Magnus) communicating with Optimus Prime outside the temple.

ABOVE: A sketch of the temple's interior structure.

RIGHT: Sketches show the increased detail that went into the design of the temple through the production process.

VOLCANO

LEFT: Production painting depicting the moment in *Kingdom* when Starscream confronts Megatron on the *Nemesis* and tells him the truth about Galvatron's true plan.

ABOVE: A detailed sketch presented in comic form depicting the showdown between the *Ark* bot and the *Nemesis*.

OPPOSITE TOP: When creating the scene of the *Nemesis* attacking the *Ark*—still in vehicle mode—the designers had to meticulously lay out the flowing lava and collapsing rock.

OPPOSITE BOTTOM: Concept art of the *Ark* bot grabbing the *Nemesis* inside the volcano.

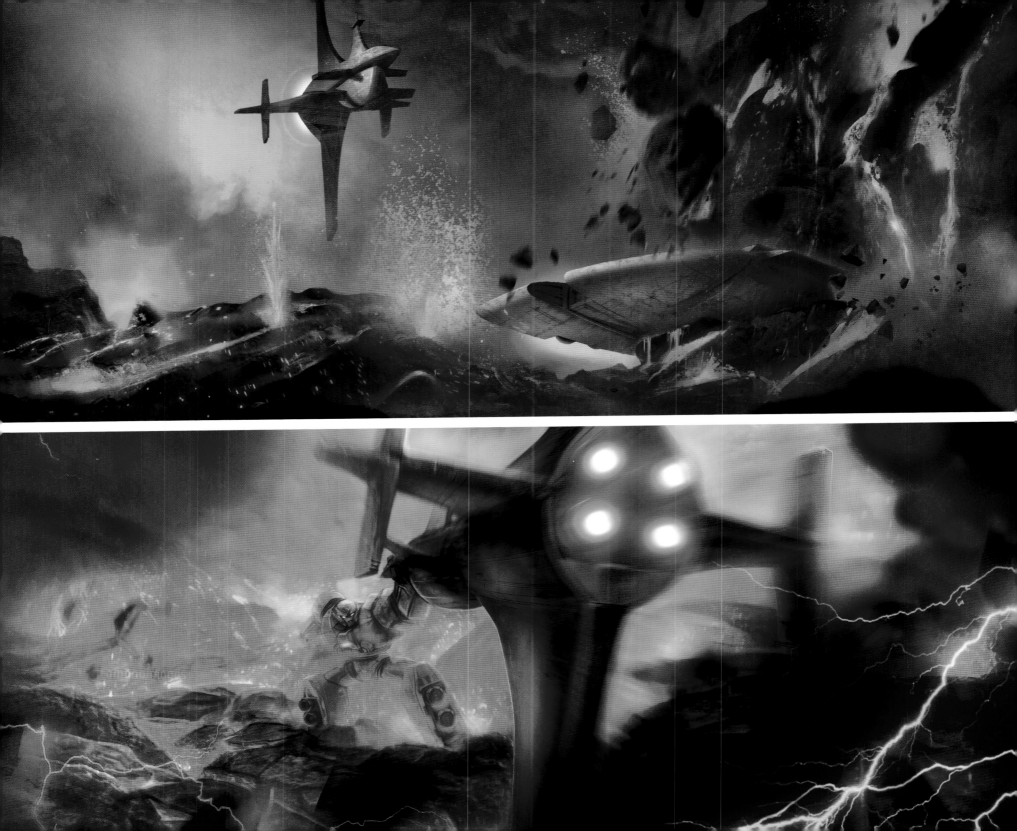

THE ALLSPARK TEMPLE ON CYBERTRON

OPPOSITE: With its gothic features, the ancient AllSpark Temple resembles a cathedral more than the monastary-like temple on prehistoric earth.

TOP: Early concept art of Bumblebee at the entrance to the AllSpark Temple on Cybertron.

BOTTOM LEFT: Color-study art showing Megatron and Optimus Prime watching as the AllSpark ghosts join the fight against Galvatron and Nemesis Prime.

BOTTOM RIGHT: An Initial sketch of the entrance to the temple.

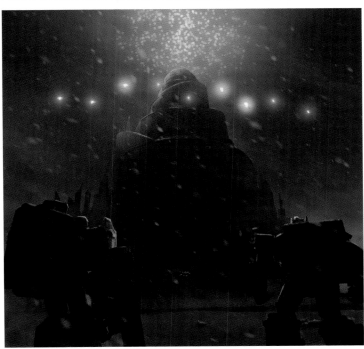

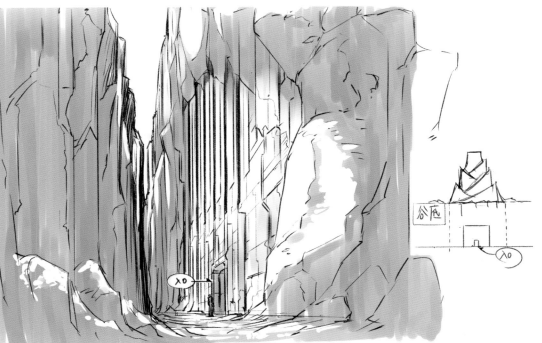

MEMORIAL SITE

TOP LEFT and RIGHT: With the war over, Optimus Prime and Megatron lead their factions to the now-sacred ground where the Kaon Arena once stood.

BELOW and OPPOSITE: Concept art of the crystal monument at the former site of Kaon Arena, which depicts an Autobot and a Decepticon standing back-to-back.

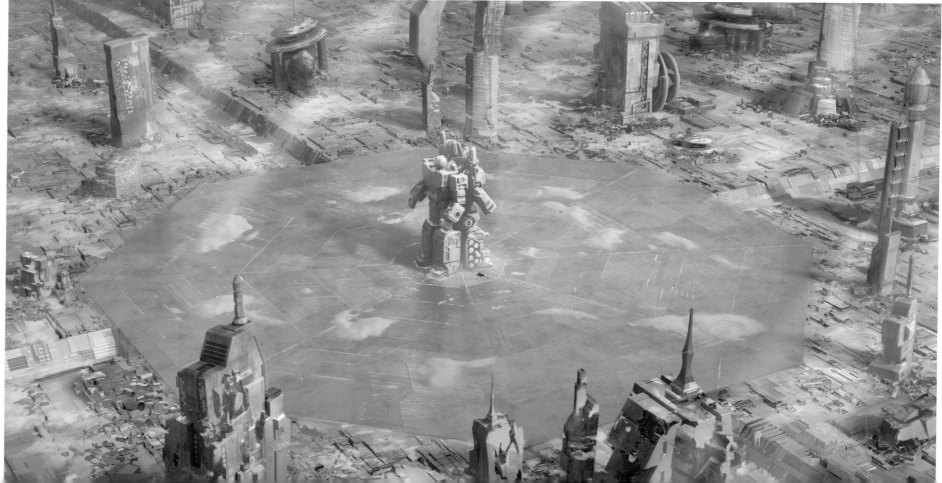

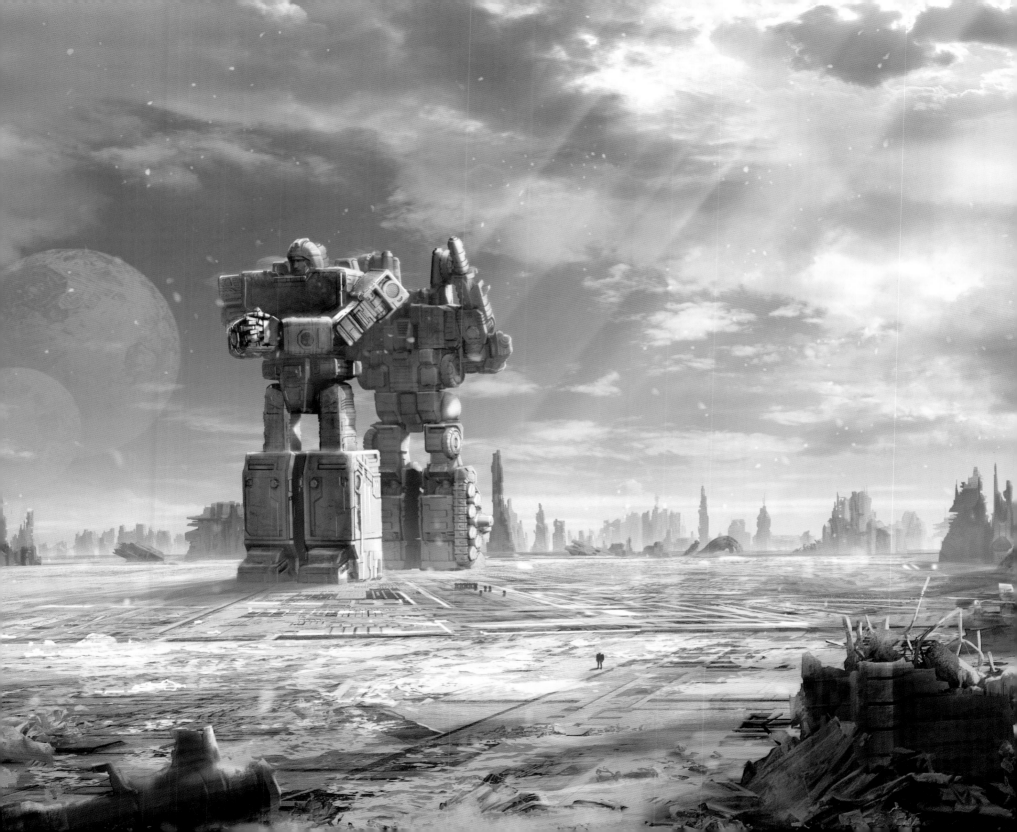

WORLDBUILDING

reating the universe in which *War for Cybertron Trilogy* takes place was a daunting challenge. *Transformers* mythology is deep and dense, but there was much about the Cybertronian civil war that had never been described before, nor had the Transformers character's arrival on Earth been fully explored previously. The producers were encouraged to take advantage of these opportunities.

"With such a timeless history of good versus evil on a cataclysmic scale, there is room for each unique POV to be explored," says Kelly Johnson, *Transformers*' senior brand manager. "So long as we don't contradict the iconic and established history that we consider official canon."

The production team knew lighting would be essential for capturing the separate moods of each chapter. "In terms of the lighting and color palette, we had different ideas for all three chapters," says DeSanto. "Because of the very intense battle occurring on Cybertron and [because] people are dying, as the episodes progress in the first season, the colors get more and more harsh, darker."

Kamei notes, "If you take a look at each six-episode chapter, they each have a distinctive color palette."

As dark as *Siege* got at certain points thematically, it was important to signal that hope remained. That was the key role the color palette used by Polygon played. "Even in *Siege*, which is the darkest chapter, we always had the intention that every shot would have some splash of color in it," DeSanto says. "If you go back and look, no matter how dark and dreary [a scene is], there's usually some primary color poking through it."

The scope was captured with CG set pieces like the Arena. The atmosphere was built by the incredible

OPPOSITE: Iterations for the primary *Siege* promotional poster.

THIS PAGE: Various color-study images from across the series, showing the show's varied palettes.

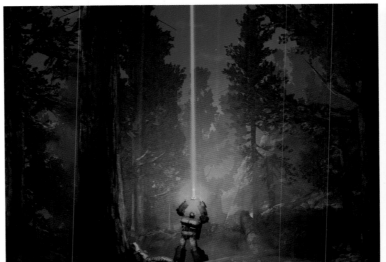

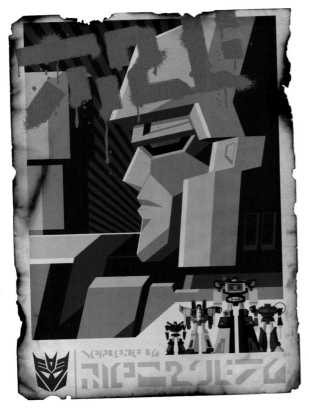

attention to detail put forth by Polygon Pictures' animators. The wreckage suggesting a once-thriving metropolis and the brief bits of dialogue hinting at the culture that once existed offer a vision of the Cybertron that once was.

"The biggest thing that I wanted to make sure of was that it was lived in," says supervising producer Matt Murray. "There was a very conscious decision to make sure that Cybertron felt like these characters had lived here."

Eagle-eyed viewers with a 4K television may be rewarded with brief glimpses at the attention to detail Polygon's designers put into the background of the first chapter. They used the Cybertronian alphabet to create propaganda posters that line the walls of what remains on Cybertron.

"We created a lot of propaganda posters on the walls of certain locations on Cybertron that try to recruit people to join either the Autobot cause or the Decepticons'," says Yoshimitsu Saito. "We also included a lot of Cybertronian graffiti in the background that we adapted from the Cybertronian alphabet."

Saito says his team relished the opportunity to create these posters, even though they were not the primary focus of the setting. "When we got to the actual lighting and animation phases of production, we used a lot of smoke to capture the warlike environment in *Siege* and made the lighting quite dark," he says. "So the smoke and darkness obscured many of the posters. But if you look carefully, you'll see some of the posters in the background of episodes."

TOP: An early production image showing the propaganda posters created for *Siege* visible in a scene.

ABOVE: The propaganda posters featured elements like tears and burn marks to match the environment of Cybertron.

OPPOSITE: Propaganda poster designs.

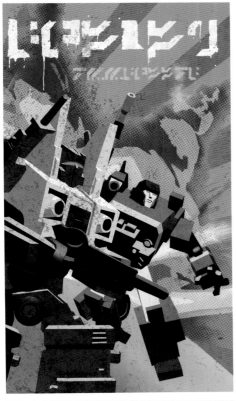

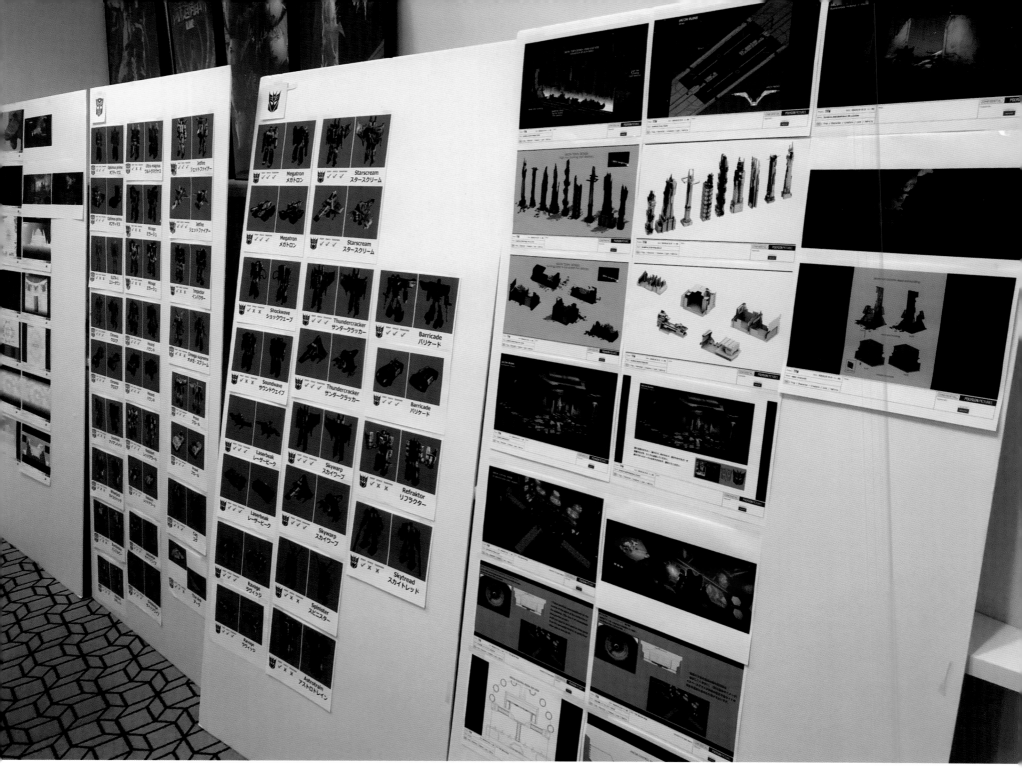

ANIMATION

The animators at Polygon Pictures were given wide latitude to flex their creative muscles. "When I saw the comments on storyboards for the first episode, I knew we were set. The Polygon team was elevating everything on the page," said F.J. DeSanto.

The storyboard process was aided by one helpful workaround DeSanto and his LA-based team came up with. "We did the voices early in the production process and got the voice tracks to Polygon really quickly," he says. "That allowed the team in Japan to incorporate those voices as opposed to doing scratch vocal tracks [when dialogue is read by random people just to help build the animatics]. That saved a lot of time and effort and helped them to understand the director's intentions.

"From there, we would see the animatics and give our notes based on that and send them to Hasbro and Netflix to get their input," DeSanto adds. "That allowed the Polygon animators to work off just one larger set of notes from everyone. That saved months of time during production. I think [supervising director Takashi] Kamei-san appreciated that he didn't have to deal with constant revisions or constant questions as he went through the storyboards."

The trust between the Los Angeles–based writing and producing team and the animation unit in Japan became essential during the making of *Earthrise*, because that's when COVID-19 spread worldwide and forced much of the world into lockdown.

"Thankfully, we already had a really good working relationship with Polygon and were already doing lots of video calls with them," notes Matt Murray. "We also had gone through postproduction in person with Technicolor for season one, so in many ways, we had the tone of the show set well before COVID took hold."

Social distancing rules meant strict limits on how many people could be in a room, which meant a production aspect like sound mixing moved from a recording studio to a video conferencing session. For the animators in Japan, keeping the trains running on time on *War for Cybertron Trilogy* meant quickly adjusting to work-from-home procedures.

"We adapted as quickly as we could and set up remote work. We got things up and running for our team," says executive producer Jack Liang. "Obviously, it took a while to adjust and fine-tune the technology side of things, but whatever impact there was to the workflow could have been a lot worse. We're very proud with how we adapted during that period."

OPPOSITE: Character art and designs filled the Polygon Pictures offices in Japan.

TOP LEFT: The production offices in Burbank, California.

TOP RIGHT: This propaganda portrait was drawn by supervising director Takeshi Kamei. It is displayed in the Arena conference room and was designed to accentuate Megatron's strength.

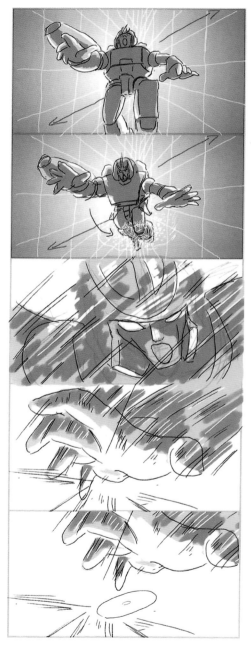

LEFT: Storyboard featuring Galvatron showing the Golden Disk to Megatron in the penultimate episode of *Earthrise*.

TOP and ABOVE: Composer Alexander Bornstein knew how he wanted to score the moment in *Earthrise* when we first encounter Unicron: "I really wanted to make his appearance this very unsettling, uncertain event, and it was a good opportunity to introduce that theme there."

MUSIC

The music of *War for Cybertron Trilogy* was designed to underscore the different themes across each season. "I basically did a theme for the Autobots, the Decepticons, and also for Cybertron itself," recalls composer Alexander Bornstein. "A big goal for us was to give every chapter of the trilogy a different sound that would help us establish this core identity for the main story arc."

For *Siege*, Bornstein relied on a combination of orchestral arrangements and synthesizers to achieve the aggressive futuristic sound that echoes the scores of science-fiction films such as *Blade Runner* and *Tron: Legacy*. "I was definitely looking at darker stuff from composers like Jerry Goldsmith and Alan Silvestri for *Siege*," says the composer, who wrote the music based on initial concept art and early animatics. "We also used a lot of what F.J. DeSanto called militaristic percussion to capture some of the aggression and the war elements of that season."

The music reflected the mood of the devastated planet. "There is barely any major key writing in *Siege*," he says. "I think the only time you really hear any [music in a] major key [that season] is when the Cybertron theme appears." Major keys typically denote positive emotions. Given the bleak atmosphere the Autobots find themselves in during the first chapter, a melancholy score seemed appropriate.

Bornstein utilized an increasing amount of orchestral texture during *Earthrise* to portray the gradual shift in tone. The composer says one of his favorite moments working on the series was planting a sliver of Unicron's theme in episode 5 of the second season. "I used this instrument called the 'PIPE,' which is an electronic vocal processing instrument," says Bornstein, who has been a *Transformers* fan since childhood. "I really went all out on this tease of Unicron that you get when they encounter Galvatron in the Dead Universe."

Perhaps the biggest challenge was scoring the final season and the reintroduction of the Maximals and Predacons. "It was intimidating to find a way to keep it interesting and kind of reinvent the sound of the show while also not getting too far away from what we'd already done," Bornstein admits.

MAPS

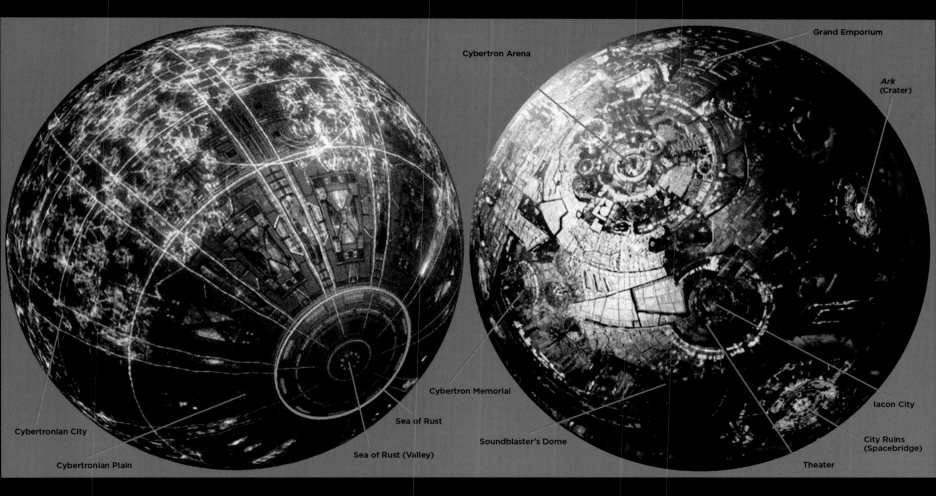

Cybertron Arena

Grand Emporium

Ark
(Crater)

Cybertron Memorial

Sea of Rust

Iacon City

Cybertronian City

Soundblaster's Dome

City Ruins
(Spacebridge)

Cybertronian Plain

Sea of Rust (Valley)

Theater

THIS PAGE: The map of Cybertron shows the placements of key
locations in *War for Cybertron Trilogy*, such as the Sea of Rust. The

ABOVE: An interstellar map showing the worlds traversed by the Autobots and Decepticons during *War for Cybertron Trilogy*.

Antilla **Nebulos** **Paradron** **Junkion** **Aquatron** **Dominus** **Cybertron**

Chaar **Quintessa** **Botropolis** **Nebulon** **Caminus** **Alpha Centauri**

Dead Universe **Earth** **Velocitron** **Biosfera** **Micron** **Gigantion** **Unicron**

THIS PAGE: During their space-spanning, galaxy-hopping adventure, the Transformers robots visit or encounter some of the following planets or their denizens.

WORLDBUILD

NAME: BIG SHOT
FACTION: AUTOBOT
DIVISION: GROUND COMMAND
UNIT: WEAPONS
RANK: PRIVATE

NAME: CHROMIA
FACTION: AUTOBOT
DIVISION: GROUND COMMAND
UNIT: SPECIAL OPS
RANK: SERGEANT

NAME: COG
FACTION: AUTOBOT
DIVISION: GROUND COMMAND
UNIT: WEAPONS
RANK: SERGEANT

NAME: FIREDRIVE
FACTION: AUTOBOT
DIVISION: GROUND COMMAND
UNIT: WEAPONS
RANK: PRIVATE

NAME: FIRESHOT
FACTION: AUTOBOT
DIVISION: GROUND COMMAND
UNIT: INFANTRY
RANK: PRIVATE

NAME: HIGHJUMP
FACTION: AUTOBOT
DIVISION: GROUND COMMAND
UNIT: SPECIAL OPS
RANK: PRIVATE

NAME: HOUND
FACTION: AUTOBOT
DIVISION: GROUND COMMAND
UNIT: INFANTRY
RANK: SERGEANT

NAME: IMPACTOR
FACTION: AUTOBOT
DIVISION: GROUND COMMAND
UNIT: SPECIAL OPS
RANK: CAPTAIN

NAME: IRONHIDE
FACTION: AUTOBOT
DIVISION: GROUND COMMAND
UNIT: INFANTRY
RANK: CAPTAIN

NAME: JETFIRE
FACTION: AUTOBOT
DIVISION: AIR COMMAND
UNIT: ENGINEERING
RANK: CAPTAIN

NAME: LIONIZER
FACTION: AUTOBOT
DIVISION: GROUND COMMAND
UNIT: WEAPONS
RANK: PRIVATE

NAME: MIRAGE
FACTION: AUTOBOT
DIVISION: GROUND COMMAND
UNIT: SPECIAL OPS
RANK: SERGEANT

NAME: OMEGA SUPREME
FACTION: AUTOBOT
DIVISION: SPACE COMMAND
UNIT: TRANSPORT
RANK: CAPTAIN

NAME: OPTIMUS PRIME
FACTION: AUTOBOT
DIVISION: GROUND COMMAND
UNIT: INFANTRY
RANK: GENERAL

NAME: OPTIMUS PRIME (GALAXY UPGRADE)
FACTION: AUTOBOT
DIVISION: SPACE COMMAND
UNIT: SPECIAL OPS
RANK: GENERAL

NAME: POWERTRAIN
FACTION: AUTOBOT
DIVISION: GROUND COMMAND
UNIT: SPECIAL OPS
RANK: PRIVATE

NAME: PROWL
FACTION: AUTOBOT
DIVISION: GROUND COMMAND
UNIT: INFANTRY
RANK: MAJOR

NAME: RED ALERT
FACTION: AUTOBOT
DIVISION: GROUND COMMAND
UNIT: MEDICAL
RANK: PRIVATE

NAME: ROADHANDLER
FACTION: AUTOBOT
DIVISION: GROUND COMMAND
UNIT: INTELLIGENCE
RANK: PRIVATE

NAME: SIDESWIPE
FACTION: AUTOBOT
DIVISION: GROUND COMMAND
UNIT: INFANTRY
RANK: PRIVATE

NAME: SIXGUN
FACTION: AUTOBOT
DIVISION: GROUND COMMAND
UNIT: INFANTRY
RANK: SERGEANT

NAME: SLAMDANCE
FACTION: AUTOBOT
DIVISION: GROUND COMMAND
UNIT: INTELLIGENCE
RANK: PRIVATE

NAME: SPRINGER
FACTION: AUTOBOT
DIVISION: AIR COMMAND
UNIT: SPECIAL OPS
RANK: SERGEANT

NAME: STAKEOUT
FACTION: AUTOBOT
DIVISION: GROUND COMMAND
UNIT: INFANTRY
RANK: PRIVATE

NAME: SWINDLER
FACTION: AUTOBOT
DIVISION: GROUND COMMAND
UNIT: INTELLIGENCE
RANK: PRIVATE

NAME: ULTRA MAGNUS
FACTION: AUTOBOT
DIVISION: GROUND COMMAND
UNIT: INFANTRY
RANK: MAJOR

NAME: AIMLESS
FACTION: DECEPTICON
DIVISION: AIR FORCE
UNIT: WEAPONS
RANK: PRIVATE

NAME: BARRICADE
FACTION: DECEPTICON
DIVISION: GROUND FORCE
UNIT: INFANTRY
RANK: SERGEANT

NAME: BLACKJACK
FACTION: DECEPTICON
DIVISION: GROUND FORCE
UNIT: INFANTRY
RANK: PRIVATE

NAME: BLOWPIPE
FACTION: DECEPTICON
DIVISION: AIR FORCE
UNIT: WEAPONS
RANK: PRIVATE

NAME: BRUNT
FACTION: DECEPTICON
DIVISION: GROUND FORCE
UNIT: WEAPONS
RANK: PRIVATE

NAME: CALIBURST
FACTION: DECEPTICON
DIVISION: AIR FORCE
UNIT: WEAPONS
RANK: PRIVATE

NAME: FLYSPY
FACTION: DECEPTICON
DIVISION: AIR FORCE
UNIT: INFANTRY
RANK: PRIVATE

NAME: HYPERDRIVE
FACTION: DECEPTICON
DIVISION: GROUND FORCE
UNIT: INFANTRY
RANK: PRIVATE

NAME: LASERBEAK
FACTION: DECEPTICON
DIVISION: GROUND FORCE
UNIT: ESPIONAGE
RANK: PRIVATE

NAME: MEGATRON
FACTION: DECEPTICON
DIVISION: GROUND FORCE
UNIT: INFANTRY
RANK: GENERAL

NAME: RAVAGE
FACTION: DECEPTICON
DIVISION: GROUND FORCE
UNIT: ESPIONAGE
RANK: PRIVATE

NAME: SHOCKWAVE
FACTION: DECEPTICON
DIVISION: SPACE FORCE
UNIT: APPLIED SCIENCES
RANK: MAJOR

NAME: SKYWARP
FACTION: DECEPTICON
DIVISION: AIR FORCE
UNIT: INFANTRY
RANK: PRIVATE

NAME: SOUNDWAVE
FACTION: DECEPTICON
DIVISION: GROUND FORCE
UNIT: ESPIONAGE
RANK: MAJOR

NAME: STARSCREAM
FACTION: DECEPTICON
DIVISION: AIR FORCE
UNIT: INFANTRY
RANK: CAPTAIN

NAME: STORM CLOUD
FACTION: DECEPTICON
DIVISION: AIR FORCE
UNIT: INFANTRY
RANK: PRIVATE

NAME: THUNDERCRACKER
FACTION: DECEPTICON
DIVISION: AIR FORCE
UNIT: INFANTRY
RANK: SERGEANT

THESE PAGES and PAGE 184: The military insignias for the Autobots and Decepticons. For the Autobots, the central component denotes their division, the top element identifies their unit, and the lower right component shows their rank. The Decepticons' division is represented by the circular design in the center, their unit is displayed in the center of the circle, and their rank appears at the bottom of the insignia.

AUTOBOT MILITARY INSIGNIA SYSTEM

DIVISION

GROUND COMMAND

SEA COMMAND

AIR COMMAND

SPACE COMMAND

UNIT

SPECIAL OPS

MEDICAL

INFANTRY

ARTILLERY

INTELLIGENCE

TRANSPORT

ENGINEERING

RANK

PRIVATE

SPECIALIST

SERGEANT

CAPTAIN

MAJOR

GENERAL

DECEPTICON MILITARY INSIGNIA SYSTEM

DIVISION

GROUND FORCE

SEA FORCE

AIR FORCE

SPACE FORCE

UNIT

BLACK OPS

MEDICAL

INFANTRY

WEAPONS

ESPIONAGE

TRANSPORT

APPLIED SCIENCES

RANK

RAIDER

CORPORAL

SERGEANT

CAPTAIN

MAJOR

GENERAL

TRANSFORMERS TIMELINE

CYBERTRON WAR OF THE PRIMES

13.5-1.4 BILLION YEARS AGO

CYBERTRONIAN GOLDEN AGE

250 MILLION YEARS AGO

CYBERTRONIAN CIVIL WAR

200.4 MILLION YEARS AGO

TRANSFORMERS ROBOTS LAUNCH ALLSPARK AND LEAVE CYBERTRON (EXODUS)

200.008 MILLION YEARS AGO

ALLSPARK TRAVELS TO EARTH VIA SPACE BRIDGE

TRANSFORMERS BOTS TRAVEL THOUGH TIME AND SPACE VIA DEAD UNIVERSE

BEAST TRANSFORMERS BOTS LAND ON EARTH (NEW TIMELINE CREATED)

170 MILLION YEARS AGO (PRE ICE AGE EARTH)

NEW TIMELINE

BEAST TRANSFORMERS BOTS TRAVEL THROUGH TIME AND SPACE VIA A PORTAL IN SPACE

MODERN DAY EARTH

1984-2022

FUTURE CYBERTRON

-7000 AD

ORIGINAL TIMELINE

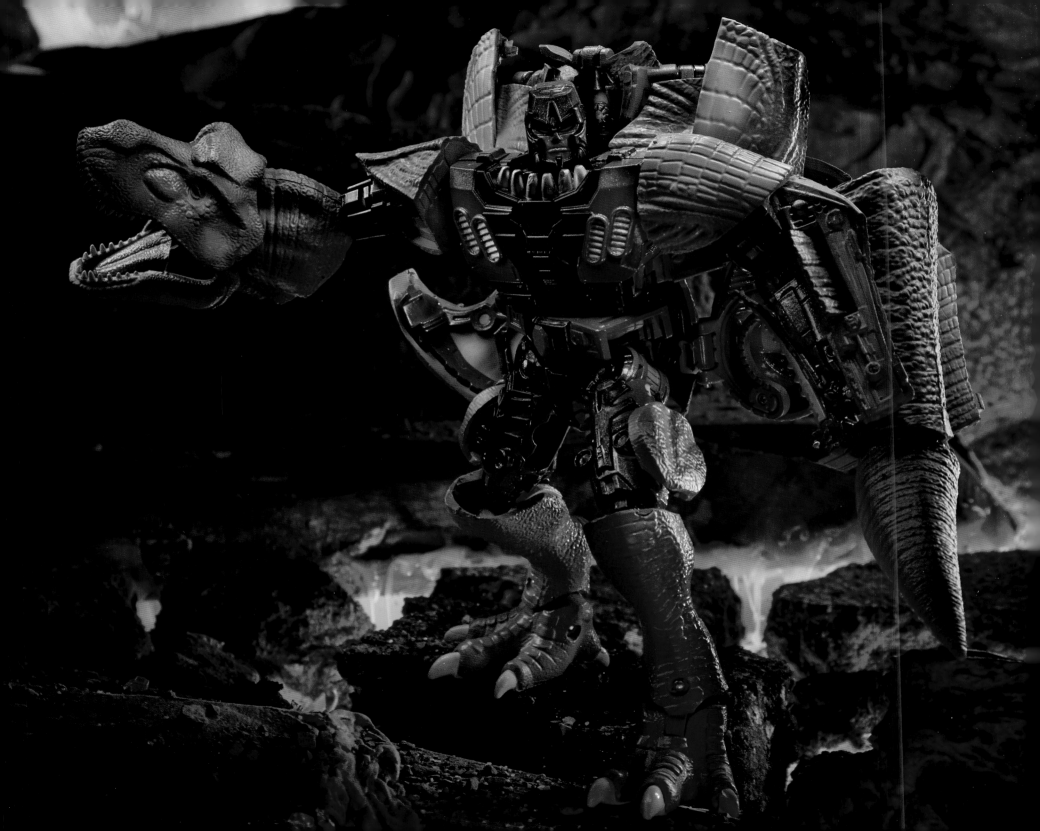

CHAPTER 6

TOYS

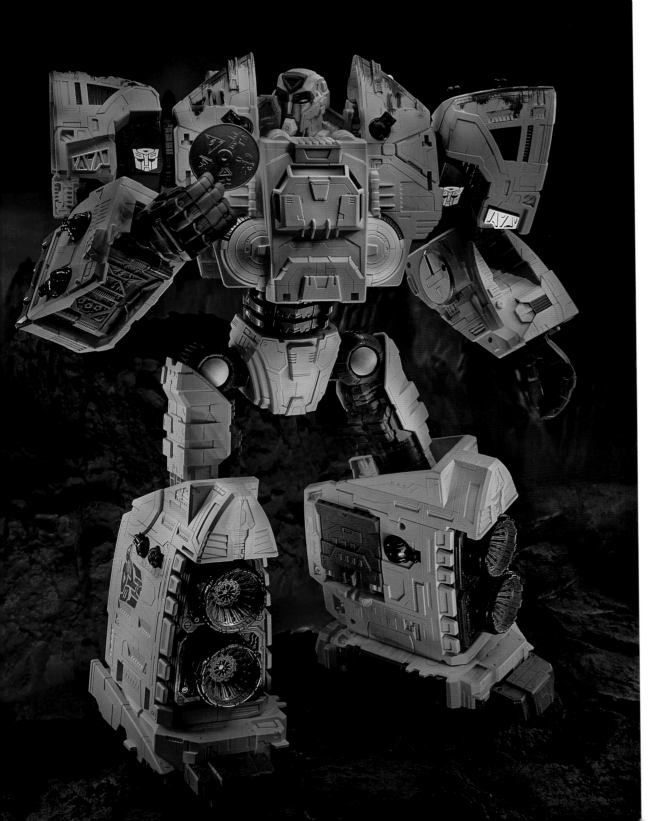

The creative synergy flowed freely between the producers of the animated series and the toy makers at Hasbro. Story meetings in Rhode Island yielded sparks of inspiration that would then turn into story lines.

"I remember spending several days at their headquarters talking with Hasbro's brand team to pitch ideas and get feedback," recalls DeSanto. "We'd find out things like they were going to do this Ark-bot as a toy, and it's going be the *Ark*, *and* it's going to turn into a robot. Once we knew that, we'd go back to [Los Angeles] and figure out how to get it into the show."

A similar moment led to the introduction of the Mercenaries faction. The prominent inclusion of Elita-1 as one of the pillars of the story made her a surprise hit in the toy aisle. Often, design choices for the series would lead to adjustments for Hasbro's toy division, and the new elements would wind up on the box art of some toys.

The idea for *War for Cybertron Trilogy* began with Hasbro's John Warden, Matt Clarke, and Tom Marvelli brainstorming ideas to refresh the *Transformers* toy line. "We had essentially been challenged to turn a toy line into an animated trilogy," Warden says.

"Hasbro gave [the production team] story beats to use and a list of characters they could choose from," said senior creative manager Tom Marvelli. "F.J. and the entire production team just ran with it. They took it further than Hasbro could have hoped."

PAGE 186: *Beast Wars* Megatron in bot mode from the *War for Cybertron: Kingdom* toy line.

LEFT: The 19-inch "Ark bot" action figure.

TOP: Elita-1 in her bot and vehicle forms.

OPPOSITE: Though the animated series includes a truly staggering number of characters, even more characters appeared as toys.

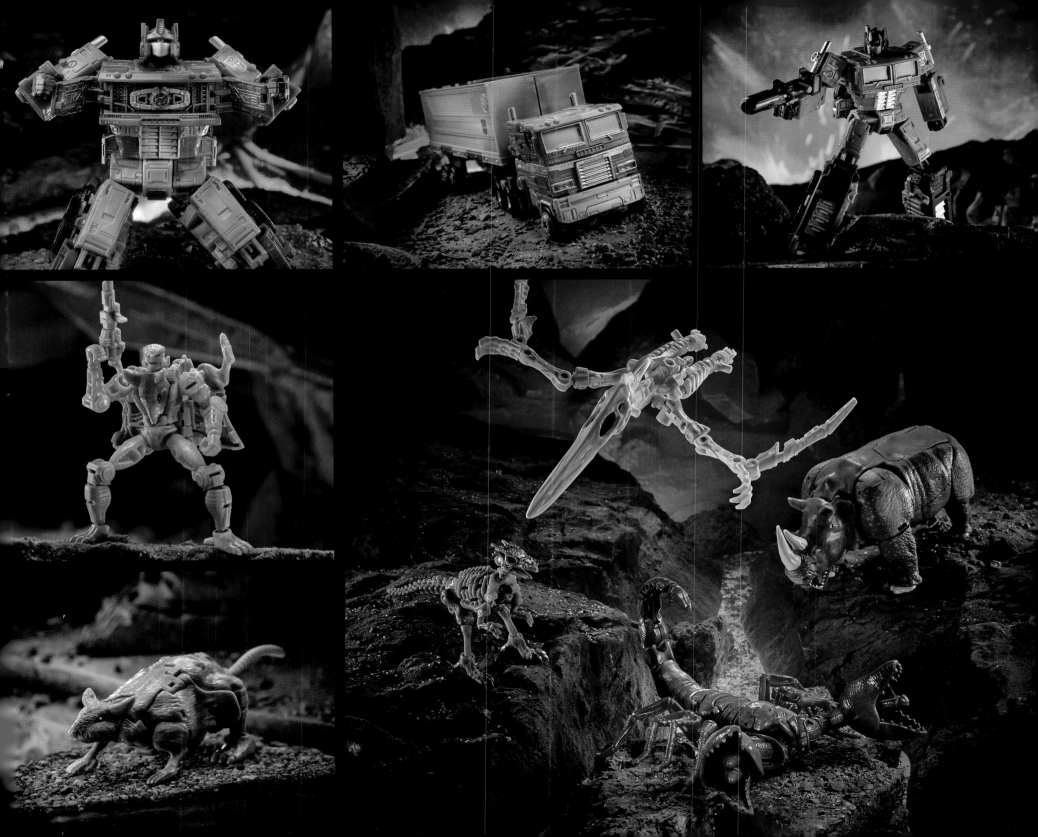

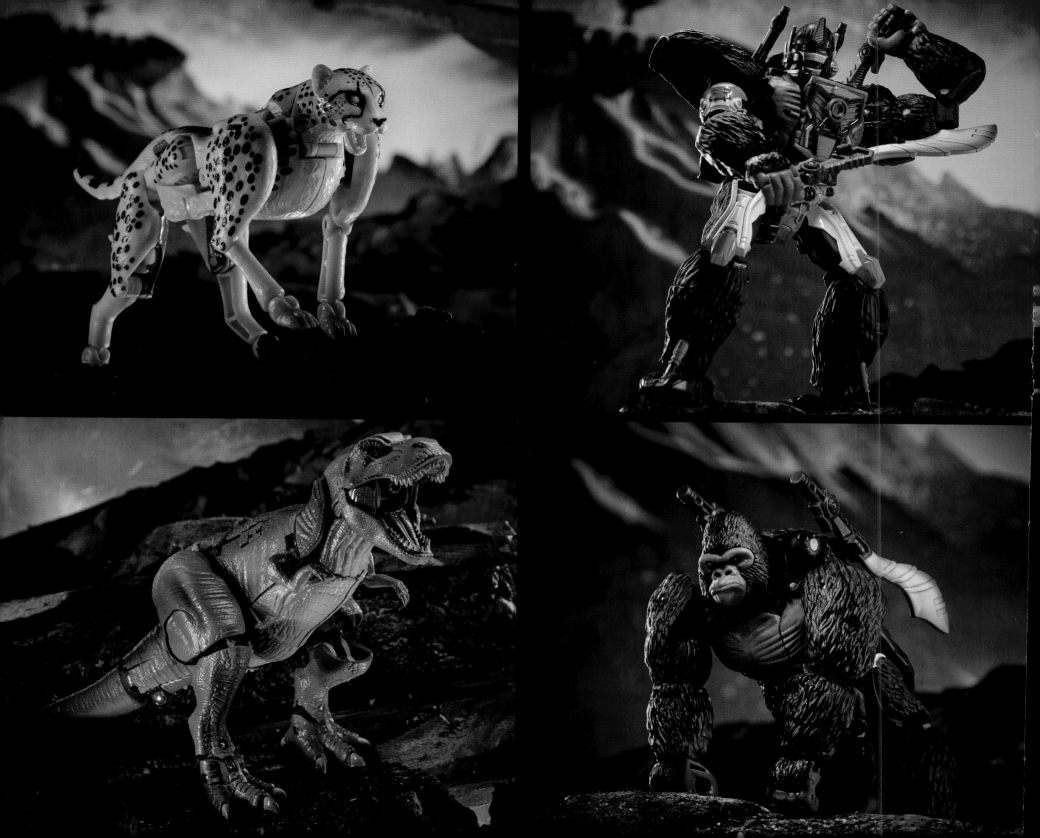

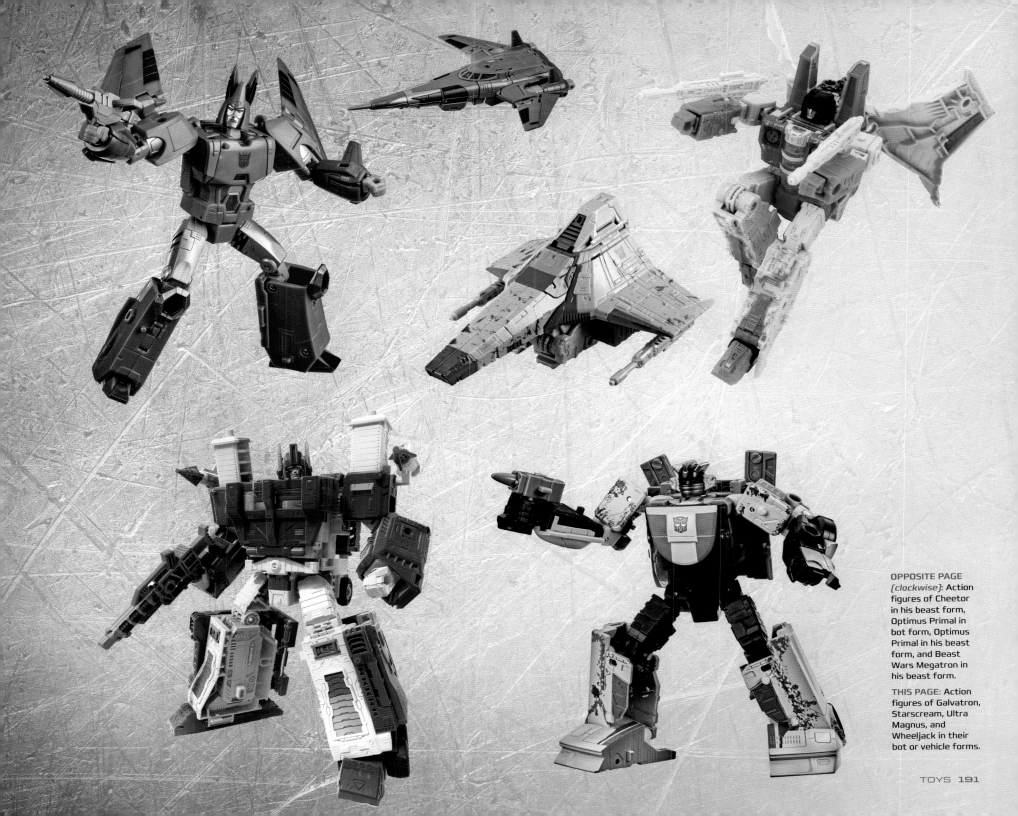

OPPOSITE PAGE (*clockwise*): Action figures of Cheetor in his beast form, Optimus Primal in bot form, Optimus Primal in his beast form, and Beast Wars Megatron in his beast form.

THIS PAGE: Action figures of Galvatron, Starscream, Ultra Magnus, and Wheeljack in their bot or vehicle forms.

THE ART AND MAKING OF
TRANSFORMERS
WAR FOR CYBERTRON
TRILOGY

WRITTEN BY **MIKE AVILA**

DESIGN //// Alice Lewis
SENIOR EDITOR //// Amanda Ng

SPECIAL THANKS TO:

Amy Bence, Kayla Bernier, Ted Biaselli, Mario Carriero, Cecil Cates, Matt Clarke, Rob Dube,
Alyse D'Antuono, F.J. DeSanto, Nicole Effendy, Riya Gandhi, Derek Krossler, Edmund Lane,
Tom Marvelli, Ben Montano, Chris Nadeau, Kelly Johnson, Scott Johnson, Takashi Kamei,
Michael Kelly, Shawn Kenney, Jack Liang, Ben MacCrae, Christina Murphy, Matt Murray,
Michelino Paolino, Tayla Reo, Yoshimitsu Saito, Nick Silvestri, Picture Plane, Rooster Teeth,
Emily Walter, John Warden, Isabella Weiss, Michael Willmott, Geoff Yetter, and Lily Zahn.

Library of Congress Catologing-in-Publication Data available.

Published by VIZ Media, LLC
P.O. Box 77010
San Francisco, CA 94107

10 9 8 7 6 5 4 3 2 1
First printing, September 2022
Printed in China

ISBN 978-1-9747-3250-0

viz.com